Drawn from Courtly India

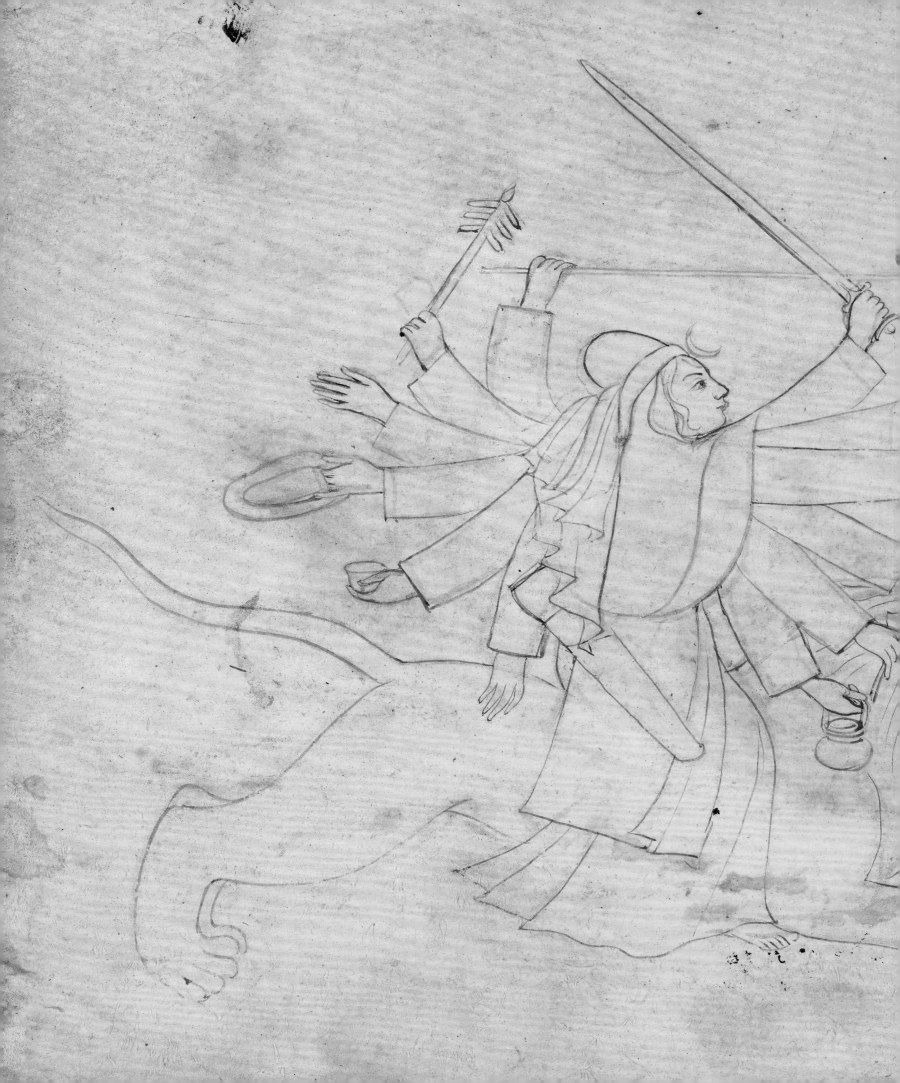

Drawn from Courtly India

THE CONLEY HARRIS AND HOWARD TRUELOVE COLLECTION

AINSLEY M. CAMERON

WITH AN ESSAY BY
DARIELLE MASON

PHILADELPHIA MUSEUM OF ART
IN ASSOCIATION WITH
YALE UNIVERSITY PRESS
NEW HAVEN AND LONDON

Published on the occasion of the exhibition
Drawn from Courtly India: The Conley Harris and Howard Truelove Collection
Philadelphia Museum of Art, December 6, 2015–March 27, 2016.

Support for this exhibition was provided by The Pew Charitable Trusts and
The Robert Montgomery Scott Endowment for Exhibitions.

The publication was also generously supported by Conley Harris.

Credits as of July 15, 2015

Produced by the Publishing Department
Philadelphia Museum of Art
Sherry Babbitt
The William T. Ranney Director of Publishing
2525 Pennsylvania Avenue
Philadelphia, PA 19130-2440 USA
www.philamuseum.org

Edited by David Updike
Production by Richard Bonk
Design by Katy Homans
Map on page 1 by Tom Willcockson
Color separations, printing, and binding by Graphicom, Verona, Italy

Published in association with
Yale University Press
302 Temple Street
P.O. Box 209040
New Haven, CT 06520-9040 USA
www.yalebooks.com/art

Library of Congress Control Number: 2015947020

ISBN 978-0-87633-269-6 (PMA)
ISBN 978-0-300-21525-0 (Yale)

Cover image: Attributed to Manaku (Indian, active 1730–60). *Battle Scene with Demons.* Himachal Pradesh, Guler, c. 1740
(detail of plate 1)
Frontispiece: *Chandi Defeats Shumbha.* Himachal Pradesh, Kangra, c. 1780 (detail of plate 11)
Pages 2–3: *Studies for a Pleasure Barge.* Rajasthan, Udaipur, 1817 (detail of checklist no. 41)
Pages 22–23: *Devi and the Shakti Forces Attack Nishumbha, Shumbha, and Their Army.* Himachal Pradesh, Guler, c. 1760
(detail of plate 23)
Page 132: *Men Falling from Their Rearing Horses.* Himachal Pradesh, Guler, c. 1790 (detail of plate 36)

Contents

Foreword

It is always a pleasure to celebrate—and to share—new and noteworthy additions to our collection with audiences here in Philadelphia as well as with colleagues, both near and far, who care as much as we do about such things. The opening of the exhibition *Drawn from Courtly India: The Conley Harris and Howard Truelove Collection* and the publication of this catalogue present just such an occasion. They also serve to remind us of one of our most important responsibilities—the strengthening of our collection—and of the enduring value of this work.

The ongoing development of a collection like that of the Philadelphia Museum of Art—for it is always a work in progress—is done almost invariably in partnership with others who are as passionate as we are not only about collecting, but also about sharing the art in their care with others. In this regard, we are fortunate to have forged a friendship with Conley Harris and the late Howard Truelove, and through that friendship to have had the opportunity to acquire the marvelous collection of Indian drawings that they assembled largely over the past decade. By doing so, we have added strength to strength, enriching what is one of the finest collections of Indian art in any public museum in this country. And we have added to it a dimension that was missing. Our holdings of Indian art are rich in painting, but until now were not as strong in the field of drawing. As Darielle Mason notes in her catalogue essay, the two disciplines are interrelated, but the interest in Indian drawings—as fascinating as they can be—has until recently been relatively limited.

The acquisition of the Conley Harris and Howard Truelove Collection of Indian Drawings and the sharing of this resource with the public through this catalogue and exhibition represent an effort to foster a broader understanding of this important aspect of Indian art and bring it to the attention of a wider audience. Toward this end, Ainsley M. Cameron's essay on the nature and function of drawing within the workshops that thrived under the patronage of the rulers of India's many kingdoms from the sixteenth to the nineteenth centuries is a welcome contribution to the growing literature on this subject.

I am delighted to have this opportunity to express, on behalf of our Board of Trustees, our deepest thanks to the many individuals who have made this project such a success. As always, the staffs of our divisions of Development, Education and Public Programs, and Marketing and Communications have worked tirelessly to secure the resources needed to support both the exhibition and the catalogue and to promote them to audiences in the region and beyond. Thanks are due as well to our departments of Exhibition Planning and Installation Design, and to the staff of our Publishing Department, and especially David Updike, who served as the editor for this catalogue. We are also grateful for the financial support of several funders, most notably The Pew Charitable Trusts, Conley Harris, and The Robert Montgomery Scott Endowment for Exhibitions.

Finally, I would like to convey our deepest gratitude to the members of our Department of South Asian Art, particularly Darielle Mason, The Stella Kramrisch Curator of Indian and Himalayan Art, who was instrumental in the acquisition of the Harris-Truelove Collection and supervised the development of this project, and Ainsley M. Cameron, The Ira Brind and Stacey Spector Assistant Curator of South Asian Art, who contributed the principal essay to this catalogue while also serving as the organizing curator of the exhibition. She has done an exemplary job.

Timothy Rub

The George D. Widener Director and Chief Executive Officer

Collector's Acknowledgments

Howard Truelove and I were deeply grateful to the many individuals around the world who shared their knowledge and helped us to better understand the art-historical context of individual Indian drawings in our collection. We greatly enjoyed their conversations, insights, and enthusiasm.

Both on a professional and a very personal level as colleague and generous friend, Darielle Mason continues to play a large role in the life of our drawings. I am also especially indebted to Ainsley M. Cameron for her in-depth studies of our drawings and the writing of this exhibition catalogue.

Joan Cummins, now at the Brooklyn Museum of Art (formerly at the Museum of Fine Arts, Boston), Kimberly Masteller, now at the Nelson-Atkins Museum of Art, Kansas City (formerly at the Harvard Art Museums), and Navina Haidar at the Metropolitan Museum of Art, New York, are all exemplary curators with whom we shared many wonderful discussions and who provided us frequent access to their storage vaults. Mary McWilliams, Curator of Islamic and Later Indian Art at the Harvard Art Museums, has not only been a constant friend and resource, but also reached out and invited us into the Harvard Art Museums community, offering us many unique opportunities around Indian and Islamic art. Debra Diamond, Curator of South and Southeast Asian Art at the Freer Gallery of Art and Arthur M. Sackler Gallery in Washington, DC, and her husband, the photographer Neil Greentree, took us to see the great royal collection in Jodhpur. Milo Beach, former director of the Sackler Gallery, offered many insights to guide us along the way. Eberhard Fischer at the Rietberg Museum, Zurich, and Rosemary Crill at the Victoria and Albert Museum, London, invited us to study the rich collections of Indian drawings and paintings in storage in their respective museums.

Terry McInerney was a great supporter of our drawing interests, both as a teacher and as a friend. We had the opportunity to share our collections with numerous other scholars and curators, including John Seyller, Woodman Taylor, and Sheila Canby, all of whom were generous with their expertise. In our earliest days of awakening to Indian drawing and miniature painting styles, Francesca Galloway, Sam Fogg, Simon Ray, and Leng Tan were especially helpful and patient with our many questions, for which we were truly grateful. Rajeshwari Shah at Harvard University was a valuable friend and shared her expertise around the study of our drawings.

Lastly, I want to personally thank Timothy Rub for his support and deep understanding and sympathy during the final months of Howard's life. Howard was so profoundly excited, grateful, and honored that our drawings were joining the great collections at the Philadelphia Museum of Art.

Conley Harris

Boston

Author's Acknowledgments

Conley Harris and the late Howard Truelove—collectors, discovers, and dreamers—thoughtfully and enthusiastically assembled the splendid collection of drawings on which this book and the accompanying exhibition are based. Thank you, Conley, for the hours we spent visually devouring line, form, and composition of these magnificent works. My involvement in this project started shortly after Howard's death, so thank you also for revealing your mutual passion for drawing. The desire to share your collection with the public by ensuring its continued life in a museum is admirable.

The Philadelphia Museum of Art acquired the Conley Harris and Howard Truelove Collection of Indian Drawings in 2013, and the resultant research project, publication, and exhibition thrived under the guidance of our director, Timothy Rub, and in the capable hands of Museum staff. Particular thanks are due to my colleagues in South Asian Art, Darielle Mason, Neeraja Poddar, and Leslie Essoglou. The works were prepared for exhibition by Nancy Ash, The Charles K. Williams, II, Senior Conservator of Works of Art on Paper; Scott Homolka; and Rebecca Pollak. In Prints, Drawings, and Photographs, I am grateful to Innis Howe Shoemaker, The Audrey and William H. Helfand Senior Curator of Prints, Drawings, and Photographs; Shelley Langdale; and Nathaniel M. Stein. In Publishing, the catalogue was ably shepherded by Sherry Babbitt, Richard Bonk, and David Updike; Katy Homans provided the elegant design. Additional thanks are due to Jason Wierzbicki and Tim Tiebout, whose photographs bring the works in the collection to life in the pages that follow, and to James Montgomery, whose installation design does the same in the galleries. Yana Balson of Special Exhibitions was integral to the exhibition's planning and orchestration. In Editorial and Graphic Design, I am grateful to Luis Bravo, Jacqui Baldridge, and Gretchen Dykstra for the exhibition graphics and texts. My colleagues in Education and Interpretation—Marla K. Shoemaker, The Kathleen C. Sherrerd Senior Curator of Education; Joshua Helmer; and Mekala Krishnan—generously devoted hours to discussing how best to capture visitors' imagination with this collection. David Blackman in Development was instrumental in the acquisition process.

My training as a painting specialist always included looking at drawings, but it wasn't until I delved into the Harris-Truelove Collection that I truly discovered the medium. Museum and academic colleagues near and far helped immeasurably by answering many a random question. Special thanks are due to Malini Roy and J. P. Losty at the British Library, London; Andrew Topsfield at the Ashmolean Museum, Oxford; Richard Blurton and David Bone at the British Museum, London; Rosemary Crill, Susan Stronge, and Nick Barnard at the Victoria and Albert Museum, London; Jackie Elgar and the paper conservation team at the Museum of Fine Arts, Boston; and Joan Cummins at the Brooklyn Museum. I am also indebted to Francesca Galloway, Jai and Sugandha Hiremath, Juhie Kapoor, Jeremy Kramer, Jim Mallinson, Laura Neufeld, Wendy Palen, Christine Ramphal, Mark Rasmussen, Eberhard Rist, John Seyller, and Morgan Tingley, all of whom fielded questions, provided images, and discussed the art of drawing throughout many stages of my research.

Ainsley M. Cameron

The Ira Brind and Stacey Spector Assistant Curator of South Asian Art

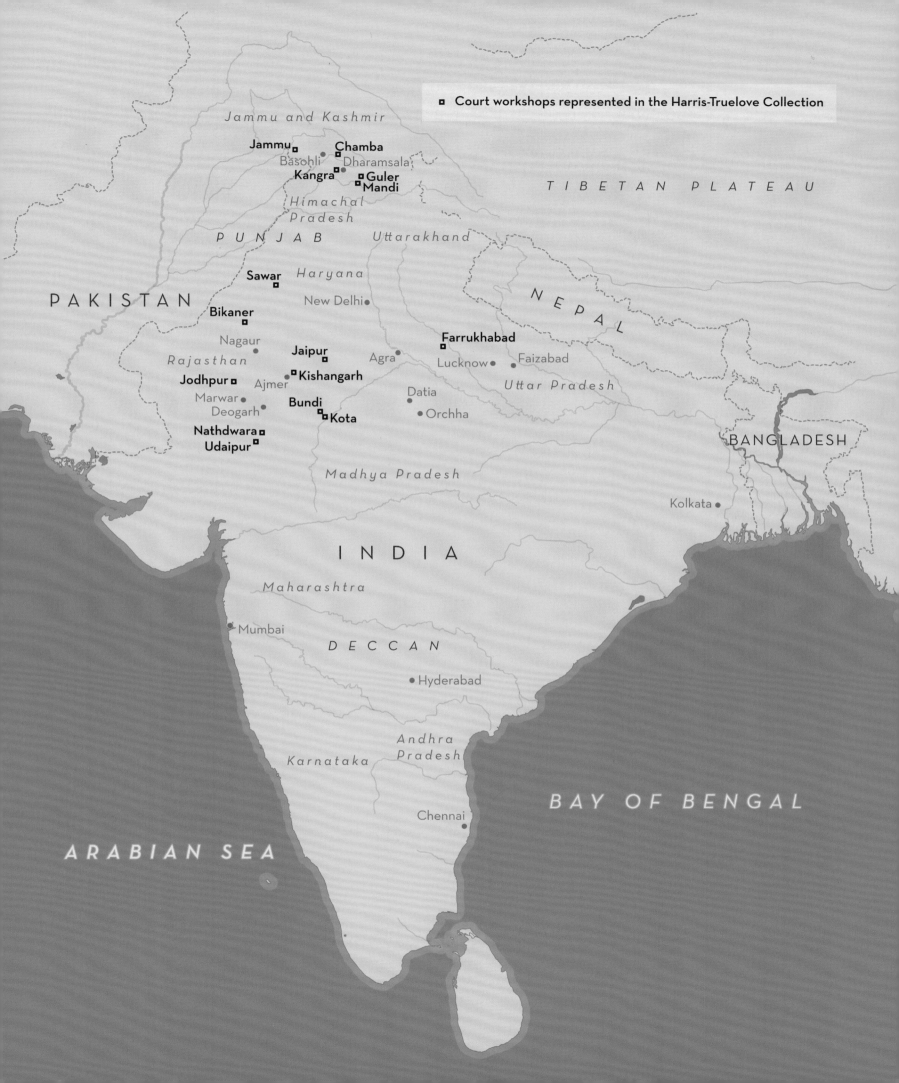

Court workshops represented in the Harris-Truelove Collection

TIBETAN PLATEAU

Jammu and Kashmir

Jammu Chamba
Basohli Dharamsala
Kangra Guler
Mandi

Himachal Pradesh

PUNJAB

Uttarakhand

NEPAL

Haryana

Sawar

New Delhi

PAKISTAN

Bikaner

Nagaur

Farrukhabad

Jaipur

Agra

Lucknow Faizabad

Rajasthan

Jodhpur Ajmer Kishangarh

Uttar Pradesh

Marwar
Deogarh Bundi
Nathdwara Kota
Udaipur

Datia

Orchha

BANGLADESH

Madhya Pradesh

Kolkata

INDIA

Maharashtra

Mumbai

DECCAN

Hyderabad

Andhra Pradesh

Karnataka

BAY OF BENGAL

Chennai

ARABIAN SEA

"Where We Were Drawn"

Conley Harris, Howard Truelove, and the Artist as Collector

DARIELLE MASON

WITH QUOTATIONS FROM CONLEY HARRIS

ARTISTS ARE A CURIOUS SUBSET OF ART COLLECTORS. Their passion for the object, obsession with gathering, and eye to the market may mirror those of their nonartist counterparts. Yet as practitioners they often possess a level of critical facility unavailable to the layperson, and their motivation may have the additional facet of professional inspiration. Perhaps most ineffably, their skills, experience, and vision provide a link across time and space to other artists, a link that can transform our perception of the collected object.

It has been said about the phenomenon of collecting that "the need to respond gives the chance both to bring out what is in the object and what is in ourselves. It is a dynamic and complex movement which unfolds as time passes, and in the act of interpretive imagination we give form to ourselves."[1] Not only are artists particularly adroit at such acts of interpretive imagination, but in them these acts may progress another step, literally giving form to new objects.

Conley Harris (b. 1943) and W. Howard Truelove (1946–2012) began as artists and became collectors. The sixty-five drawings that form their collection, now at the Philadelphia Museum of Art, were created primarily at the many court workshops active across northern, central, and western India between the sixteenth and nineteenth centuries. The collection as a whole reflects Harris and Truelove's intimate engagement with the process of drawing. During the years they collected, the pair made periodic trips to India, where they imbibed the country, especially its landscapes, through their own drawing practice. Yet their collection neither documents India nor surveys a particular aspect of its artistic history; instead it illuminates the art of drawing through India's court artists.

The shape of this volume springs from the nature of the Harris-Truelove Collection. It does not follow the standard format of museum catalogues of Indian paintings and drawings, which typically present individual object entries grouped by court workshops. Instead, Ainsley M. Cameron weaves together works from the collection to create a lucid and engaging introduction to the art of drawing in the context of courtly India. Cameron breaks down the artistic process of sketching, outlining, correcting, and coloring so that we understand how artists worked, as well as how to read the works they made.

Conley Harris (left) and Howard Truelove,
Kishangarh, India, 2002. Courtesy of Conley Harris

She investigates the qualities of these drawings—including their immediacy and the transparency of the artists' visions—so that we may better appreciate their aesthetic power, which sometimes exceeds that of their fully colored counterparts. Most significantly, she uses this often-unfamiliar body of work to help us reconsider our accepted definitions, especially the distinctions we make between drawing and painting, incomplete and finished, process and product.

The art-historical literature specifically focused on Indian courtly drawings is not extensive. Collections formed in the late nineteenth and early twentieth centuries of Persian/Islamic manuscript illustrations (commonly called "miniatures"[2]), and the concomitant publications, often include paintings originating in India done primarily for the Mughal rulers (a Turkic-Muslim dynasty that was the major power in the subcontinent, particularly between the sixteenth and eighteenth centuries). The few "drawings" (non- or minimally colored works) that appear are usually mounted in decorated borders, showing that they were once included in royal albums.[3]

It was art historian Ananda K. Coomaraswamy (1877–1947) who broadened the focus beyond the Mughal court to examine the miniature paintings of the Rajputs (interrelated Hindu families who ruled variously sized kingdoms across a broad swath of northern and western-central India).[4] Coomaraswamy's 1916 book *Rajput Paintings* is often considered the pivotal introduction to the genre,[5] but his first foray into this realm had come earlier, in 1910, in the form of a pioneering short essay and portfolio of images titled *Indian Drawings*, followed two years later by a second volume.[6] Coomaraswamy began the 1910 volume with a quote from William Blake: "The distinction that is made in modern times between a Painting and a Drawing proceeds from ignorance of art. The merit of a Picture is the same as the merit of a Drawing. The dawber dawbs his Drawings; he who draws his Drawings draws his Pictures."[7] While Blake was in actuality arguing for a particular aesthetic, Coomaraswamy instead strove to validate as works of art what others might have seen as the detritus of the painting process—even before he had introduced the paintings themselves.

Coomaraswamy's portfolios of drawings and book on Rajput painting were the result of an extraordinary bout of collecting in which he gathered hundreds of works on paper. These included not only completed paintings but also entire trunks purchased from workshops, some of which contained hundreds of years' worth of working sketches and drawings handed down from generation to generation. Coomaraswamy had begun collecting Rajput works for the United Provinces Exhibition held in Allahabad, India, in 1910–11, and continued with the hope of creating the core of a national museum for India. When this dream failed, he persuaded the Museum of Fine Arts, Boston, via its trustee, Denman Waldo Ross, to acquire the collection in 1917 and hire Coomaraswamy as its keeper. Despite being in the museum's collection for nearly a century, these works remain little known and are most often considered a study collection even today.[8]

After India achieved independence in 1947, not only paintings but also superb drawings began to arrive on the market from royal collections.[9] Yet there was little literature on the latter, and even less popular appreciation for them. It was not until decades later that collectors started to take drawings more seriously. The change came thanks in large part

to two major collector-connoisseurs, both of whom also happened to be accomplished draftsmen: Stuart Cary Welch (1928–2008) in the United States and Jagdish Mittal (b. 1925) in India. In their own ways, both men were primary tastemakers for later Indian art in the second half of the twentieth century.

As a young man, before he discovered Indian art, Welch's collecting passion had been European drawings. Throughout his career he was also an active museum curator; his 1976 exhibition and catalogue for New York's Asia Society, *Indian Drawings and Painted Sketches: 16th through 19th Centuries*, represented a revelation to a new generation of U.S. collectors. As a result, drawings began to migrate from obscure study boxes into the realm of fine art. Carefully matted in the silk mounts favored by Welch, many such works were then framed and exhibited in museums where only paintings had hung before.

Other exhibitions followed. Also in 1976, the Los Angeles County Museum of Art exhibited drawings from the Paul F. Walter Collection.[10] In 1983 the British artist-collector Howard Hodgkin, who had himself acquired a significant number of Indian drawings and paintings, assembled an exhibition of drawings for the Arts Council of Great Britain.[11] Despite this greater appreciation, the spate of exhibitions of Indian miniatures mounted during and after the U.S. Festival of India in 1985–86 all focused on paintings; none included more than a few drawings.[12]

This century has seen an increased focus on drawing, especially through private collections entering U.S. museums. One such collection is Welch's spectacular assembly of Indian, Persian, and Turkish works, given to the Harvard University Art Museums in 1999.[13] Another is the family collection begun by Delhi dealer Parshotam Ram Kapoor and presented to the Metropolitan Museum of Art in 2009. In 2006, the Philadelphia Museum of Art also received a small but excellent group of drawings as the bequest of Dean Walker, its longtime Curator of European Decorative Arts and Sculpture.[14]

A primary proponent of drawings in India has been Jagdish Mittal. Throughout his long career as a connoisseur, collector, and scholar, Mittal opened many new areas in the history of Indian art. Yet he began as an artist, trained at Rabindranath Tagore's prestigious Visva-Bharati University at Santiniketan, West Bengal. Recently, he wrote of his own collection of drawings, now in the Jagdish and Kamla Mittal Museum of Art in Hyderabad: "To my mind, Indian drawings possess a language entirely their own. . . . As an artist, my love for them began in 1949 when I first saw them, only as great works of art."[15] In this he echoes his fellow artist-collector Hodgkin, who had written: "When I first became interested in Indian drawings and began to collect them I succumbed to the easy temptation of equating them with great European drawings. . . . Tentatively at first, I began to see them as great drawings in their own right, executed in a language entirely their own."[16]

Conley Harris and Howard Truelove likewise began with appreciating Indian drawings as great works of art. While their own practices focused on landscape and architecture, respectively, the drawings they collected, like other Indian drawings and paintings, focus in large part on human and divine figures and stories. (Images of pure landscape or architecture, without human elements, are nearly unknown in the Indian workshop tradition.)[17] Prevalent themes include princely portraits and court scenes along with illustrations from Hindu religious stories such as the *Bhagavata Purana* and *Ramayana*, devo-

tional and semi-devotional love poetry like the *Gita Govinda* and the *Rasikapriya*, and *ragamalas* (visualizations of music via verse and image).

Despite their extreme fragility, a surprising number of paintings produced by royal workshops remain extant thanks to their preservation in court treasuries—and to the value placed on individual works when they were eventually dispersed to private and public collections around the world. In comparison, the relatively lower importance assigned to sketches and drawings, along with a lack of interest in the broader context for paintings, means that, while many drawings survive, they are far less accessible to the public, even for study. It is also rare to find a drawing or sketch directly connected to a painting, let alone the multiple related pieces that must once have existed in artists' workshops. The few collections of Indian drawings in museums around the world—now including the Harris-Truelove Collection—help unlock workshop practice and permit greater appreciation of India's unique painting heritage.

There is certainly little in the early biographies of Howard and Conley to prefigure their love affair with Indian drawing. Howard (William Howard Truelove) was born in 1946 in the small Canadian town of Smiths Falls, Ontario, where his father, V. Edward Truelove, worked at Frost & Wood, a farm equipment manufacturer. While Howard was still in his teens, Edward moved the family south to Rochester, New York, to take a position producing camera equipment at Graflex. Rochester was a wealthy industrial city, home to such innovative companies as Western Union, Xerox, and Eastman Kodak. Howard became fascinated with the city's rich legacy of late nineteenth- to mid-twentieth-century architecture. By the time he was sixteen, he was regularly sketching and painting buildings, perched with pencil or watercolors on the curbs, lawns, and railings of Rochester. He went on to earn a BA in psychology in 1968 from Muskingum University in New Concord, Ohio, where he began taking steps to translate his obsession with drawing into a career path.

> *After college, Howard backpacked around Europe, including Russia and Scandinavia. He drew everywhere. Recently I found his diary, written in detailed, descriptive language interspersed with sketches. He was recording everything; it helped him develop his taste, his focus on visual experience, atmosphere. Decades later, he did this when we were traveling to India—he would pause and just draw.*

Howard returned to Canada to pursue a degree in interior design at the University of Manitoba in Winnipeg, and eventually, in 1981, he joined Stubbins Associates in Cambridge, Massachusetts. He spent the rest of his career there, focusing primarily on corporate work, and retired as a vice president of design in 2011, the year before his death. While Howard's passion lay in geometry, space, and line, coworkers and clients remember him best for his creativity as a colorist. His interior design work is characterized by subtle combinations of complex, rich colors and luminous neutrals, although its collaborative nature makes his individual contributions difficult to document.

Born in Wichita, Kansas, Conley Harris was similarly drawn to the visual arts at an early age, but he began in a more formal setting by attending "adult" art classes at the Wichita Art Association every Saturday from the age of ten. From still life to live figure

Pages from Howard Truelove's diary, Florence, Italy, March 3, 1977. Courtesy of Conley Harris

drawing, this early training gave him classical skills in both drawing and painting. His teachers also wove in art history, and Conley retains strong memories of his introduction to European drawings, from the works of Titian to those of Juan Gris and Max Beckmann.

In high school nearly every Sunday I went to the Wichita Art Museum. It has a surprising collection of American modernists, especially Marsden Hartley and Arthur Dove.

Conley attended the University of Kansas in Lawrence, where he focused on figurative painting—and continued to haunt museums, developing the deep knowledge of art that has become an intrinsic part of his work and his personality.

While I was at the University of Kansas, I worked at the [Spencer] art museum. I'd keep a suit there and run over from the studio, change out of my jeans, and introduce people to the museum and the collections.

He graduated from Kansas with a BFA in 1965 and went on to the University of Wisconsin, Madison, where he earned an MFA in 1968. Conley began his teaching career at Boston University, but his transition from primarily a figure painter to primarily a landscape painter came later, when he was a professor of drawing and painting at the University of New Hampshire, Durham.

I was living in a very beautiful and old countryside in New Hampshire and at the same time traveling a lot to Gloucestershire, England. Both landscapes were lyr-

ical, poetic, and sometimes very otherworldly. Those aspects attracted me a lot. First I painted them in watercolor, but in time that led to landscapes in oil. Just like that, people started hearing about my landscapes. Dealers were knocking at my door, and I started selling them. It was just a natural.

Yet while Conley gravitated toward the natural environment in his art, and while landscape continues to be his "bread and butter," he has long lived in the heart of Boston and considers himself very much an urbanite. And when he discusses landscape, surprisingly often he references it through historical art.

I remember once going to visit a friend in the countryside in Connecticut and finding an old landscape, rock covered, rocks all over the ground that had never been cleared. It was like a Marsden Hartley painting. I felt "I'm in this painting." I had the weirdest sense of personalizing the landscape.

Although he and Howard utilized drawing in entirely different ways in their professional capacities, Conley believes its centrality to their lives individually and together was rooted in a shared personality trait:

Both Howard and I were shy as children and young adults, so drawing became a means of entering and expressing our inner, private lives. Our parents didn't encourage us to do art—we both went where we belonged, where we were drawn.

Yet rather than creating abstractions or images wholly from imagination, both came to articulate these inner lives through close examination and interpretation of the inanimate world around them, including the works of older artists.

Independently, each had built a significant library on the art of drawing, but neither had considered himself a collector, especially not of art.

I remember having a stamp collection as a child, but I thought about it as wonderful bits of color on a page. Of course both Howard and I traded with other artists while we were in school, collecting friends' work like most artists do, but neither of us had the notion of being a collector.

Howard and Conley met in Boston in 1980 and soon discovered their shared deep appreciation for drawing—not only its practice and material expression, but also the very idea of it, what they came to call "the expressive hand." They even shared a particular predilection for the landscapes and architectural images of seventeenth-century Europe, a time when careful observation blended with the romantic eye. They found themselves traveling around the United States and Europe, seeking out collections of drawings.

We were soon going regularly to Europe together. I remember one trip where we headed straight to the Rijksmuseum in Amsterdam to see drawings, then on to stops at the great museums of London . . . to see drawings.

In the mid-1980s the pair traveled to Asia, making their first of many visits to Japan. In that country's historic temples and gardens, they discovered an aesthetic that sensitively min-

gled architecture and landscape. The well-considered sight lines, spare ornament, subtle colors, and rich natural materials of Japanese architecture particularly pleased Howard, and he carried them into his own work, as Conley describes:

> Howard was a mathematician; part of his work was always numbers. He was very interested in geometry, in shape, and in spatial relationships—the relationships between things. In Japan he and I would walk through palaces and temples talking—look how this sliding screen breaks up the space, look how that opening punches out to reveal a landscape, look how the sky comes right down to reflect itself in that water.

Japan was also where the collecting bug truly entered their systems, and they came back from each trip with examples of late nineteenth- and early twentieth-century decorative art, especially from the Meiji Dynasty (1868–1912), eventually creating the core of a collection.

> We brought back paintings, ceramics, lacquerware. They were both historic and contemporary. We didn't just get things to put around the house—those were things we took great pride in and loved. Actually, we have a fabulous collection of Japanese nineteenth-century combs. I guess I would have to put the word "collection" on that.

It was through their growing interest in collecting Meiji art that Conley and Howard first stumbled upon Indian drawings. The second half of the 1990s had seen the commercial popularity of historic Asian art rise steeply, thanks in large part to the launch of a highly successful annual Asian art fair in New York.[18] It was in this context that the pair first encountered the works that would subsequently become the focus of their collecting:

> The art fairs were, oh my god, glamorous, filled with gorgeous orchids. It was at one of these early fairs that we first discovered Indian drawings, hidden away in the booths of several London dealers. I don't exactly know which dealer first showed them to us, but I do know we fell in love instantly.

Since Indian drawings are so rarely displayed, it is not surprising that the pair had not previously seen them, despite their familiarity with the Indian painting collection of the Arthur M. Sackler Museum at Harvard University.

Conley had actually visited India more than a decade earlier, in 1983. His itinerary was unusual, as he traveled through the state of Himachal Pradesh, home to the Pahari Rajput painting tradition. He recalls the experience vividly:

> I went with a friend working for Pan Am. We went way up into the foothills of the Himalayas, seeing the hill states by local bus. We traveled from Chandigarh to Mandi to Kangra, then on to Dharamsala, finally returning from the Punjab to Delhi by train. During that trip the temperature in North India reached a searing 108 Fahrenheit, but it was a journey full of experiences I will never forget. When I came back, I told Howard that this was the most amazing country and that he would love it.

It was their discovery of Indian drawings that finally pushed Howard into agreeing to forgo another visit to Japan in favor of one to India. The two made their first journey there in 2001, traveling across western India and focusing on Rajasthan, a region dotted with Rajput courts and rich in painting traditions. The Shekawati region, near Jaipur, with its mural-filled houses that transform miniature paintings into architectural environments, made the deepest impression.

> *That journey unfolded like pages in an art book, one remarkable historical site, temple, textile market, breathtaking landscape after another, all surrounded by India's pulsating and unrelenting tempo. Our lives were changed forever.*

The trip also marked the beginning of their collecting adventure with Indian drawings:

> *On my 1983 trip, it was at the National Museum in New Delhi that I had encountered my first really knockout display of miniature paintings. I wanted Howard to see it, so we went together. By then we had learned a bit about paintings, but what we saw there was amazing to us. We were now fully hooked.*

Luckily, a layover in London on the flight back from India in 2001 gave them an opportunity to make their first purchases:

> *We raced over to one of the major galleries and asked to see drawings. The dealer was surprised. "No one is asking to see drawings!" He didn't even have any in the shop. He wanted us to come back the next day so his assistant could get them from storage. The next morning there was a pile of drawings put before us. It was beautiful to go through that pile! Right there we started separating things. We could recognize styles even then, but it wasn't what was really important to us—*

Krishna Seated on a Throne. Rajasthan, Kishangarh, c. 1800–1825. Brush and brown and black inks with corrections by the artist in white opaque watercolor on beige laid paper; 10⅜ x 13½ inches (26.4 x 34.3 cm). Philadelphia Museum of Art. The Conley Harris and Howard Truelove Collection of Indian Drawings, purchased with the Stella Kramrisch Fund for Indian and Himalayan Art, 2013-68-5

we were looking at the drawing. On that visit we bought six drawings, including the Manaku [see plate 1], the gorgeous Guler with the arch [see plate 2], and a Kishangarh [see illus. on p. 11].

Soon Conley and Howard became regulars on the Indian art scene, buying in London and New York, and learning from dealers, their own reading, and their constant looking. Although they bought mostly Pahari works initially, they soon broadened that focus, choosing each drawing for its quality and vibrancy.

As collectors—"gatherers" was our term of choice—Howard and I were never interested in creating an encyclopedic opus. We looked at every drawing put before us, but what we went for were the most remarkably drawn sheets we could find. Mastery of composition, sensitivity of brushed lines, a sense of artistic purpose perceived through the artist's gestures and vision—these were what directed our decisions to acquire.

Yet it was many years into the process before they began to think of themselves as true collectors.

At first the drawings were parts of our personal lives, just what we had gathered. It was only when other people started calling us collectors that we realized we were. We would look at each other and say, "We are collectors"; we thought that the term was somehow elevating. But over time the ramifications and responsibilities of having such old and remarkable pieces began to dawn on us. As we visited institutions and met curators, it became clear that we were holding important things.

Conley and Howard were very much equal partners in the collecting process, playing off of one another with individual but complementary visions.

We never disagreed—it just didn't happen. We would talk about the pieces as we looked at them, and we would come to very quick decisions about them: These aren't of interest to us, but let's look at this group. Well, these three make a beautiful group, but, oh, maybe this one too. And we would make a decision. We were also surrounded by fabulous paintings, but we were both realistic, that was beyond our means. We were very comfortable within the realm of drawing, and we could enter the realm of Indian art through that door.

As they frequented museums, auctions, and openings, Conley and Howard soon become friends with curators, academics, and other collectors. In Joan Cummins, then curator at the Museum of Fine Arts, Boston, they found a fellow enthusiast, and through her they discovered Coomaraswamy's drawing collection, most of it still kept in storage. These works became a primary resource, helping them to train their eyes.

Their trips to India became more and more frequent throughout the decade, until Howard's illness finally made such journeys too difficult. And the act of drawing itself was a fundamental part of all their travels:

Conley Harris. *Drawing of Howard, 2003, outside Chennai, India.* Pencil on paper, 10¾ x 7⅛ inches (27.3 x 18.1 cm). Courtesy of the artist

We dedicated times of day to drawing. We would look at the top of a building, how it appeared from a balcony, maybe with a mural peeking out. Howard would draw buildings and their details; I would sketch and create the landscape in watercolor. We would be off in our own universes, taking in India. Our focus wasn't people; we were about seeing and about drawing.

One element that intrigued them both, but particularly Howard, was the complex way in which Rajput and Mughal palace architecture deals with space, its rhythms of light and dark, its intricate and layered vistas.

We were constantly talking about space, how one moved from space to space, the flow—Howard was very interested in the flow of space in buildings. When we visited the great palace of Bikaner or Jodhpur's Mehrangarh Fort, we were awestruck at how the jalis [pierced screens] and repeated openings let you see through walls, how light was used to break up spaces.

A passage on the Alhambra from Howard's 1977 diary shows how longstanding his fascination was: "Walking into rooms and seeing the panorama of hills and city beyond. The continually changing vistas of looking from one arched opening through to another and another and another . . . the geometry punches through to allow in the light which falls in wonderful patterns on the filigreed walls."

In addition to architecture, they also discussed color, atmosphere, and, of course, landscape. But in the context of India, landscape and architecture for Conley and Howard were also the threads that connected them to the long-ago artists whose hands they came to know intimately through the works they collected.

Howard and I came to the decision that our journeys to India would focus on discovering where artists lived, seeing the landscapes and architecture that they saw every day. We started in the Himalayan foothills, and Pahari drawings and paintings soon came even more alive for us.

The romance of this tangible link between artists of two very different places and times colored how they thought about their collection, and how they thought about India. They never sought out working artists creating miniatures in the "traditional" style, not even those with links to older ateliers. Instead, their link to the past was through scenery and buildings. Often, passages of landscape would bring to mind passages from the drawings they owned or from paintings they had seen:

There are these great rolling hills that lead to the town of Mandi, and as you drive you have this spectacular view down onto the river at the base of the town, with the palace perched above you. Once, as we were coming into Mandi, we saw it: Look at those hills! Look how one hill folds into the next, how they pass in front of each other, the greenness, the color, the small trees and other plantings. They were all very real, but they were right out of the paintings. It showed us that artists were not making up the landscapes—they were painting based on what they knew and what they looked at every day. They might make variations, they might make abbreviated versions, but they were painting their knowledge, they were painting where they lived their lives.

Conley and Howard also found links to artists of the past embedded in the cities and buildings where these artists had lived and worked. The pair traveled extensively, focusing on the most active painting workshops, and often veering well off the tourist path. From hill sites such as Mandi, Kangra, Chamba, and Basohli, they moved down to Rajasthan, spending time in Kishangarh, Bikaner, Bundi, Ajmer, Kota, Jaipur, Nagaur, Deogarh, Udaipur, Datia, and Orchha, among many other places. Frequently they would revisit a site on multiple trips.

Page from Howard Truelove's diary, Mandi, India, October 16, 2005. Courtesy of Conley Harris

We went two or three times to see the palace murals at Bundi and Kota; they are paradise. We had collected a lot of Bundi-Kota drawings by then, sometimes unfinished. At Kota we found niches where the artist's drawings were visible [where the paint had flaked away]. It was great to be aware of the sense of process in murals still in their original palace location. We loved finding works that were unfinished, abandoned, where the sense of process and progress remained visible. Doing a painting is like that; you start here, this element evolves over there, in time the subject is revealed.

While recent scholarship has taught us that during their own time Rajput and Mughal painters were far from the anonymous devotees described by earlier writers, the paucity of primary sources still makes it impossible to visualize their lives in any but the broadest strokes. As Conley and Howard became more intimate with the works of art, their curiosity about the lives of Indian painters grew. The questions they asked reflected their own experiences as artists:

We became fascinated with the artists who had created the drawings we were collecting. We tried to re-create their lives in our minds. What was it like to negotiate commissions with the rulers and courtiers of royal India? What were the relationships like between artists in an atelier? If an artist wasn't permanently employed by a court, how stressful was it to seek commissions? What about everyday activities—preparing brushes and painting materials, procuring food, or finding ways to keep warm in the frigid winters of the Himalayan foothills?

The traveling and collecting that Conley and Howard did together had an impact on their artistic and professional lives as well, especially for Conley. Japanese art and architecture retained their hold on Howard's aesthetic, at least in terms of his design production.

Krishna and Balarama Hear About the Demon in the Palm Grove. Probably an additional page for a composite series of the *Bhagavata Purana.* Probably Punjab region, c. 1870–80. Opaque watercolor on paper; 12 x 16⅛ inches (30.5 x 41.1 cm). Philadelphia Museum of Art. 125th Anniversary Acquisition. Alvin O. Bellak Collection, 2001-43-2

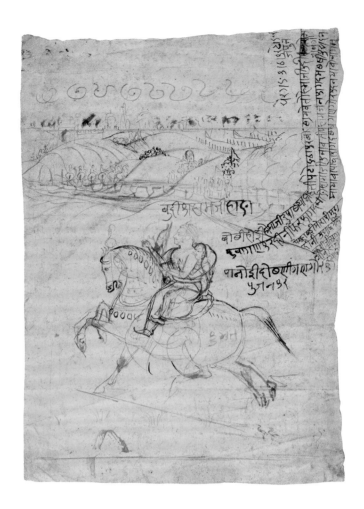

Clockwise from top left:

Maharao Ram Singh II and Courtesan on a Hunting Expedition. Rajasthan, Kota, c. 1840. Brush and brown and black inks on beige laid paper; 14½ x 9½ inches (36.8 x 24.1 cm). Philadelphia Museum of Art. The Conley Harris and Howard Truelove Collection of Indian Drawings, 2013-77-13

Conley Harris. *Glowing Twilight,* 2008. Oil on canvas, 36 x 36 inches (91.4 x 91.4 cm). Collection of Sarah Phillips and Frank Reis, Belmont, Massachusetts

Conley Harris at the exhibition *Glorious Beasts,* Museum of Fine Arts, Boston, 2009–10. Photograph by W. Howard Truelove

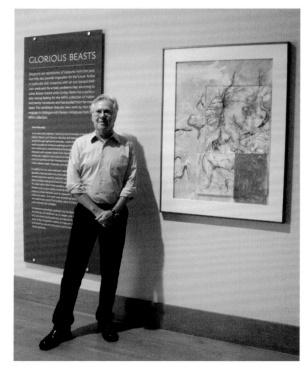

Howard didn't use the Indian drawings in his work in the same way I did; he was most interested in the sensibilities of Japanese art and architecture, the minimalist simplicity of the culture.

Conley, on the other hand, incorporated into his painting practice a growing vocabulary of motifs and concepts from the Indian works he and Howard collected, as well as the paintings and decorative arts they assiduously studied. He often wove these elements into and around more traditional landscape. At times the motifs became landscapes in themselves, overlapping to form fore-, middle-, and backgrounds. These motifs have become not only Conley's source, but also his obsession:

Landscape is the root of all my work, but in time I started incorporating Indian and Persian motifs because they were just in my brain all the time. I had to get them out. At first no one wanted to look at these paintings; my dealers and their clients rejected them—I'm talking conservative Boston here—but it didn't keep me from doing them.

In time he found dealers who appreciated this unusual work, and soon he also achieved museum recognition. In 2008, the Museum of Fine Arts, Boston, asked him to create a group of works on paper responding to their Persian collection; the following year these were displayed together with the historical works in the exhibition *Glorious Beasts*. Conley created a dialogue with the earlier paintings, both in subject matter and in technique, providing visitors new ways of seeing the historical objects. He also collaborated with the museum's conservation scientist to examine the original paintings in detail and then experimented with materials, even grinding his own lapis lazuli to create the luminous blue favored by Persian and Indian painters.

Since Howard's passing, Conley has continued in this vein, building his visual archive on drawing- and painting-focused trips to India, as well as creating finished works during residencies in that country. At the same time, he has been experimenting more and more with photography. Indeed, during Howard's final hospitalization, Conley turned toward photography both as an aspect of his art and as a way to continue their shared aesthetic life by bringing Howard images from their collection along with daily views of their beloved roof garden as it went through its seasonal shifts.

I try to capture the atmospheric. Along with my watercolors, photographs let me hold atmosphere for later, to refer to passages. For me photography is also an art form—the rectangle is the canvas, it's a way to capture the essence and the color.

I did not meet Howard and Conley until 2006, when they came to the Philadelphia Museum of Art to see the small exhibition *Lines of Thought: Indian Drawings from the Dean Walker Collection*. They wrote in advance to ask if they could have access to some of the other drawings not on view. I had heard their names from friends in Boston and looked forward to their visit, gathering what little Philadelphia had in the way of drawings along with some special paintings for them to see.

I remember that first meeting. Howard was tall, composed, and quiet; dressed in a dark suit, he carried a cane that lent him even more distinction. Only his avant-garde glasses, the wry humor escaping in his glance, and his quiet comments hinted otherwise. Conley, with lively green eyes, a white fetlock, and a brightly checkered shirt, was clearly Howard's foil and complement. Howard's gravity tethered Conley's enthusiastic buoyancy; Conley's vivacity amused and enlivened Howard.

When we reached the storage area, they pulled out a notebook filled with photographs of the drawings in their collection. I was delighted not only at the quality of their works, but also at the way the two spoke and how they looked at the art. They explored the quality of lines, the massing and layering of forms. They debated the artists' choices in composition and color, critiquing historical pages as the work of fellow artists. And they enjoyed the process enormously. Howard and Conley were certainly interested in the stories behind the works, and in discovering when and where pieces in their own collection originated, but it was far from the obsession of many collectors to pigeonhole each work into a text, court, and century.

> For us, time and time again, it was not the narratives being illustrated but the art of drawing that engaged our imaginations and seduced our hearts. Drawing is a sensual act, revealing perceived images through a series of lines. As Howard put it, drawing is "line as it defines form, structure, and surface, and the way one can travel through the illusion of pictorial space." We knew about drawing.

On that first visit, I spent at least three hours with them poring over the Museum's Indian drawings and paintings, often comparing them with photographs of works from Conley and Howard's collection. Thereafter, they came regularly; Howard had work in Philadelphia, and at times he would visit alone, but more often they came together.

Not long after our first meeting, I went up to see them in Boston. Their apartment is embedded in Bay Village, a neighborhood as centrally located as it is possible to be, yet retaining the odd feeling of being hidden at the forgotten outskirts of a city. Entering their apartment was a visual delight. Antique textiles, framed drawings, and other works line the narrow hall leading into a small living-dining room filled with masses of rich and colorful objects, from sleek Japanese woodwork to a troupe of vintage plaster Hindu gods painted in bright colors.

> Howard and I put high value on surrounding ourselves with very beautiful things from different cultures. Along with drawings and Japanese arts, we were also so interested in textiles—an Indian sari draped over that chair, a piece of Japanese indigo on the wall over there. For a long time we couldn't share this with very many people—most of our long-standing friends weren't very interested, so it felt like it was our realm, our private universe.

After I snooped happily through the textiles and objects, we sat on the floor to look at drawings. Each was carefully matted in acid-free board and stored in ideal museum Solander boxes.

We were very responsible gentlemen about our collections. The drawings were not casually tossed about the apartment. And it wasn't like we would buy a drawing, put it away, and then rediscover it; we were constantly going through our drawings. Because they were so nicely matted it gave them a kind of respectful context. They were very elegant, and I think that complemented our lives, and I say that humbly.

As Howard and Conley talked me lovingly through each work, it was evident that they had researched every piece in the collection, asked and assiduously recorded the opinions of numerous scholars. It also became clear that, for them, each piece had a personality and a memory.

We would put a number of drawings out on the carpet because we might want to make a change in our little exhibit on the wall. Sometimes we would pursue a theme. More often, though, we would just look at them and talk about them, how much we loved them because they reminded us of our travels, and the things that we had learned about each one.

They also loved showing the drawings to a range of selected guests, and did so regularly. They would extend invitations to visiting curators coming to speak at Harvard or the Museum of Fine Arts, and usually pay their institutions visits in return.

We liked to share the collection and share what we loved in the drawings. "Oh, look at the invention in this gesture! Look how intelligent this artist was that he could put all these ideas together into a coherent composition!" We also liked to learn about our drawings and about which collections had related ones. "So we have five of that series and the rest are in Zurich? Let's go to Zurich and the Rietberg!"

Like their painted counterparts, Indian drawings rarely concentrate on either landscape or architecture. So one of the most intriguing questions is why Conley and Howard, given their artistic predilections, gravitated toward this genre in the first place.

We never saw drawings that were principally landscape. In the drawings, landscapes are just noted by a few marks; here's the profile of the horizon, here's a graceful hill indicated by just a simple brush mark.

Perhaps it was this minimalist aesthetic, akin to the Japanese brush paintings they had earlier admired, that sparked their interest. More likely, though, it was Conley and Howard's own obsession with artistic practice and the process of drawing, rather than the subject matter. In fact, it is this focus that distinguishes their collection even from other collections of Indian drawing.

We value Indian drawings, as we value all drawings, because it's through them that artists express their preliminary ideas, their earliest thoughts laid down in the quiet of their studios. Howard and I were always partial to unfinished paintings that reveal through their several exposed layers the artist's thinking and painting

techniques. Certainly we could find very finished drawings, but what really excited us was when we could see through the drawing—I love that expression, seeing through the drawing—and have the privilege of looking through the artist's thoughts.

This partiality expresses itself most clearly in the large percentage of works with whited-out areas (see, for example, plates 2, 22, 24a), a correction technique that both conceals and reveals the artist's intention.

> *Whitewashing sections of the initial drawing is a step in the process that can show the hand of the artist and how he makes his decisions. Over time the underdrawing often bleeds back through, but initially it was clean. Seeing the layers adds a sense of real life to a drawing; it lets us feel the artist's struggle. The artist might think, "I want to emphasize the figure of the goddess Durga over here, so I have to minimize this other element over there, and to minimize it I have to put a wash over it and restate it so it's not quite so vivid in the balance of things." Seeing the struggle reveals the process, but it's really all about the struggle.*

As their exposure to other collections and to scholarship grew, Conley and Howard gradually recognized the historical significance of their drawings. They came to feel responsible to the long-dead artists, and the collection became more than the sum of its parts. As Howard's illness progressed, they decided to look for an institution that would keep the collection safe and intact, but also share the drawings with a larger public.

The Philadelphia Museum of Art's collection of Indian paintings has great depth and includes a number of masterworks, thanks especially to the gifts of Alvin O. Bellak, Stella Kramrisch, and William P. Wood. With the notable exception of Dean Walker's gift of drawings, however, it has virtually nothing in this aspect of the art form. Conley and Howard were searching for a museum where their collection would not only be complemented by a strong history of engagement with and scholarship on Indian art, but would also be truly transformative. Their home institutions—Boston's Museum of Fine Arts and Harvard's Sackler Museum—also happen to be the ones with the strongest Indian drawing collections in the United States (those of Coomaraswamy and Welch, respectively). They came to see the Philadelphia Museum of Art as the logical choice.

> *We were becoming more and more mindful of the importance of this work, and it became about protecting it. It had to have a destiny. We hope that people coming to the Philadelphia Museum of Art in the future see our collection as a window onto the many ways of creating. We hope it helps them understand the constant struggle of all artists to create.*

NOTES

1. Susan M. Pearce, *On Collecting: An Investigation into Collecting in the European Tradition* (London: Routledge, 1999), p. 358.

2. A term inappropriately adopted from European medieval book illustration, where *miniature* refers to the use of a red lead pigment called minium, rather than to their small size.

3. See, for example, the collection of Victor Goloubev, published in Ananda K. Coomaraswamy, *Les miniatures orientales de la collection Goloubew au Museum of Fine Arts de Boston*, Ars Asiatica no. 13 (Paris: Les Éditions G. van Oest, 1929); see also David J. Roxburgh, *The Persian Album, 1400–1600: From Dispersal to Collection* (New Haven: Yale University Press, 2013).

4. In the art-historical literature, the Rajput kingdoms are traditionally divided between those on the plains (more or less the modern states of Rajasthan and Madhya Pradesh) and those in the Himalayan foothills (primarily in the modern state of Himachal Pradesh). The latter region is variously labeled Pahari (mountainous) or Punjab.

5. Ananda K. Coomaraswamy, *Rajput Painting*, 2 vols. (London: Oxford University Press, 1916). The argument in these volumes was anticipated by a series of articles he published in *Burlington Magazine* in 1912.

6. Ananda K. Coomaraswamy, *Indian Drawings* (London: India Society, 1910), and *Indian Drawings: Second Series, Chiefly Rajput* (London: India Society, 1912).

7. The quotation is from William Blake, *A Descriptive Catalogue of Pictures, Poetical and Historical Inventions* (London: D. N. Shury for J. Blake, 1809), p. 62.

8. Ananda K. Coomaraswamy, *Catalogue of the Indian Collection in the Museum of Fine Arts, Boston*, 6 vols. (Boston: Museum of Fine Arts, 1923–30); Alvan Clark Eastman, *The Nala-Damayanti Drawings* (Boston: Museum of Fine Arts, 1959). While this collection cannot be lent, individual works have been exhibited in the museum's galleries over the years, including in the 1992 collection exhibition *Making an Indian "Miniature" Painting*.

9. According to Jagdish Mittal, the two main conduits for drawings during this period were Delhi dealer P. R. Kapoor and Jaipur-based painter-academic Ramgopal Vijaiwargiya. See Jagdish and Kamla Mittal Museum of Indian Art, "Indian Drawings," jigyasa0.tripod.com/drawings.html.

10. Pratapaditya Pal and Catherine Glynn, *The Sensuous Line: Indian Drawings from the Paul F. Walter Collection* (Los Angeles: Los Angeles County Museum of Art, 1976).

11. Terence McInerney, *Indian Drawing: An Exhibition Chosen by Howard Hodgkin*, exh. cat. (London: Arts Council of Great Britain, 1983).

12. These included *India!* at the Metropolitan Museum of Art, New York; *Painted Delight* at the Philadelphia Museum of Art; *Life at Court* at the Museum of Fine Arts, Boston; *Pride of Princes* at the Cincinnati Art Museum; and *Essence of Indian Art* at the Asian Art Museum of San Francisco.

13. Stuart Cary Welch and Kimberly Masteller, eds., *From Mind, Heart, and Hand: Persian, Turkish, and Indian Drawings from the Stuart Cary Welch Collection*, exh. cat. (New Haven: Yale University Press; Cambridge, MA: Harvard University Art Museums, 2004).

14. Aaron M. Freedman, *Mala ke Manke: 108 Indian Drawings from the Private Collection of Subhash Kapoor* (New York: Art of the Past, 2003). For Dean Walker's 2006 bequest of twenty-six drawings to the Philadelphia Museum of Art, see philamuseum.org/exhibitions/2006/241.html.

15. See Mittal, "Indian Drawings."

16. Howard Hodgkin, "Introduction to the Exhibition," in McInerney, *Indian Drawing*, p. v. Hodgkin's text is also a wonderfully lucid attempt to articulate what he sees as the difference between European and Indian drawing.

17. The rare examples that do exist are invariably included in a series to illustrate a specific scene in a narrative, rather than for their own sake. See, for example, a page from a mid-seventeenth-century *Bhagavata Purana* (*The Rainy Season*; Philadelphia Museum of Art, 2004-149-18), and a page from a sixteenth-century *Kalpa Sutra* (*Glorious Sunrise*; Museum of Fine Arts, Boston, 35.58).

18. The Haughton Asian Art Fair, which ran from 1996 through 2008, created not only a feeding frenzy in the market but also significant cross-fertilization of and for collectors, especially in its early years.

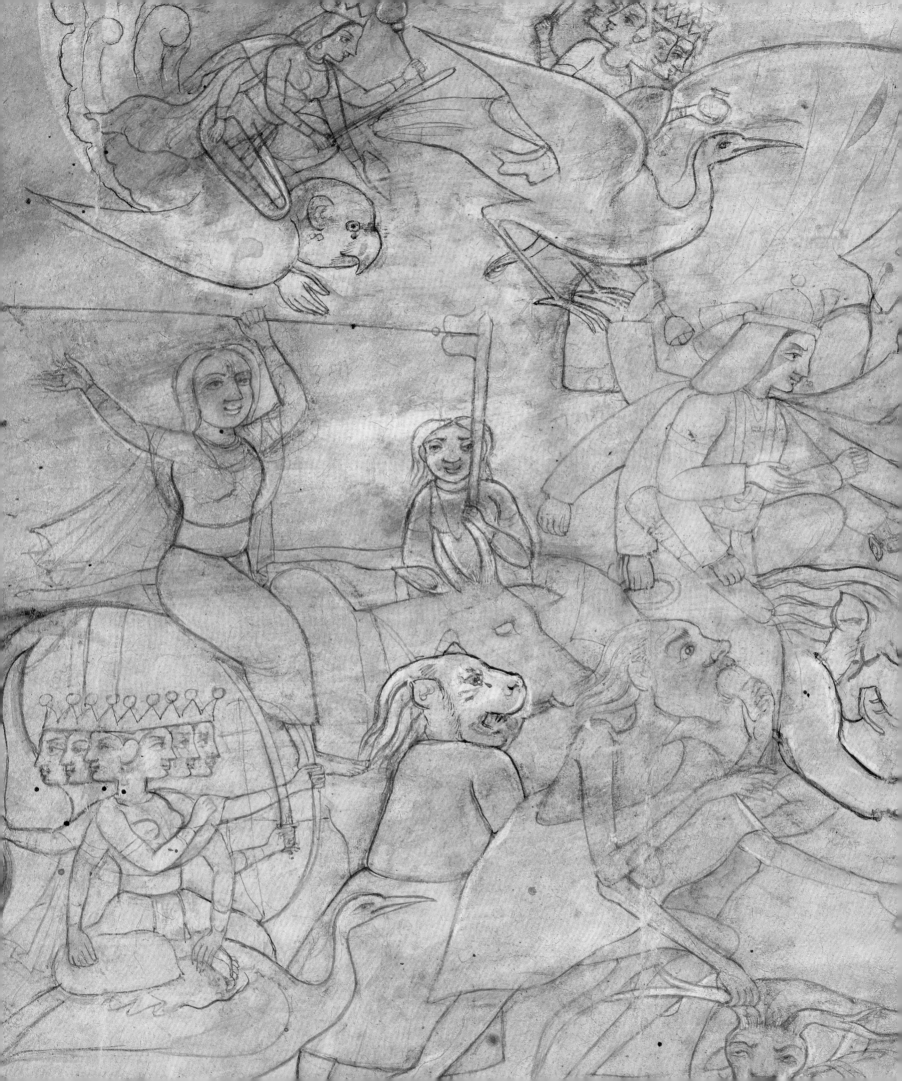

The Art of Drawing
in Courtly India

AINSLEY M. CAMERON

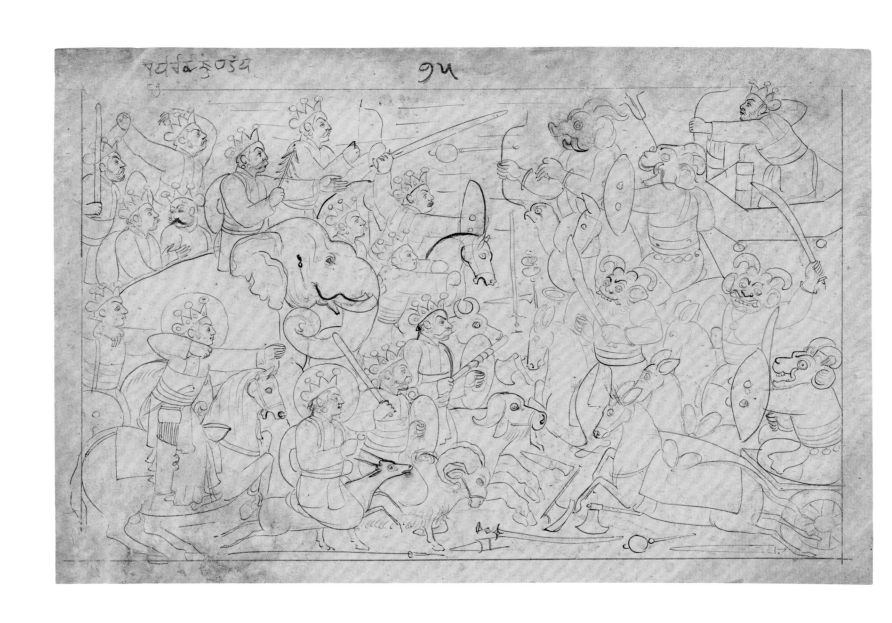

The Artists' Workshop

A DRAWING FROM THE ROYAL COURTS OF NORTH INDIA CAN BE A CAPTIVATING expression of an artist's mastery of form, feeling, and technique, and a vital source of insight into artistic practice in courtly workshops. Yet, because these drawings are often considered as mere working materials in a process that finds its full realization in a painting, the art of drawing receives less attention than it deserves. Drawings *did* serve as preparatory material for paintings, often circulating within workshops over generations, prompting exchanges and experiments that enlivened the larger creative process. Moreover, while every finished painting began with drawing, not all drawings are abandoned paintings. Drawings could also be intended and valued as finished works in their own right. Indeed, drawing and painting were so closely entwined in North India that it can be difficult to make a categorical distinction between them. Whether they are preparatory studies, finished works, or an ambiguous confluence of the two, drawings can reveal much about the visualization of an idea, the emergence of a composition, the nature of a collaborative workshop process, and the transmission of techniques. Though often modest in their materials and execution, drawings are intrinsically revelatory of the creative process, as informative about a workshop's production as a finished painting.

The Conley Harris and Howard Truelove Collection of Indian Drawings is an illuminating exploration of a complex and rewarding art form. These sixty-five works on paper, amassed with love and a careful eye for detail, include practice sketches, preparatory drawings, subtly modeled scenes, and lightly colored works intended as complete compositions. Among the subjects represented are striking examples of portraiture, illustrations of devotion and devotional texts, vivid depictions of battle, and explorations of the timeless theme of love. The drawings are also temporally and geographically diverse, covering the sixteenth to nineteenth centuries and originating in many different royal courts—though the greater part of the material comes from the eighteenth-century Hindu courts of Rajasthan and the Pahari region, the area that today spans the states of Himachal Pradesh and Jammu-Kashmir.[1] The collectors—themselves artists—assembled works that delighted and intrigued them, and each drawing reveals facets of the artistic process that can be explored in depth. While the entire history of Indian drawing cannot be summarized through these works alone, the collection opens new ways of looking at and thinking about the art form as practiced in India. Gentle yet robust lines convey the creative activity of workshop-trained artists with compelling immediacy—from the

delicate shading of a ruler's facial hair to the strong contours of a god's upstretched arm in battle.

Historically, the art of drawing in India was handed down from generation to generation, from father to son or master to apprentice, usually within court ateliers. Drawings accrued within the workshop and were used to educate rising artists, so that a given workshop's drawings often share recognizable stylistic attributes, even over many generations. *Battle Scene with Demons* (plate 1), created in Guler around 1740, vividly exemplifies the consummate skill and forceful vision court artists could bring to bear in their drawings. The work portrays a scene from the *Bhagavata Purana* in which armies of crowned gods and horned demons battle one another.[2]

Modern-day scholars could take myriad approaches to analyzing *Battle Scene with Demons*. This energetic composition is attributed to the artist Manaku (active 1730–60), whose oeuvre and family ties have been extensively studied.[3] Accordingly, one might consider the style in which Manaku has executed the drawing in the context of the Guler atelier in which he was trained; how the detailed figures are placed in relation to their surroundings; and the types of scenes that predominate in Manaku's repertoire in comparison to those of his father, Pandit Seu, and brother, Nainsukh. Alternatively, *Battle Scene with Demons* could be considered in relation to the other illustrated folios from the series to which it belongs (a corpus of nearly 350 paintings and drawings for which Manaku was the master artist),[4] or it could be placed in the broader context of illustrations of the *Bhagavata Purana* by artists at the surrounding workshops of the Pahari region and Rajasthani plains.

Among other things, these modes of inquiry would help illuminate how the stories and themes of a particular mythological text are expressed through motifs and intricate visual narratives—a valuable insight into the history of the art form to be sure. Yet, it is also fruitful to consider the fundamental artistic means by which *Battle Scene with Demons* was rendered. A light gray brushstroke creates the first understanding of form, while a darker gray stroke restates and clarifies that initial expression. These confident lines seem to define form and composition from a void, expertly and economically communicating the chaotic battle, as charging figures from opposing sides morph into one center, set off by the angular thrusts of their jutting swords, in a powerful display of good versus evil. This drawing may have been used as preparation for a painting, or it may have served as an educational tool within the workshop. However, when viewed as an act of drawing, it is also an accomplished work of art. Looking closely and thinking about the drawing process itself yields a deeper appreciation of the art form, which in turn brings into focus matters of form, practice, and history.

DRAWING AS BLOSSOMING

While each painting workshop in courtly India had slightly different techniques, the basic elements of the drawing process were shared. An artist began with a prepared sheet of handmade paper, which he burnished. The initial line was created in charcoal, black ink, or red ochre to introduce the suggestions of form and composition, either drawn freehand or using a guideline pounced from another picture. This first touch was strengthened

with black or gray ink, following the initial line while also allowing for slight alterations in form. Corrections could be made by painting white pigment over a particular area where the line was to be reconsidered and redrawn. Once the composition had been established, the paper was burnished again, usually with an agate stone. A white wash primer was often used to coat the entire sheet, smoothing the establishing brushstrokes and filling any voids in the paper. With the initial line still visible, the drawing could then be rearticulated and strengthened with black ink. At the same time, detail was added to the composition, often followed by color notations (either written or indicated through dabs of pigment) to instruct artists at the next stage. Pigments were mixed to achieve desired shades; brilliance and adherence were enhanced with a temper of gum arabic. Color was applied in a slow, additive process, with each layer being given time to dry before the next was added. The coloring was often done sequentially, from top to bottom, starting with the broad swaths necessary to fill the background of the composition. Color was added to the main figures last, bringing life and movement to the work. The addition of gold—either in a powdered form that was burnished to help adhere it to the page, or as gold leaf delicately glued to the finished painting's surface—completed the work.

A picture worked from start to finish in this fashion is generally regarded as a painting, but the process was not only driven toward one end result. In fact, works regarded as drawings can exist almost anywhere along the continuum, including stages of coloring. A late eighteenth-century drawing from the Pahari court of Guler, *A Nobleman and His Family Seated in a Pavilion* (plate 2), exemplifies this idea. The delicately rendered figures and beautifully articulated composition reveal the working and reworking that can be considered the building blocks of a painting. The pillars of a pavilion frame the central figures as well as the lush landscape setting. The husband, wife, and small playful child were delineated first, followed by the landscape. A delicate red line—the initial line added to the page—remains visible even with the additional layers of ink, white wash, and color. The artist's reconsideration of this initial line is clearly visible in the figure of the demure wife, where a black line subtly varies from the underdrawing. Further changes to both stages can be seen where white wash ground has been added to correct areas of the composition, most noticeably in the young figure in the foreground and the female attendant to the left (see detail on p. 29). The background architecture of the pavilion is visible through her form, demonstrating that the figures were added after the composition was fully conceived. This is not to say they were added significantly later in the process, only that they were not blocked out in the initial drawing. The artist's practice of working and reworking continues in the next step in the painting process with the addition of color to the foreground and landscape. The landscape is covered in a wash, establishing the initial layer of color that, despite its light touch, obscures the drawn details of the trees and bushes. Further changes to the composition can also be seen along the upper border, where the cusped arches of the pavilion have been lowered to create a more intimate family setting.

Ananda K. Coomaraswamy compared this reflective, additive artistic process to the blossoming of a flower; as color is applied, it reveals that which is "both shown and unshown."[5] Many works from the Pahari region survive suspended in this "blossoming"

Plate 2 (following pages)

A Nobleman and His Family in a Pavilion

Himachal Pradesh, Guler, c. 1790
Brush and black and red inks, watercolor, and opaque watercolor with corrections by the artist in white opaque watercolor on beige paper
10½ x 8¼ inches (26.7 x 21 cm)
Philadelphia Museum of Art. The Conley Harris and Howard Truelove Collection of Indian Drawings, purchased with the Stella Kramrisch Fund for Indian and Himalayan Art, 2013-68-14

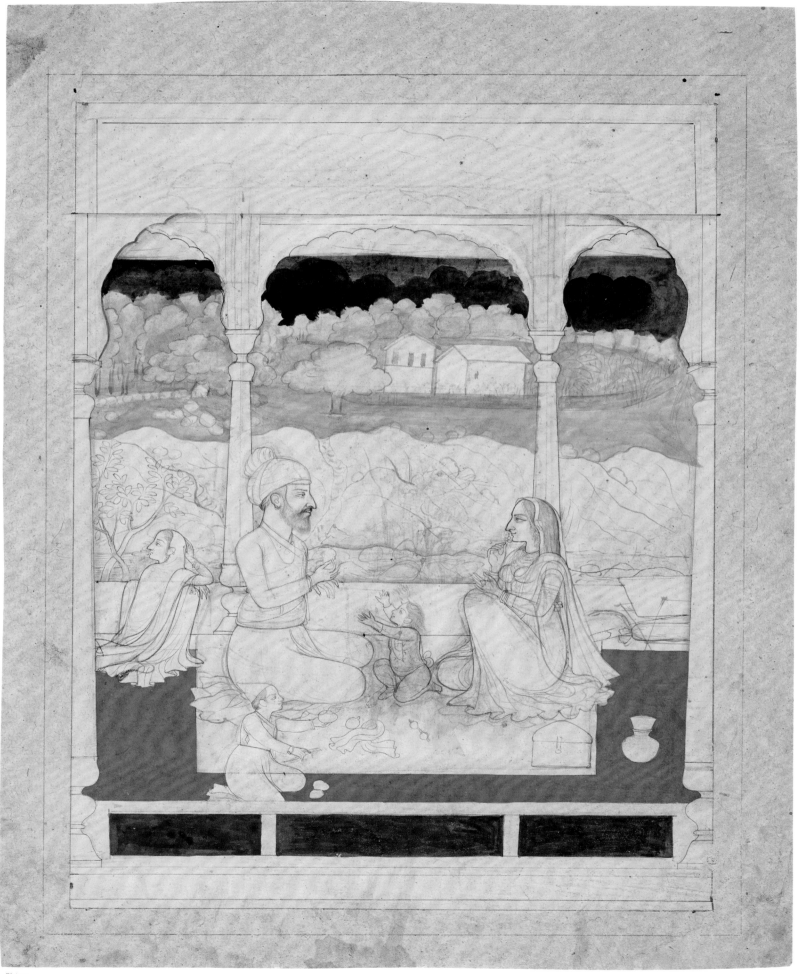

Plate 2

Detail of p

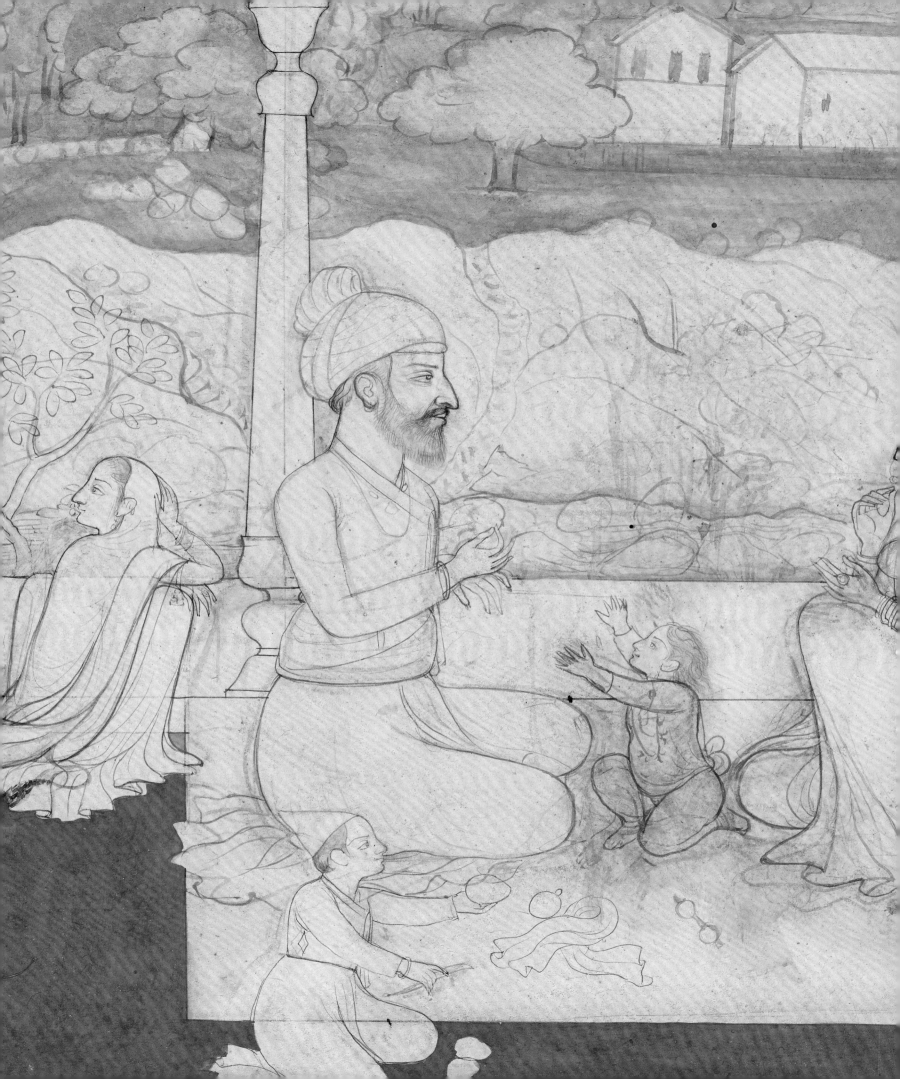

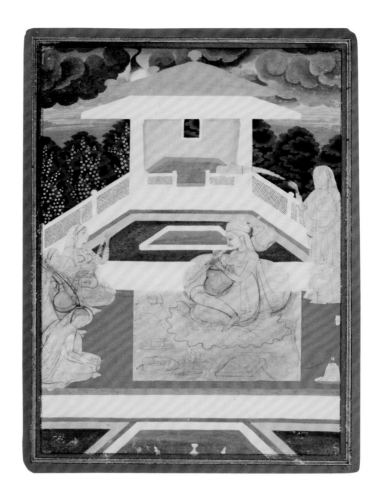

Fig. 1. ***Women Playing Music on a Terrace***. Himachal Pradesh, Guler or Kangra, c. 1820–30. Ink wash with opaque watercolor on paper; image: 9¾ x 6¾ inches (24.8 x 17.1 cm), sheet: 10½ x 7¾ inches (26.7 x 19.7 cm). Philadelphia Museum of Art. Lent by the City of Philadelphia, 17-1964-6

stage.[6] *Women Playing Music on a Terrace*, from about 1820–30 (fig. 1), for example, has progressed from the light wash of color added to the background to a fuller, more robust opaque watercolor. Distinct layers of details have been added to the trees in the background, where the artist has painted first the shadows, then the individual leaves, and finally the colorful flowers. The heavy clouds above a bright orange sunset are also fully painted, drawing attention to the lightly sketched figures in the foreground. Though it is more finished than *A Nobleman and His Family*, this work, too, is "blossoming"; it survives not as a discarded, unfinished painting, but as a work that was valued and preserved precisely in this rich state of becoming.

If the act of drawing can be understood as a flowering of form, meaning, and experience, then understanding the process by which drawings are made is fundamental to seeing and knowing them more fully. In the following sections, each stage of a drawing's creation is examined: The present section assesses the role of artist and patron in forming a workshop and encouraging its output; "Paper, Ink, and Brush" and "Realms of Color" read meaning into subtle variations in tone; "Reuse, Repetition, and Reinvention" explores the role of innovation within the confines of the workshop system; and "What Line Reveals" examines subtle characteristics particular to certain artists and workshops. The drawings in the Conley Harris and Howard Truelove Collection speak to all of these ideas. Their enticing details reveal much about specific acts of making, yet they also tell a larger story about the importance of drawing—not only in the production of paintings, but as an art form.

THE WORKSHOP IN PRACTICE

The artistic workshop in courtly India was a sophisticated cultural formation. Generally located within palace grounds, the atelier was more than a workplace—it was also a production system and a social structure encompassing hereditary apprenticeships and feudal fealty. Artists were paid a living wage and often provided with lodging, as well as added benefits depending on the quality of work they produced. While documentation about daily life in the workshops that produced most of the drawings in the Harris-Truelove Collection is rare, we do know that they were closely modeled on the system that preceded them: the Mughal atelier.

The Mughal Empire was a dominant political force in the subcontinent from the early sixteenth century, and its rulers were great patrons of the arts. In the sixteenth and seventeenth centuries the imperial atelier, itself based on a Persian predecessor, functioned on a grand scale, and the Mughal court employed an army of artists, craftsmen, and architects. By 1590 the emperor Akbar (r. 1556–1605) had more than a hundred painters—mostly Hindu—working for him, and, according to the chronicler Abu'l Fazl, he examined their work every week.[7] Akbar's enthusiasm for the art form, along with increased political stability, led to a period of intense artistic growth and experimentation, as Mughal artists developed a style that intermingled Persian, European, and indigenous aesthetics.

This artistic innovation continued under subsequent Mughal rulers and created a very strong visual record of the empire. In order to achieve the required output, the Mughal atelier quickly developed an advanced bureaucracy, creating distinctions (in rank as well as function) between the master draftsman responsible for the drawing—including the initial composition and the finishing touches such as the addition of facial features—and the junior workshop member tasked with the application of color in between those stages. This hierarchy also included the officials responsible for the selection of texts, artists, and calligraphers. The structure of the Mughal workshop was likely based on that of the *kitab-khana*[8] of Safavid Iran (1501–1722), which functioned as a small industry in which many different types of artists and artisans, including calligraphers, scribes, painters, and binders, were offered lifetime employment, room and board, an annual salary with incremental adjustments, grants of land, and bonuses for masterpieces particularly enjoyed by the patron.[9] It was not unusual for patrons even to bestow titles on their preferred artists; the Mughal painter Mansur, for example, was given the prefix *ustad* (master) early in his career, and later the title *Nãdir-al-'Asr* (Wonder of the Age) by the emperor Jahangir (r. 1605–27).[10]

An extraordinary variety of production emerged from the many interconnected painting traditions of India from the sixteenth through nineteenth centuries: from the delicate shading and modeling favored by the Mughals, to the bold contour line associated with the Hindu courts of Rajasthan and the Pahari region, to the fanciful compositions of the Deccan. These traditions are united by exquisite craftsmanship, subject matter, medium, and the workshop production system. The objects they created were a means to express the wealth, military prowess, and status of the ruler as patron of the arts.

While the Rajasthani, Pahari, and Deccani workshops lack the deep and detailed textual record that exists for the Mughal court, many of their works include lengthy inscriptions on the reverse. These can afford several kinds of information: the name of the artist;

the identities of patrons, sitters, and depicted attendants or nobles; the date of the work; excerpts from literary texts in Brajbhasha or Sanskrit; and details of when and where the work was presented to the patron.[11] An important, if perhaps less explicit, testimony to the practices of the Hindu and Islamic court workshops comes from the art-historical record itself. Works that have been preserved represent many approaches to and stages of the drawing process, including practice sketches, compositions exploring space within the picture plane, heavily shaded and expressive drawings, and lightly colored complete compositions. This suggests that the artist's role encompassed more than skilled production; he, like the patron, was also a collector and preserver of drawings.

THE ARTIST AS COLLECTOR AND PRESERVER

As David Roxburgh writes, drawings may be considered "a fragile and dispensable detritus" of the design process—"processual compost," so to speak.[12] However, the abundance of drawings that survive either preserved in albums or kept by artists' families suggests that they were highly valued. Two contemporaneous works from the Rajasthani court of Bikaner demonstrate how drawings were kept, cared for, and esteemed.

Maharaja Gaj Singh with Court Ladies Playing Holi (plate 3) is an intimate scene that depicts the ruler of Bikaner, Gaj Singh (r. 1745–88), holding a female attendant snugly around the waist. Ten other female attendants accompany the couple, nine to the left and one to the right.[13] The figures on the left are very finely drawn and animated. Some cover their faces or hold each other, and one is filling a large *pichkari* (syringe), presumably with colored water to spray in celebration. The figure on the right is also delicately drawn, but in a later style and with a stiffer mien. The variations evident in the female figures suggest that this drawing was reworked over time, with perhaps decades elapsing between the addition of figural details and passages of color. The background, in a recognizable Bikaner hue, gives the figures little context, but it does call attention to the fact the paper has been repaired numerous times.[14] Telltale patchwork on the reverse demonstrates how cumulative wear resulted in a need to adhere new corners to the sheet (fig. 2). Clearly this drawing had a long life in the workshop, during which it was consulted, appreciated, and revised by generations of artists.

In an interesting contrast, *Maharaja Hari Singh of Kishangarh* (plate 4) left the workshop through presentation to a patron and was subsequently enshrined in an album. This work is very finely drawn, with brush lines so thin as to be practically indistinguishable from each other. The subject, likely Hari Singh of Kishangarh (r. 1629–43), is depicted in costume appropriate to his time period but anachronistic to the mid-eighteenth-century, when the drawing was made. Thus this Bikaner work emulates Mughal tradition on several levels, from the heavy shading and modeling, to the historiographical subject matter, to the patron's practice of enshrining historical portraits in albums. Both systems of preserving drawings—retention in the workshop and presentation in album format—demonstrate a high regard for their importance as works to be returned to for inspiration, guidance, or visual enjoyment.

These two drawings—one a timeworn and repeatedly repaired sheet, the other a pristine work kept in an album—provide clues to what defines a complete

Plate 3 (opposite)

Maharaja Gaj Singh with Court Ladies Playing Holi

Rajasthan, Bikaner, c. 1750
Brush and black and red inks on opaque watercolor over traces of charcoal on beige laid paper
9 x 6½ inches (22.9 x 16.5 cm)
Philadelphia Museum of Art. The Conley Harris and Howard Truelove Collection of Indian Drawings, 2013-77-14

Fig. 2. Reverse of plate 3 showing new corners adhered to the paper, which was made brittle by the use of green malachite pigment

हरिसिंह

composition, or "finished drawing." Where the portrait of Gaj Singh with his female attendants includes a variety of lines in various stages, the carefully modeled and shaded figure of Maharaja Hari Singh was offered to the patron as a finished work in its lightly colored state. But what of *The Birth of Krishna* (plate 5), an energetic, heavily shaded composition drawn at the Kangra court around 1780?[15] In this scene from the *Bhagavata Purana* villagers crowd in from the left to celebrate the god's birth. Several villagers hold celebratory offerings of grass, while musicians performing on the roof in the top left corner add to the festive atmosphere. In an interesting use of architecture, the building's sharp angles both reveal and contain the birth scene on the right. Positioned on a raised platform, with sprigs of offered grass before them, the mother and child are being treated as royalty by eleven attendants, one of whom wields a flywhisk. The undulating crowd of well-wishers is carefully modeled and shaded, so that any addition of color would obscure the delicate drawing (see detail on p. 37). These well-articulated lines could be read as guides provided by the master drafts-man to indicate to the colorist the subtleties and emotive responses desired in the finished painting.[16] However, it is more likely that this drawing was preserved in its present state as a template to inspire future generations of artists who might attempt to portray this scene. While not "finished" in the sense of coloring and presentation, it is a complete answer to the needs and intentions of artist and workshop.

The role of the artist as preserver of drawings continues in the contemporary workshops in Rajasthan. In small family workshops at the pilgrimage center of Nathdwara, for example, drawings and sketchbooks created by ancestral artists continue to influence and teach younger generations how to draw and paint in a process that resonates with earlier workshop tradition.[17] These sketchbooks are valued so highly that workshop artists are reluctant to share them with outsiders—their pride in the family legacy is conflated with the fear that valued designs might be revealed to other artists intent on copying them.[18] In interviews conducted by Tryna Lyons, contemporary Nathdwara artists emphasized the importance of drawing for their practice: "Gulabji observed that artists cannot keep themselves from illustrating any idea they are discussing. Sketching is their natural means of expression and communication."[19]

If the artist and his family can be identified as important collectors and pre-servers of drawings, there may also be a relationship between the decline of a work-shop and the prominence of its productions in public collections. Coomaraswamy acquired hundreds of drawings from artists' families in the Pahari region in the 1910s and 1920s, as the fabric of the regional workshops began to unravel. Many of these works are now in the Museum of Fine Arts, Boston, arguably the strongest public collection of Indian courtly drawings. Coomaraswamy's early activities as a scholar and collector guaranteed that Pahari drawings would be well represented in the art-historical canon. However, the fact that there was such a strong corpus of work for him to collect reflects not only the dissolution of local structures of art production, but also likely the heightened importance of drawings within the long Pahari artistic tradition. On the level of historiography and the history of collections, too, drawings have much to tell us about the story of art and artists in India.

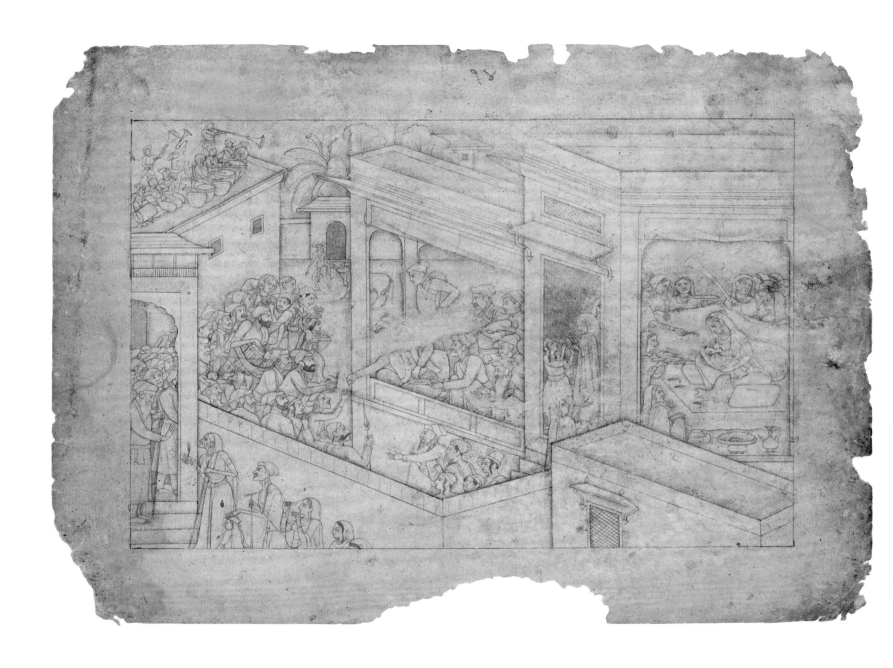

Plate 5

The Birth of Krishna

From the *Bhagavata Purana*
Himachal Pradesh, Kangra, c. 1780
Brush and black ink over charcoal with touches of blue
watercolor on beige laid paper
8 x 12 inches (20.3 x 30.5 cm)
Philadelphia Museum of Art. The Conley Harris and
Howard Truelove Collection of Indian Drawings, purchased
with the Stella Kramrisch Fund for Indian and Himalayan
Art, 2013-68-17

Detail of p

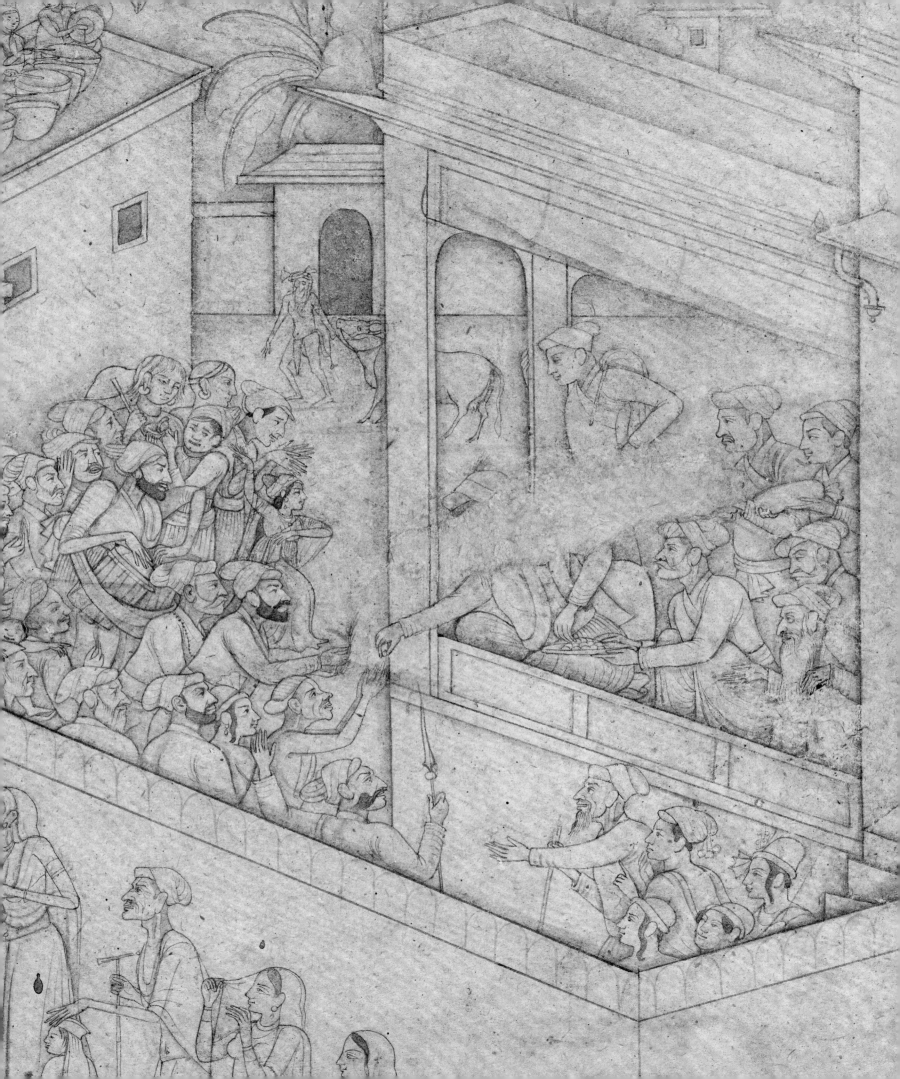

Paper, Ink, and Brush

Fig. 3. Reverse of plate 6 with lines of script likely to be
Lahnda, also known as Western Punjabi

IN ADDITION TO SERVING AS SITES OF DRAWING, PAINTING, AND LEARNING, ARTISTS'
workshops were places where materials and implements were manufactured. These mate-
rials were handmade, expensive, and time-consuming to create. From paper support to
brushes and pigments, the selection and fabrication of materials were careful and consci-
entious matters for the artist, as much a part of art making as drawing or painting. Papers
were manipulated in the workshop to suit the works they would support, as well as the
expressive and technical needs of the artist. Inks and pigments were similarly made for
specific uses.

Until the nineteenth century, papermakers in India used textile and grass fibers
in varying mixtures.[20] Jute, linen, and hemp were macerated into a pulp and mixed with
water, yielding a thick paste that was laid to a uniform thickness across screens and
allowed to drain. The resultant sheets were then dried and treated.[21] Paper could vary in
size, thickness, and texture; its final appearance was linked to its ingredients as well as
regional differences in its construction.

Papermaking was a specialized skill, and most of the paper used in the imperial
Mughal workshop, for example, had been imported from Persia or manufactured in Sialkot
or Kashmir.[22] Later workshops in courtly India also purchased and modified paper. Once
in the workshop, thin sheets of handmade paper were combined to create *wasli,* a thicker,
cardboard-like support that could withstand the burnishing necessary to create a smooth,
paintable surface. To prepare *wasli,* sheets of rough paper were glued together with *layee,*
a gently heated mixture of wheat and water. Drops of copper sulfate were added between
layers to protect against insects. This sandwich of fine paper sheets was then burnished
with a conch shell or agate stone, resulting in a smooth, water-absorbent surface.

On average, five layers of paper provided enough support to accept the pigment
added in the final stages of painting. While the top sheet of *wasli* was usually new, the
supporting layers were often recycled workshop remnants. Such reuse affected the final
work, as over time ink from the interleaving layers would often bleed through. A beau-
tifully rendered drawing from Kangra, *The Sage Narada Awakening the Gopis* (plate 6),
demonstrates such a transfer of ink from the papers beneath.[23] Two very thin sheets are
here glued together, with rows of script in dark black ink on the reverse of each (fig. 3).[24]
This black ink permeates the drawing, making it difficult to focus on the subtlety of line.
Yet despite these visual distractions, three stages of the drawing process are visible in

this work: the initial red line, a white wash interleaving layer, and the secondary sketch in black ink. The confluence of these lines reveals fourteen *gopis* (female cowherds), whose overlapping forms and free-flowing clothing echo the rolling hills of the landscape setting. The sage Narada, wearing an antelope-skin garment and carrying a *vina* (a stringed musical instrument), gestures toward the hills as he inquires after the whereabouts of Krishna, who can just be glimpsed in the distance with his three cowherd companions.

Paper appears to have been a rare and expensive commodity, and papermaking centers developed their own formulas and technologies, which they guarded carefully. Thus, particular types of paper are associated with different workshops. In the Rajasthani court of Kota, for example, two types of paper were primarily in use: one produced from finely macerated off-white pulp that resulted in thin and smooth sheets, the other from fibrous brown paper pulp that resulted in rougher, buff sheets. These two papers were employed interchangeably in the workshop, regardless of subject matter. However, while the ingredients appear not to have mattered for Kota artists, the size of available paper was an important consideration; scale was emphasized over paper color and smoothness, which could be addressed through coating and burnishing.[25] In Kota, as in other workshops, every scrap of paper was utilized; practice sketches often trail off the page, and new drawings added over time create cumulative layers of artistic process.

This cumulative drawing process is evident in a large work from Kota in the Harris-Truelove Collection, which has an elephant battle scene on one side and sketches of several court scenes and a British officer on the other (plates 7a,b).[26] The elephant battle scene is detailed, hectic, and lively. Rampaging elephants carrying howdahs atop their muscular backs career across the page while the opposing army, mounted on horseback, weaves between the beasts. Bows and spears are at the ready, and it is unclear who will emerge victorious (see detail on p. 42). Elephant scenes became a specialty of the Kota workshop in the late seventeenth and early eighteenth centuries, and the figures portrayed in this drawing, datable to around 1710–20, resonate with that period.[27]

The opposite side of the drawing, also drafted in Kota, contains four distinct scenes. The largest and most detailed is a *darbar* (court) scene with an unidentifiable Kota *maharao* (king) amid his attending courtiers. Directly in front of him are two acrobats caught mid-performance. The many short inscriptions dotted around the scene are color notations and other aide-mémoire, including precise notes on the positions of court musicians and guards within the prescribed hierarchy (see detail on p. 43). These detailed instructions are revelatory of workshop practice, and of the social organization and etiquette of the court. Below this courtly tableau is a worship scene where Srinathji, a form of Krishna, appears as the central deity surrounded by architecture and with his devotees in the foreground.[28] Further down the vertically aligned page is a drawing in black ink of two figures on the back of a camel.[29] The fourth and final sketch on this side of the page depicts a British officer, complete with colorful plumage in his cap, and an inscription in Devanagari that identifies him as *kompanii*, shorthand to indicate his involvement with the East India Company. Judging from his uniform of red coat and black trousers, this officer was added to the page during or after the 1880s.[30] This single, large leaf of paper thus had a long and varied life in the Kota workshop. The five drawings covering both sides

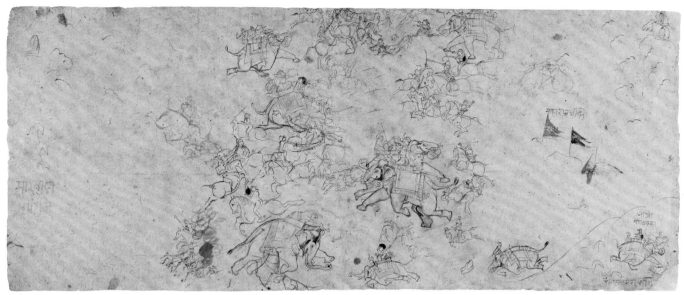

Plate 7a

Plates 7a,b

Elephant Battle Scene (a)

Sketches of Several Court Scenes and a British Officer (b)

Rajasthan, Kota, c. 1710–20 to c. 1880
(a) Brush and black and blue inks and watercolor on beige laid paper; (b) brush and black and colored inks and watercolor on beige laid paper
9 x 21 inches (22.9 x 53.3 cm)
Philadelphia Museum of Art. The Conley Harris and Howard Truelove Collection of Indian Drawings, 2013-77-9a,b

Plate 7b

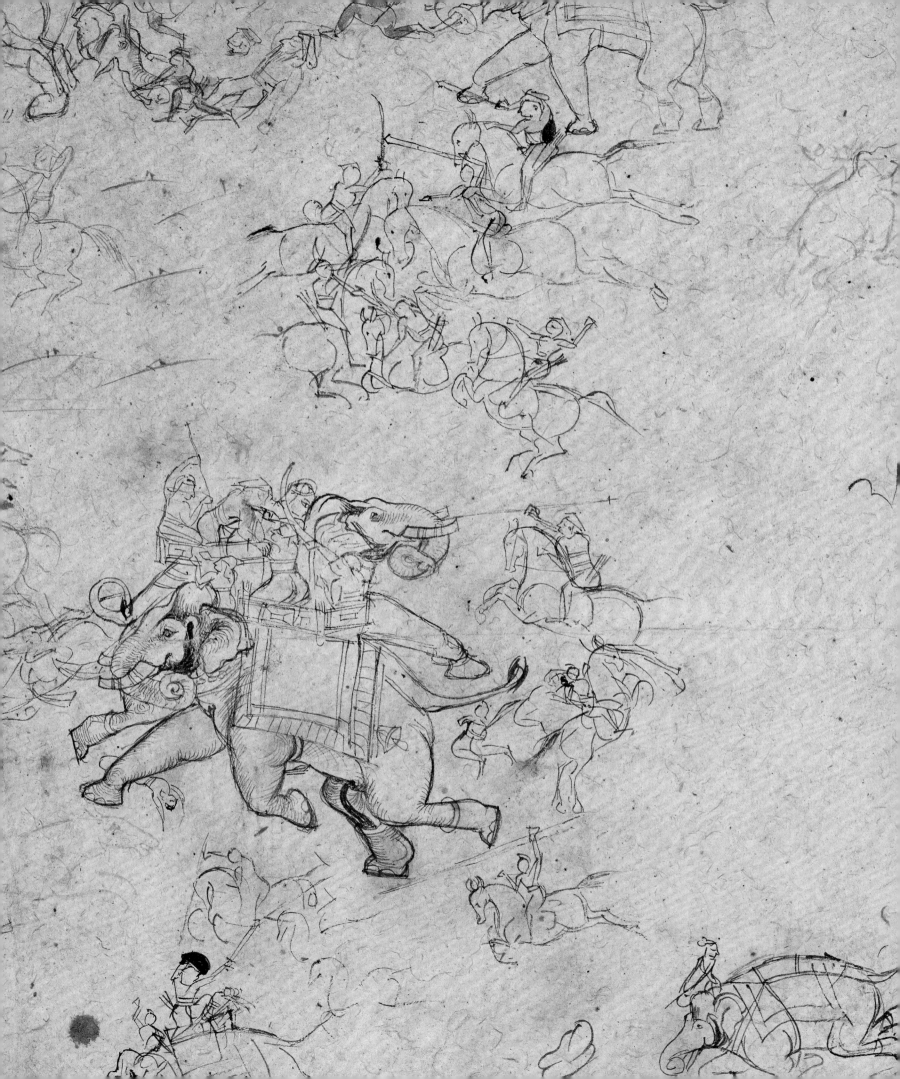

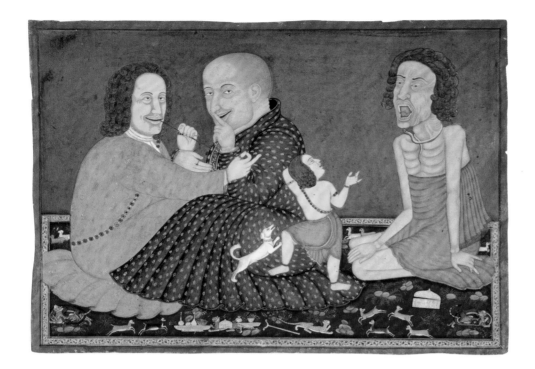

Fig. 4. *A European Concoction*. Rajasthan, Udaipur, c. 1760. Opaque watercolor, gold, and silver-colored paint on paper; image: 10¼ x 14⅝ inches (26 x 36.5 cm), sheet: 10¾ x 15 inches (27.3 x 38.1 cm). Philadelphia Museum of Art. 125th Anniversary Acquisition. Alvin O. Bellak Collection, 2004-149-59

Fig. 5. *Two Ladies, One Caressing or Squeezing the Throat of the Other*. Rajasthan, late eighteenth century. Brush drawing and slight color on paper, 7⅞ x 6⁵⁄₁₆ inches (20 x 16.1 cm). Ashmolean Museum, University of Oxford. Purchased 1999, EA1999.8

Plates 8a,b

A Satirical Drawing of Two Ladies (a)

A Standing Portrait of Two Noblemen (b)

Rajasthan, Udaipur and Bikaner, c. 1760–1800 and early eighteenth century
(a) Brush and black ink and watercolor over charcoal on beige laid paper; (b) brush and black ink and watercolor on beige laid paper
7 x 6⅛ inches (17.8 x 15.6 cm)
Philadelphia Museum of Art. The Conley Harris and Howard Truelove Collection of Indian Drawings, 2013-77-28a,b

of the sheet were executed over more than a century and a half, as the artists of the Kota court returned to it time and again, adding drawings, and drawing inspiration from what came before.

Another intriguing sheet from Rajasthan in the Harris-Truelove Collection has *A Satirical Drawing of Two Ladies* on one side and *A Standing Portrait of Two Noblemen* on the other (plates 8a,b). Looking first at the bust-length portrait of the two female figures, a very strange scene unfolds. Each woman wears four strings of pearls and a circular pendant around her neck, and both have wild, unkempt hair, oversize eyes, small teeth, and dramatically arched eyebrows. One woman, portrayed in three-quarter profile, appears to be choking the other, whose mouth gapes as her eyes narrow. This work resonates with both the Bundi and Udaipur workshops, where there was a pictorial tradition of this type of grotesque imagery. Inspired by the Dutch East India Company trading mission led by Johan Ketelaar in 1711–13, Udaipur artists in particular developed a fascination with the exotic newcomers and with the motifs and figures they encountered in European prints.[31] With their European features and accoutrements, the two women in the Harris-Truelove drawing exemplify these fascinations.

An obvious relative to the Harris-Truelove drawing can be found in *A European Concoction* (fig. 4), painted around 1760 at the Mewar court of Udaipur, which portrays three bizarre male figures reminiscent of the two fighting women. Two of the men clutch one another and leer out at the viewer. The contorted face of a third man, seated to the right, shows obvious displeasure; upon closer inspection, he is being bitten on the chin by a small snake. As with the *Two Ladies*, we can assume a European source (or many) for the conflated imagery.[32] Furthermore, stylistic cues such as the pronounced oval surrounding the eyes and the heavy use of shading in the facial features indicate that *Two Ladies* and *A European Concoction* likely originated in the same workshop, where source material would have been shared among artists. These satirical drawings and paintings depicted

Plate 8a

Plate 8b

Europeans, whose strange clothing and unfamiliar ways were new to the Mewar court. The resulting imagery is an amalgam of European and Rajasthani sources, firmly entrenched in the realm of caricature. This trend, most common in the mid- to late eighteenth century, was short-lived: once the Udaipur throne was forced to accept British suzerainty in 1818, the whimsical depiction of foreigners seems to have ceased.[33]

An interesting conflation of European and Indian imagery is found in a closely related work in the Ashmolean Museum at Oxford, *Two Ladies, One Caressing or Squeezing the Throat of the Other* (fig. 5), which dates to the eighteenth century and is also from Rajasthan. The nearly identical strained expressions and exaggerated upturned noses of the women being choked in the two drawings indicate a shared source that was likely one or more European prints. Intriguingly, the red hennaed fingers, Shaivite forehead markings,[34] and earrings of the women in the Ashmolean drawing—as well as the suggestion of a veil covering the hair of the figure on the left—combine to recast them as Indian rather than European. However, the strange, satirical air of the work remains.

The drawing on the other side of the Harris-Truelove *Two Ladies* (see plate 8b) is regal by comparison. A fairly typical Mughal-style portrait study, it depicts two noblemen facing one another. The figure on the left, who is smaller in stature to indicate his lower status in the court hierarchy, opens his arms to the figure on the right. Each man wears a string of red beads around his neck, carries a dagger tucked into his belt, and sports an Akbari-style turban—all indications of status as a Muslim gentleman. Their outfits are reminiscent of the early seventeenth century, though this style of turban remained in vogue long after Akbar's death in 1605. However, on close inspection, both of the figures have their *jamas* (jackets) tied to the left, a style reserved for Hindu gentlemen. This sartorial mistake, combined with the stiffness of the standing figures, indicates that the drawing is a later Rajasthani rendition of Mughal courtiers, likely created in the early eighteenth century in the Bikaner workshop and in emulation of an earlier Mughal model.

Far from simply a quirky double-sided drawing, the Harris-Truelove page conveys fascinating historical insight. It demonstrates that one piece of paper traveled between two independent Rajasthani courts, where two very distinct drawings were created at least fifty years apart. Each drawing is a reinterpretation of an unknown earlier work, re-envisioned and reworked in a different yet recognizable style. We are left to question how and when this sheet went from Bikaner to Udaipur. Was it carried by an itinerant artist, following a common practice in which independent artists moved from court to court in search of patronage? Or was this transmission the by-product of the courtly workshop tradition by which artists often traveled with their patrons and traded drawings with other artists they encountered while visiting courts, pilgrimage sites, or elsewhere on their journey? Whatever the precise perambulation of this work, the interaction between artists, the transmission of materials and ideas, and the excited response to new imagery that it demonstrates bring to life the complexities of artistic production at the courts of India. The reuse of paper within a workshop demonstrates continuity as well as change. And the movement of paper, as a commodity, demonstrates the intricate network of trade and communication among various regional centers.

WHEN BRUSH FIRST MEETS PAPER

The brush and ink used to create a drawing in the Indian court workshop was as thoughtfully considered as the paper support. The initial line on a page gives the impression of the subject; smooth and delicate, it is the drawing's foundation. Its contour could be used to block out space, to show the relationships among forms, and to craft the overall composition. This initial line was most often done in a charcoal-like substance[35] that was mixed with water and glue (gum arabic) as a binder. This enabled the black particulate material to flow smoothly so that the artist's hand could impart a gestural quality to a drawing—as evidenced in a study of an elephant from the Harris-Truelove collection (plate 9), in which short, sketchy lines are used to delineate the trunk and ear, while a thicker, more robust line articulates the mouth and strong forehead. This combination of sweeping stroke and rapidly drawn, shorter lines in the dusty medium of charcoal lends immediacy to the initial stage of a drawing.[36]

A drawing from Chamba datable to about 1800 depicting the goddess Durga (plate 10) retains this immediate quality of the heavy charcoal, but here a thin ink line has been traced over top. The addition of ink strengthens the underdrawing, giving the overall composition an expressive, powerful effect. These secondary brushstrokes would often be done in black ink, combined with water or watercolor to create a wash that softened the line and altered its hue. Variations in ink tone range from gray to black to brown to red/orange. The brush chosen by the artist also influenced this line; a brush that was too hard or too soft lacked the dexterity to create a long, sweeping contour. Coomaraswamy discusses the three styles of brushes used for painting, described in detail in the *Shilparatna*, a sixteenth-century treatise on art: a coarse brush for sweeping on of color; a medium brush for modeling; and a fine brush, the point of which was used for drawing.[37] Artists usually preferred a brush fabricated from the tail hair of a young squirrel, bound and inserted in a feather-quill handle. Creating such a brush was often a young artist's first task. Graphite or lead pencils were not introduced in India until the nineteenth century, and, while readily adopted in the latter half of the century, they never replaced charcoal as the medium for the initial line.

For the underdrawing, many court workshops in the Pahari region favored a pigment made from red ochre. The red lines effectively disappear in the final composition, where the subsequent black ink renders them nearly indiscernible.[38] Three folios—likely all from a single series of the *Markandeya Purana*, probably drawn in the Kangra workshop around 1780—demonstrate how artists used this red underdrawing (plates 11–13).[39] Each composition concentrates on a central figure, with little landscape or architecture to provide context for the narrative. The artist intended to create only an outline of the central action in *Chandi Defeats Shumbha* (see plate 11), where he clearly articulates the energy of the fierce goddess in midfight, but includes little extraneous detail. The initial, energetic red line imbues the composition with a sense of dramatic tension. A remarkably similar drawing, now in the Museum of Fine Arts, Boston, is dated around 1775–80 and originates from Kangra or Guler (fig. 6).[40] A less vivid depiction of the battle, the Boston drawing demonstrates the subtle changes that can occur with the addition of heavier black ink delivered with a stiff brushstroke. The inclusion of a landscape, in the form of

Plate 9

Elephant Study

Rajasthan, Kota, c. 1830
Charcoal on beige laid paper
10 x 7 inches (25.4 x 17.8 cm)
Philadelphia Museum of Art. The Conley Harris and
Howard Truelove Collection of Indian Drawings, 2013-77-37b
(For opposite side, see plate 38)

Plate 10

Durga Mahishasuramardini

Himachal Pradesh, Chamba, c. 1800
Brush and black ink over charcoal on beige laid paper
7⅛ x 6 inches (18.1 x 15.2 cm)
Philadelphia Museum of Art. The Conley Harris and
Howard Truelove Collection of Indian Drawings,
purchased with the Stella Kramrisch Fund for Indian
and Himalayan Art, 2013-68-3

Plate 11

Plate 11

Chandi Defeats Shumbha

From the *Markandeya Purana*
Himachal Pradesh, Kangra, c. 1780
Brush and red and orange-red inks and white opaque
watercolor on beige paper
5⅝ x 7¾ inches (14.2 x 19.8 cm)
Philadelphia Museum of Art. The Conley Harris and
Howard Truelove Collection of Indian Drawings, 2013-77-2

Plate 12

The Gods Plead with the Goddess Durga for Help

From the *Markandeya Purana*
Himachal Pradesh, Kangra, c. 1780
Brush and red and orange-red inks and white opaque
watercolor on beige paper
5⅝ x 7⅞ inches (14.2 x 19.9 cm)
Philadelphia Museum of Art. The Conley Harris and
Howard Truelove Collection of Indian Drawings, 2013-77-3

Plate 13

*Raja Surath and the Vaishya Approach the
Ashram of the Sage Markandeya*

From the *Markandeya Purana*
Himachal Pradesh, Kangra, c. 1780
Brush and black and orange-red inks and opaque
watercolor over charcoal on beige laid paper
5⅝ x 7¾ inches (14.2 x 19.7 cm)
Philadelphia Museum of Art. The Conley Harris and
Howard Truelove Collection of Indian Drawings, 2013-77-46

Fig. 6. *Devi Killing Sumbha*. Himachal Pradesh, Kangra
or Guler, c. 1775–80. Ink with graphite on paper; image:
6¼ x 9¹¹⁄₁₆ inches (15.8 x 24.6 cm), overall: 7⅜ x 10⅞
inches (18.7 x 27.7 cm). Museum of Fine Arts, Boston.
Ross-Coomaraswamy Collection, 17.2589

Plate 12

Plate 13

foreground trees and the clouds above, also alters the feeling of the work. In the Harris-Truelove drawing, the simple proximity of the goddess and demon, as well as their contextual isolation, builds the sense of drama. Shumbha's stance, with body recoiled, captures his disbelief at Durga's piercing trident with a sense of movement lacking in the Boston drawing. The spontaneity of the red underdrawing is thus sometimes more powerful than an edited and embellished line.

Artists in the Kota workshop also preferred red for underdrawings, though their pigment is a muddier hue than the orange/red ochre-based pigment used in the Pahari region.[41] In *Noblemen on Elephant during Holi Festival* (plate 14) this red is used as both the primary pigment in the underdrawing and as part of the *holi* celebration, the Hindu festival of color where participants throw bright red, orange, and pink powders at one another to welcome spring. The comparatively wide brushstrokes used to capture the figures' likenesses are drawn quickly, lending an expressive quality to the composition as a whole.

As discussed, it is a misconception to assume that drawings are merely unfinished paintings, or that each drawing was intended to become a painting. *Shiva and Parvati Preparing Bhang* (plate 15), for example, is a pleasing drawing from Guler in which the entire composition is fleshed out in a delicately drawn line.[42] The clearly expressed figural and landscape lines converge to create a succinct mapping of the composition's various elements. The comparatively large sheet (12 × 15 inches) allows for the development of a more complex image and indicates the artist's desire to delineate space. A red ochre correction line follows the underdrawing, done in gray wash; together they demonstrate the refinement of details in successive iterations of the same composition. The two main figures—Shiva, with a protective arm around his wife, and Parvati, with bowl brought to her lips—are drawn in the initial gray line with only a limited amount of red added. Their two sons, Ganesha and Kartikkeya, on the other hand, are drawn only in red, indicating that they were likely added to the composition at a slightly later stage.

Shiva and Parvati Preparing Bhang is probably related to *The Gods Sing and Dance for Shiva and Parvati* (fig. 7), a page from an unidentified Shiva series.[43] A comparison of the god's three-quarter profile in both compositions suggests an affinity, as do his downturned gaze, long hair, and third eye (see details on p. 55). The subtle changes in landscape and framing demonstrate that the Harris-Truelove drawing was not the final work to be realized as a painting for this series. Indeed, it was not unusual for several studies to be created in an effort to refine a composition, all as part of the artist's working process.

OBSERVED PORTRAITURE

While the artist often used the initial lines to develop a smooth outline of the primary forms (which he then built in successive layers into a complete composition), these lines were just as likely to result in a quick sketch intended to record someone's likeness. Such sketches are a vital part of an artist's working method and represent raw examples of observed portraiture that reveal the artist's hand. The Kota drawing *Portrait Studies of Courtiers and Visiting Noblemen* (plate 16) shows sketches, clearly drawn from life, that

Plate 14

Noblemen on Elephant during Holi Festival

Rajasthan, Kota, late eighteenth century
Brush and red and black inks and watercolor, brushed and spattered, on beige laid paper
5 x 6 inches (12.7 x 15.2 cm)
Philadelphia Museum of Art. The Conley Harris and Howard Truelove Collection of Indian Drawings, 2013-77-22

Plate 15

Shiva and Parvati Preparing Bhang

From an unidentified Shiva series
Himachal Pradesh, Guler, c. 1770–90
Brush and black and orange-red inks over traces of
charcoal on beige laid paper
12 x 15 inches (30.5 x 38.1 cm)
Philadelphia Museum of Art. The Conley Harris and
Howard Truelove Collection of Indian Drawings,
2013-77-10

Fig. 7. **Attributed to Khushala (Indian, active late
eighteenth century).** *The Gods Sing and Dance
for Shiva and Parvati*. From an unidentified Shiva
series. Himachal Pradesh, Kangra or Guler, c. 1780–90.
Opaque watercolor and gold on paper; image: 8
x 12 inches (20.3 x 30.5 cm); sheet: 9 x 12¹⁵⁄₁₆ inches
(22.9 x 32.9 cm). Philadelphia Museum of Art. 125th
Anniversary Acquisition. Alvin O. Bellak Collection,
2004-149-77

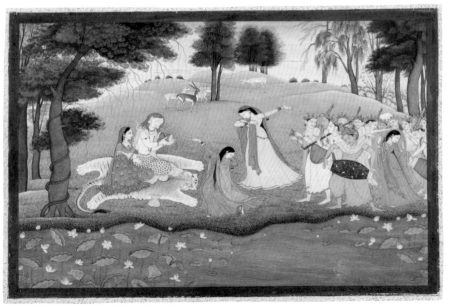

Detail of plate 15

Detail of fig. 7

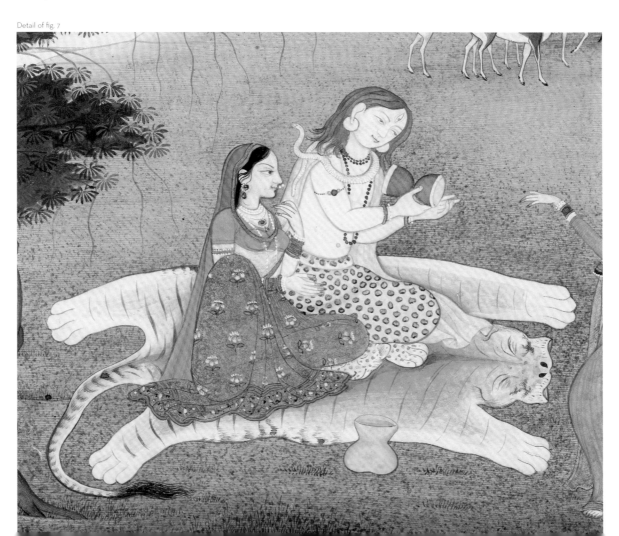

exemplify this practice. Two very detailed and partially colored portraits grace the top of the page; below them appear three roughly sketched portraits that only give an impression of their subjects. Yet the artist identifies each of the five figures through an inscription and gives them individualized facial features. To have such diversity of drawing on a single page is telling, demonstrating how a sparse contour line can capture the salient features of a subject and then quickly develop into a fully recognizable portrait. Several other sketches appear on this page, interspersed among the portraits. One is a small sketch of a larger court scene, indicating that the artist was likely recording these five noblemen in order to insert them later into a *darbar* scene, as seen earlier in *Sketches of Several Court Scenes and a British Officer* (see plate 7b). In both drawings, the artist clearly prescribed the exact position of the courtiers and their placement within a court hierarchy.

A drawing in the Victoria and Albert Museum in London, also from Kota, offers an interesting comparison to this page of portrait studies.[44] Dated 1742, *Maharao Durjan Sal of Kota* (fig. 8) includes eleven portrait studies where the figure of the ruler is comparatively large, leaning against a bolster, and with much detail added to his face for identification. The rest of his torso is sketchily drawn, demonstrating that the features necessary for identification were concentrated from the shoulders up. It is likely that the artist left the costumes and setting unfinished in part to allow as much flexibility as possible for this drawing's future use: a single portrait could be readapted and reused for numerous finished paintings. The noblemen in attendance to Durjan Sal are also mostly portrayed from the shoulders up, but the artist has added subtle details and an identifying inscription to each profile. He has carefully captured the likenesses of these noblemen, and indicated through the variety of turbans (a signifier of regional identity) that they came from other courts to pay homage to the Kota *maharao*. These portrait studies from life, kept in the

Plate 16 (opposite)

Portrait Studies of Courtiers and Visiting Noblemen

Rajasthan, Kota, c. 1750
Brush and black, green, and red inks and watercolor with corrections by the artist in white opaque watercolor on beige paper
10⅞ x 7½ inches (27.6 x 19.1 cm)
Philadelphia Museum of Art. The Conley Harris and Howard Truelove Collection of Indian Drawings, 2013-77-26a

Fig. 8. ***Maharao Durjan Sal of Kota***. Rajasthan, Kota, 1742. Brush and ink on paper, 8⅜ x 9 inches (21.3 x 22.9 cm). Victoria and Albert Museum, London. Given by Colonel T. G. Gayer-Anderson, CMG, DSO, and his twin brother Major R. G. Gayer- Anderson, Pasha. IS.441-1952

workshop as references, are tangible evidence of the importance of drawing as court reportage. The quick, fluid line is accomplished swiftly to convey likeness, with the most noticeable features of the individual captured with a few strokes of the brush.

Another drawing from Kota, *Maharao Ram Singh II Making an Offering, alongside a Study of Court Attendants* (plate 17), combines a portrait study of the ruler at worship with several courtiers, two idealized beauties of the court, and a humorous caricature of another courtier—all condensed onto a surprisingly small piece of paper. The portrait of Ram Singh is finely drawn and detailed in a gray wash, with a secondary black line to strengthen the forms. The ruler is dressed in simple robes yet with an abundance of jewelry to signify his royal status. The compositional scheme of this drawing relates it to other images of worship from the Nathdwara tradition (see plate 34), a popular theme at Udaipur and Kota in the eighteenth and nineteenth centuries. These symmetrical, formulaic devotional scenes portray the ruler on the left and the attending priest on the right, performing prayers and rituals (*puja*) to a central image of Krishna.[45] The figure to the far right may be the attending priest, as he, like the ruler, wears ritual dress. He carries the requisite implements of worship and faces the *maharao*. The remaining four figures—two female and two male—have little to do with this ritual scene and may be later additions to the page by other artists in the workshop. While the two male figures are clearly individualized, the two female figures are depictions of a type that graced Rajasthani courtly painting for centuries.[46]

Only occasionally do we find highly detailed portraits likely to have been taken directly from life. In these rare cases, delicate lines capture every detail and nuance of the subject's appearance.[47] Such an example is the expressive and emotive study from Jodhpur, *A Portrait of a Young Prince* (plate 18). The small size of the paper indicates that the sheet was most likely cut down from a larger composition that contained many practice sketches, similar to the ones just discussed. Where this skillfully rendered drawing differs from the others, however, is in the level of detail used to convey likeness and create a visual shorthand of court practice. Each touch of the artist's brush on the page was thoughtful and considered, allowing members of the royal court, Hindu deities, and lush landscapes to emerge with great economy of line.

Plate 17

Maharao Ram Singh II Making an Offering, alongside a Study of Court Attendants

Rajasthan, Kota, c. 1830–40
Brush and black and colored inks and opaque watercolor over traces of charcoal with corrections by the artist in white opaque watercolor on beige paper
4½ x 5½ inches (11.4 x 14 cm)
Philadelphia Museum of Art. The Conley Harris and Howard Truelove Collection of Indian Drawings, 2013-77-15a

Plate 18

A Portrait of a Young Prince

Rajasthan, Jodhpur, c. 1750
Brush and black ink over charcoal on beige paper
2¾ x 3⅛ inches (7 x 7.9 cm)
Philadelphia Museum of Art. The Conley Harris and Howard Truelove Collection of Indian Drawings, 2013-77-45

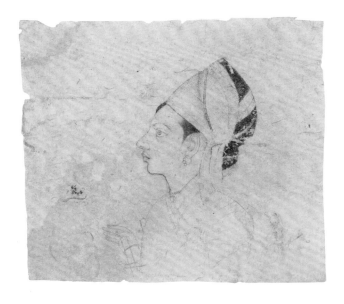

Realms of Color

TONAL WASHES OF INK—BLACK, GRAY, BROWN, OR RED—FORM THE GROUNDWORK of the majority of the drawings discussed thus far. There is also, however, a long tradition of adding color, whether to correct an initial line, provide instructions for other artists, highlight particular areas, or even "finish" a drawing. But what exactly is a drawing in the context of the artist workshops of courtly India? Stuart Cary Welch, a scholar and collector who wrote passionately about Indian art, defined drawings as "two-dimensional works of art in any medium in which color is absent or subordinate."[48] This distinction is important: subordinate need not mean absent, particularly where the addition of color adds to the intricacy of these works on paper. Color can be used to express subtle gradations in form, to transform mood, or to add a sense of depth to an otherwise two-dimensional rendering. Thinking about an artist's intentions in applying color to a drawing raises the question of what distinction, if any, exists between "finished" and "unfinished."

The sparse addition of color can be very evocative. In *Krishna and the Gopis Shelter from the Rain* (plate 19), a subtle green wash is combined with the bright red line the artist used to delineate space.[49] Krishna stands in the center of the page, turned to his left and locking eyes with one of the four *gopis* clustered around him.[50] Their proximity creates a charismatic energy under the shawl, which functions not only to keep out the rain but also to keep the actors close together. An eye-catching red line, painted more opaquely than the rest of the picture, demarcates the edge of the shawl. In an effective contrast to the red, the delicate green wash highlights the forest setting. The boughs are heavy with the weight of the rain and lean protectively around the figures. Their leaves extend to the very edge of the page, giving the impression that the lush forest can hardly be contained by the sheet. Heavy with expectation, verdant foliage such as this signifies love and fertility in Indian painting. This combination of a light green wash and a bold red line demonstrates that artists consciously and meticulously employed color to arresting effect.

A hunt scene from Kota that also employs color effectively is *Maharao Ram Singh II Hunting Tigers from a Royal Barge* (plate 20). The ruler and his attendant, with guns at the ready, are portrayed to the right, while three tigers, one of which is mostly submerged, encircle the front of their barge. Each aspect of the scene is quickly and sketchily drawn, with the horn-blower and accompanying attendants in the background formed from short, choppy lines that combine to define the figures. More detail has been added to the royal

Plate 19

Krishna and the Gopis Shelter from the Rain

Himachal Pradesh, Mandi, c. 1840
Brush and black and red inks, watercolor, and opaque watercolor on beige paper
8⅜ x 5⅝ inches (21.3 x 14.3 cm)
Philadelphia Museum of Art. The Conley Harris and Howard Truelove Collection of Indian Drawings, 2013-77-29

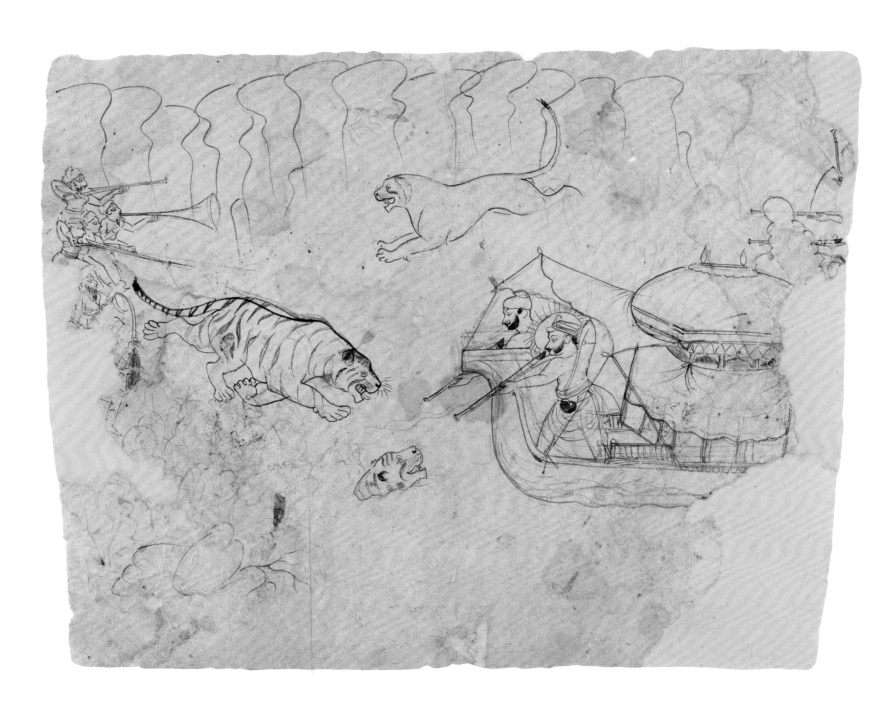

barge, a symbol of the ruler's prestige. The only use of color is in the red smudges added to the tigers to show where the animals have been shot. And yet even with the sparse line and dabs of color, the drawing maintains the energy and verve of a fully realized Kota hunt scene.

The pigments used in drawings and paintings in courtly India were minerals ground into a paste, mixed with gum arabic, thinned with water, and applied in accumulative thin layers to a prepared sheet.[51] Pigment was mixed according to need, allowing for a vast range of hues as each color was thoughtfully prepared. Identifying pigments is a useful exercise that can help us date works and determine their regional origin. Certain pigments are known to have entered South Asia during particular eras, and their popularity in different regions fluctuated widely.

The partially colored drawing *A Prince and Courtiers in a Garden* (plate 21), likely from Jodhpur in the Marwar region of southwest Rajasthan, is an informative work when contemplating pigment. The drawing is in a confident hand, with a faint underdrawing overlaid with darker brushstrokes that include corrections. Five of the eight figures have their faces drawn in detail and colored. For one of the attendants, this addition of pigment significantly changed the figure's position, with the face migrating about two centimeters from the initial line (see detail on p. 65). The coloring of the surrounding landscape is equally remarkable. The precise line of the long, thin-stemmed flowers benefits from the addition of blue, while the trees and large-leaved plants have a more overall wash. The detailed flowers are emphasized by their positioning against a green painted background likely made from malachite, identified by the copper corrosion product that mars the reverse of this work (figs. 9a,b). The attribution to Jodhpur, based on stylistic comparisons with portraits of Marwar rulers and noblemen, as well as an affinity with the wall paintings at the subsidiary court of Nagaur,[52] is complicated by the use of malachite, which was a popular pigment at the nearby court of Bikaner. Its use here may reflect the presence of itinerant artists in Marwar in the eighteenth century, including those trained in the Bikaner style.[53] The faces and turbans depicted here also question any absolute attribution to Jodhpur, and may indicate a collaborative process between artists trained in the Jodhpur and Bikaner workshops. The interaction of artists from disparate regions and

Plate 20

Maharao Ram Singh II Hunting Tigers from a Royal Barge

Rajasthan, Kota, c. 1820
Brush and black ink with touches of orange-red watercolor on beige paper
10 x 13 inches (25.4 x 33 cm)
Philadelphia Museum of Art. The Conley Harris and Howard Truelove Collection of Indian Drawings, 2013-77-35

Plate 21 (following pages)

A Prince and Courtiers in a Garden

Rajasthan, Jodhpur, c. 1720–30 with later additions
Brush and brown ink, metallic gold and silver paints, and opaque watercolor over traces of charcoal on beige laid paper
13 x 8½ inches (33 x 21.6 cm)
Philadelphia Museum of Art. The Conley Harris and Howard Truelove Collection of Indian Drawings, 2013-77-31

Figs. 9a,b. Details of front (left) and reverse (right) of plate 21, showing the malachite-green background and the resultant copper corrosion on the reverse

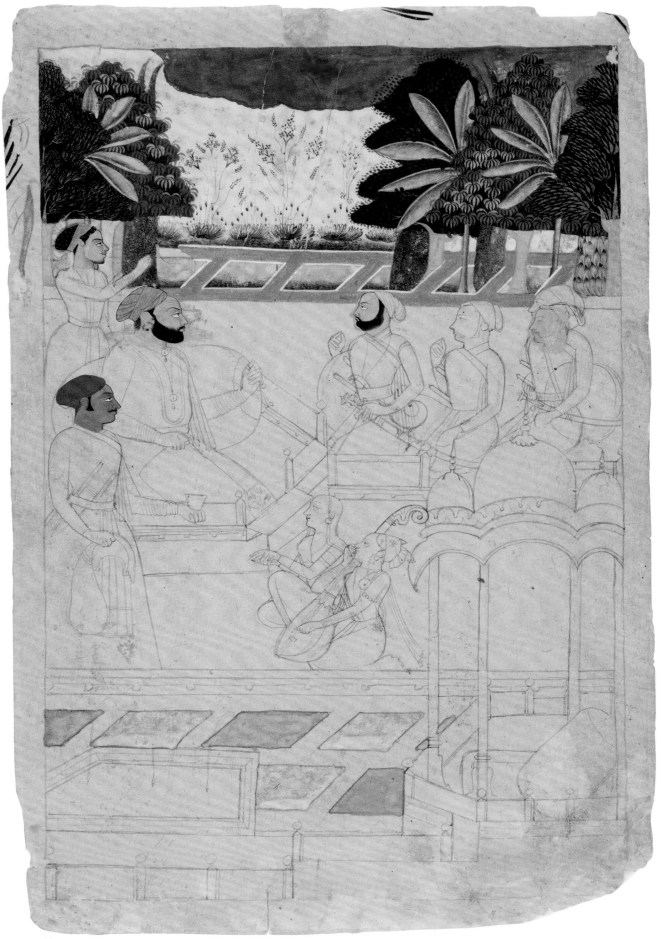

Plate 21

Detail of p

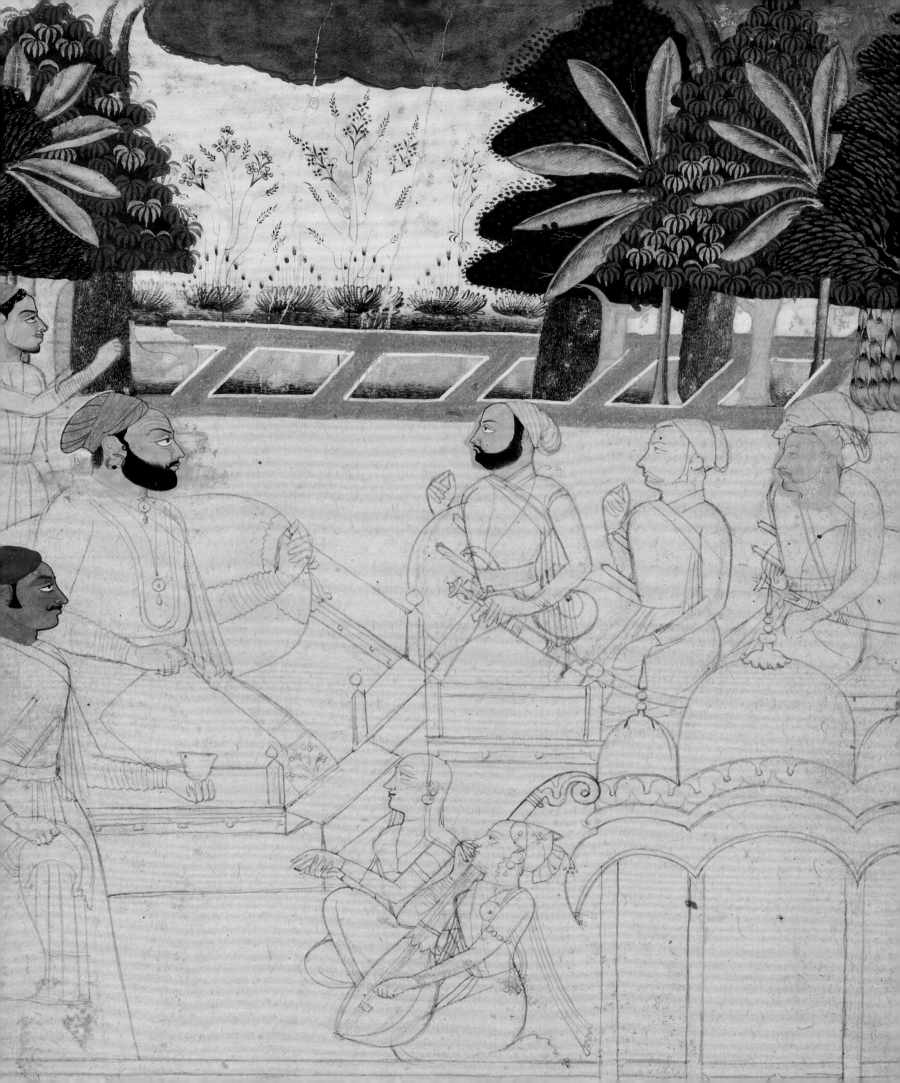

Fig. 10. *A Portrait of a Nobleman Seated on a Terrace*. Mughal Empire, Delhi, c. mid-eighteenth century, with later additions in Awadh (Oudh or Faizabad), c. 1770s. Ink wash and opaque watercolor on paper; image: 7⅜ x 4½ inches (18.6 x 11.4 cm), sheet: 15¹¹⁄₁₆ x 11⅛ inches (39.8 x 28 cm). The British Library, London, Add.Or.5602

their exposure to each other's works encouraged the continual and nuanced development of these regional styles.

While the many adjustments to the courtier's profile and the addition of color to *A Prince and Courtiers in a Garden* most likely occurred during the drawing's long life in the artists' workshop, that was not always the case. It is worth comparing this drawing with one now in the British Library, *A Portrait of a Nobleman Seated on a Terrace* (fig. 10). This work is also partially colored, where the detailed palace terrace frames the figure drawn predominantly in delicate black lines. This sheet was once in an album assembled for the collection of Antoine Polier (1741–1795), an East India Company officer who spent time as a resident in Faizabad, Delhi, and Lucknow.[54] While posted in Lucknow, Polier befriended a group of Europeans who shared his interests in Oriental studies, including Richard Johnson (1753–1807), another East India Company officer stationed in Calcutta, Lucknow, and Hyderabad, whose sizable holdings of paintings and drawings helped establish the collection of visual material in the India Office Library, now incorporated into the British Library.[55] An avid writer and diarist, Polier's letters reveal that he was an enthusiastic collector of paintings and drawings, as well as patron to several resident Faizabad artists. Polier writes about his practice of asking his artists to "finish" earlier drawings that he had acquired during his travels. Evidence suggests that Polier sent Mughal drawings from Delhi that he considered unfinished to his retained, Delhi-trained artist, Mihr Chand, requesting that he add the naturalistic landscape prevalent in late Mughal painting of the

time.[56] The unidentified figure here, probably a nobleman at Muhammad Shah's court (or possibly Muhammad Shah himself), was drawn about 1740, while the background has clear resonances with late Mughal landscape of about 1770.[57] In his role as collector and patron, Polier influenced workshop practice by encouraging artists to complete earlier works from other regional centers. Other examples of such secondary patronage abound, and it is very likely that the practice of "finishing" workshop drawings, whether done by commissioned artists trained in another style or by members of the workshop where the composition originated, was known throughout courtly India. The examples given here—from areas as disparate as north Rajasthan, Delhi, and eastern Bengal—were not isolated exceptions.

Returning to *A Prince and Courtiers in a Garden*, the peach-colored tree trunks that frame the landscape seem an unusual choice of hue for an early eighteenth-century Rajasthani drawing. And indeed, close visual analysis identifies this color as a combination of vermilion and white lead.[58] Manufactured vermilion was first imported to India from Europe in the late eighteenth or early nineteenth century,[59] so its presence on this drawing is evidence of both the common practice of modifying earlier works and the prominence of drawing in workshop practice. *A Prince and Courtiers in a Garden* may have served as a teaching tool in the workshop, where a skilled Bikaner-trained draftsman added spindly stemmed flowers to this court scene in the early eighteenth century, and an artist of decidedly lesser skill applied a new and exciting imported pigment to the tree trunks, perhaps as much as a century later.

A MODIFIED LINE

Changes to a drawing could occur over an extended period and in a myriad of ways. A white wash made from zinc or lead was often applied to alter or correct a brushstroke in the underdrawing, after which the page would be reburnished and the image redrawn. The evidence of such modification would be invisible in a finished painting but is seen clearly at the drawing stage. *A Shaivite Ascetic* (plate 22), from eighteenth-century Kishangarh, portrays an ash-covered devotee seated in a posture of meditation, with legs crossed and arms folded over his chest. The Kishangarh court workshop produced many such drawings of saints and figures at worship in the eighteenth century.[60] The ascetic depicted here wears a distinctive cap, has a begging bowl at his side, and leans on a stick, a support for long hours spent in an introspective state. His gray skin tone, thanks to the ash rubbed on his body, identifies him as a devotee of Shiva, while his purple-tinged eyes give him the appearance of being under the influence of bhang (cannabis). One of two seals on the reverse—most likely added by a religious foundation where the image was at one point kept—though only partially decipherable, reads as "Shiv/Guru," attesting to the ascetic's allegiance (fig. 11).[61]

The initial contour line and first round of details on this drawing are done in a purple wash, an interesting and unusual choice.[62] The artist corrected his brushstrokes, adjusting the outline of the right elbow and upper arm, but the initial positioning is still visible beneath the white wash. Faint outlines of the animal skin on which the ascetic sits, as well as the lower part of his stick and bowl, are rendered in a very fine wash, and del-

Fig. 11. Seal on the reverse of plate 22

Plate 22

A Shaivite Ascetic

Rajasthan, Kishangarh, c. 1740
Brush and black and red inks and watercolor with corrections
by the artist in white opaque watercolor on beige paper
6 x 4½ inches (15.2 x 11.4 cm)
Philadelphia Museum of Art. The Conley Harris and Howard
Truelove Collection of Indian Drawings, 2013-77-20

icate white and black lines define his beard. Thus, after the artist established the under-drawing, he augmented it with watercolor. In completed paintings, this watercolor would be applied in sequential layers as opaquely as possible; here, however, it is diluted into a transparent form, allowing the lines beneath to remain visible. Even with the addition of color to *A Shaivite Ascetic*, the initial purple line, the corrected line with the obvious use of white wash, and the very faint light ink wash used to articulate space in the under-drawing all remain as testimony to the artist's process.

The many layers of the artistic process visible in *Devi and the Shakti Forces Attack Nishumbha, Shumbha, and Their Army* (plate 23) reveal the delicate yet impulsive hand of a Guler artist.[63] Redrawn several times and with white wash corrections, the composition is a dynamic articulation of form. To increase her prowess in battle, the goddess multiplies herself by summoning the *shakti*, or power, of various gods, visualized as their female energies. Devi was herself created from the combined energies of the male gods, complete with divine weapons, and the female manifestations of the gods depicted here are in the customary set of eight *matrikas*.[64] Most ride their animal vehicle and carry the weapon of their male counterpart. Emanating from the upper left corner are Vaishnavi (the female form of Vishnu, atop the birdman Garuda and carrying a mace), Brahmani (the female form of four-headed Brahma, atop a gander and carrying a water pot), Aindri (the female form of Indra, atop an elephant and wielding a thunderbolt), and Varahi (the female form of Vishnu's Varaha incarnation, here represented by the head of a small boar). At the center left is Maheshvari (the female form of Shiva, atop a bull and holding a trident); below her appears Kaumari (the female form of Shiva's son Kartikkeya, whose many-headed form sits atop a peacock and holds a sword and a bow). To the right is Narasimhi (the female form of Vishnu's man-lion incarnation), while Durga herself, in the form of a ten-armed goddess riding a lion, fills the center of the composition (see detail on p. 71). Next to her is Kali, the wrathful manifestation of Durga, who was worshiped in the Pahari region, especially in her martial form, with an intensity not seen in Rajasthan.

The multiple contour lines visible in many of the Harris-Truelove drawings reveal the artists' intentions, as each brushstroke is used to either strengthen or subtly alter the composition. *Amorous Couples* (plates 24a,b), from a Sikh court in the Punjab Hills, includes multiple drawings of the same two figures. One side of the page has two depictions of the couple, each with their incredibly thin arms entwined in an anatomically impossible fashion, bringing male and female torsos into unnaturally close proximity and foregoing the intervening shoulders (see detail on p. 73). White wash correction has been used to transpose an arm from one place to another and to make other subtle changes. The very delicate line that emphasizes their flowing garments seems to conflict with the ruled lines used to create the surrounding architecture. The reverse of the page shows two more whimsical depictions of the couple. Here, however, the line is clear and confident, without the use of white wash correction. The artist experimented with viewpoint by placing the figures in a playful juxtaposition, but except for the bed on which one pair rests, there is no architectural context to contain the figures.[65] This drawing was an evolving model for the artist, a composition that could be changed in the final version—or, in

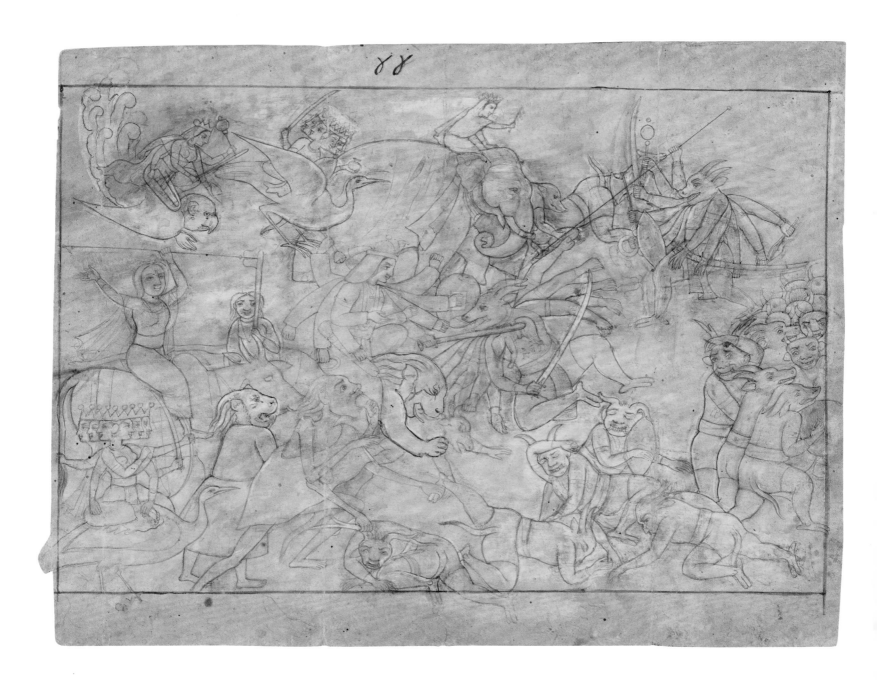

Plate 23

Devi and the Shakti Forces Attack Nishumbha, Shumbha, and Their Army

From the *Markandeya Purana*
Himachal Pradesh, Guler, c. 1760
Brush and black, red, and orange-red inks and opaque water-
color over black chalk on beige paper
8½ x 9½ inches (21.6 x 24.1 cm)
Philadelphia Museum of Art. The Conley Harris and Howard
Truelove Collection of Indian Drawings, purchased with the
Stella Kramrisch Fund for Indian and Himalayan Art, 2013-68-8

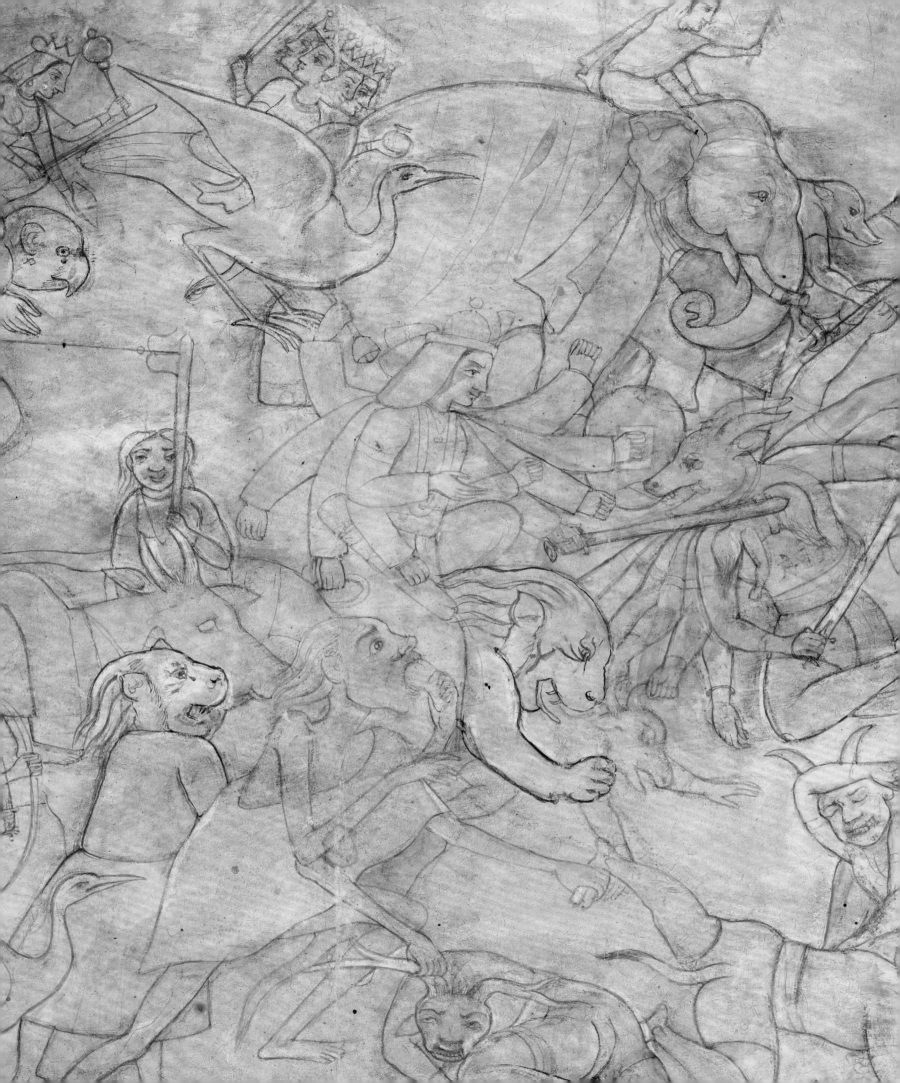

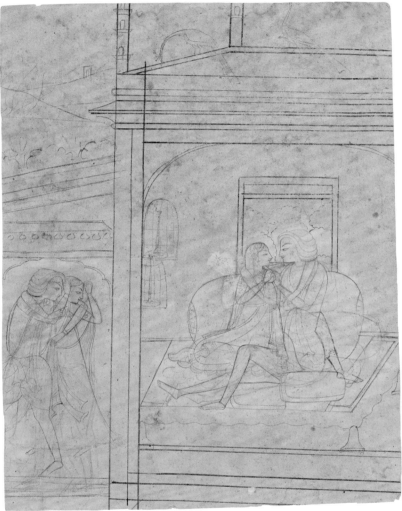

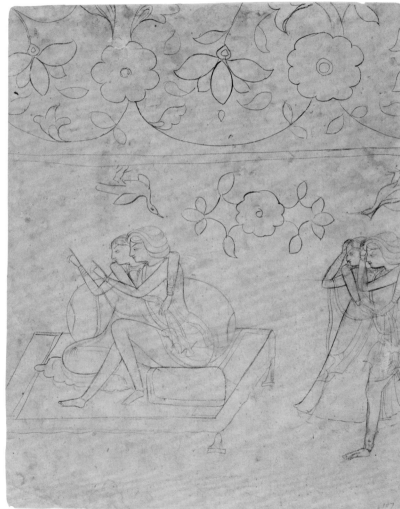

Plates 24a,b

Amorous Couples

Punjab region, c. 1830–40
(a) Brush and black ink with corrections by the artist in white
opaque watercolor on beige paper; (b) brush and black ink and
traces of white opaque watercolor over charcoal on beige paper
10 x 7 inches (25.4 x 17.8 cm)
Philadelphia Museum of Art. The Conley Harris and
Howard Truelove Collection of Indian Drawings, 2013-77-21a,b

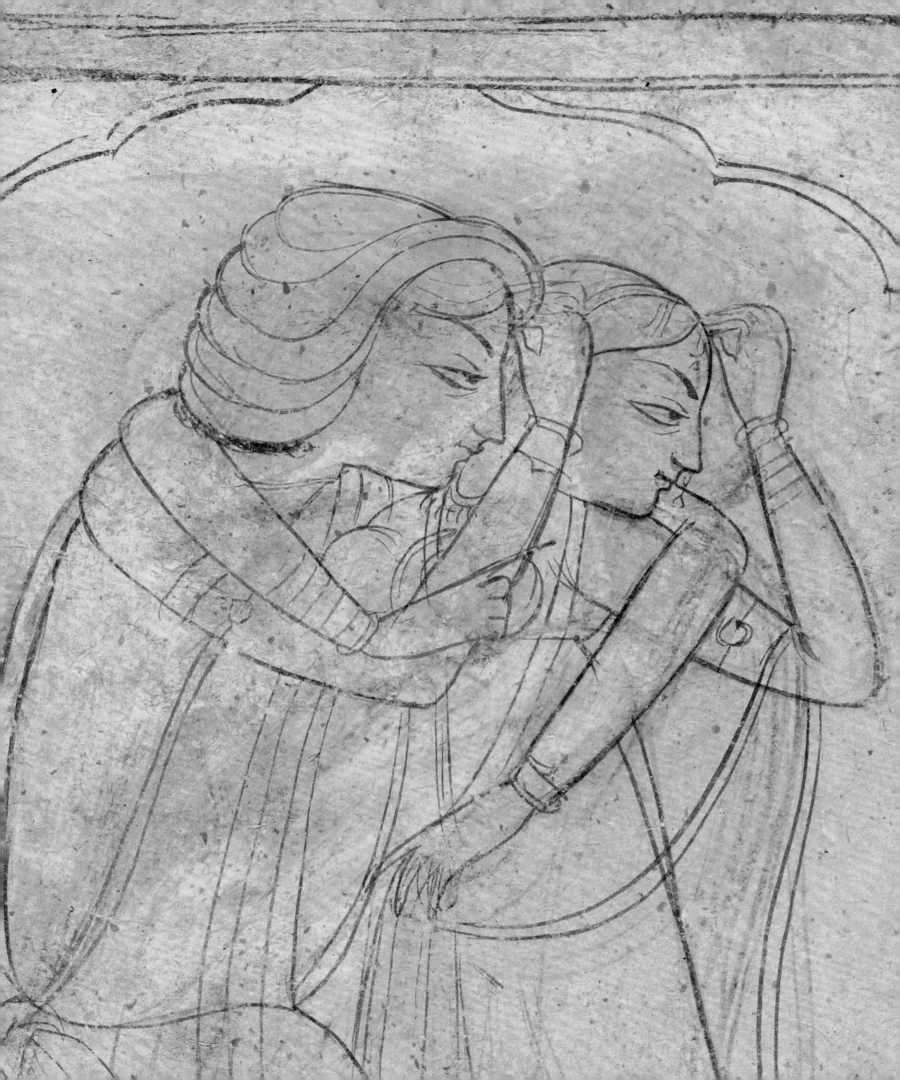

this case, numerous times on one sheet. These stages in the formation of an idea offer a visual shorthand of artistic practice.

How these corrected lines were interpreted within the Indian courtly workshop remains to be uncovered. In the Persian tradition such mistakes and necessary corrections were viewed with disdain; contemporary manuals on calligraphy were even hesitant to provide instructions for removing errors.[66] It is therefore likely that corrected Persian drawings were not as highly valued as their unsullied counterparts, which might help to explain their absence from the historical record. This reasoning need not apply to India, however, where countless drawings with a wide variety of modifications can be found in public and private collections. Instead, perhaps these many corrected lines were seen as proof that an artist was an assiduous draftsman. On *Portrait of Madho Singh of Kota* (plate 25), for example, a line on the sitter's turban has been reduced, as have the brushstrokes of his beard, nose, and chin, significantly changing the figure's profile. Rather than mistakes, perhaps such corrections should be considered as necessary steps in the pursuit of authentic representation.[67] The inscription along the upper border of the page clearly identifies the sitter as Madho Singh; one can assume the artist worked and reworked the image to achieve as close a likeness as possible to the individual.

In addition to modifying lines, white was also used to prepare a sheet for the application of color. In some workshops and regions, a thin coat of white primer (usually lead or kaolin white) would be applied over the entire sketch.[68] *Shiva and Parvati Seated in a Pavilion* (plate 26), probably from Chamba,[69] is an exquisitely drawn example in the Harris-Truelove Collection with such a white primer over the composition. This layer is always thin enough to reveal the underdrawing—here a red line followed by a black wash. After priming, the paper was repeatedly burnished to ready it for the application of color. The addition of primer as well as the light red line delineating a border indicates that *Shiva and Parvati*, a comparatively large sheet (11¾ x 9⅜ inches), was being prepared for painting; adding white primer to create such a smooth surface lessened the likelihood of dark lines bleeding through on the finished work.

The next stage in the workshop process is evident in the color notations that often grace a page and act as aide-memoire for artists. With the master artist responsible for the initial line, color was often added by subsidiary artists following his instructions. Washes or dabs of color were the most common means of leaving instruction, but notations may also appear as written directives.[70] In *A Celebration of Shiva* (plate 27), a drawing from the Rajasthani court of Bundi, prominent notations for green, red, yellow, orange, purple, and a touch of white add vibrancy to this quick artist's sketch. Before the notations were added, a very light gray wash was used to block out the lines of the original composition. The liveliness brought to this drawing through color belies its otherwise unfinished state. Shiva, with five heads and elaborate ornaments, faces Parvati. Ganesha stands behind as attendant, waving a flywhisk with his trunk. Other gods in attendance in this crowded, chaotic scene include Brahma, Krishna, Shiva, and Vishnu, along with their mounts, plus sages, dancers, and devotees. The notations indicate the importance of color choice as an integral part of the design process. And while such color notations could signal that a drawing was to be finished as a painting, the imprecise underdrawing seen here

श्री(ठ)माधोदास।
जी

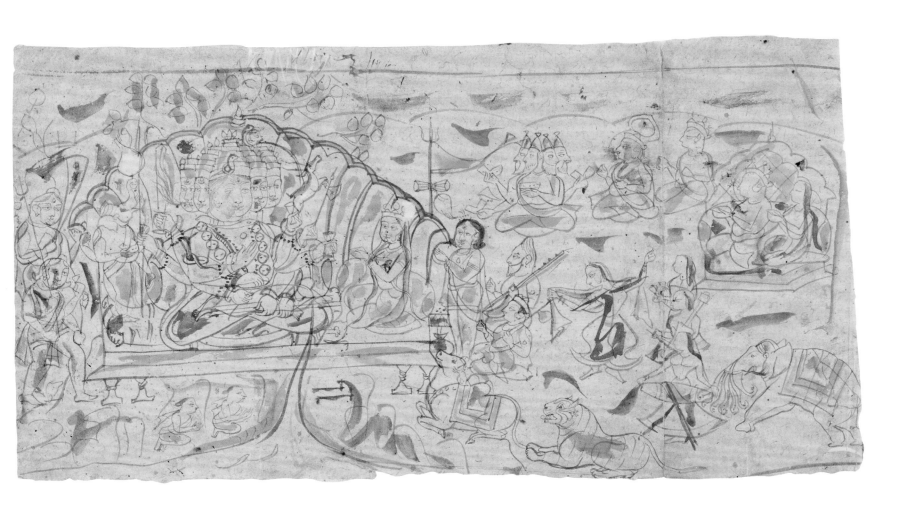

Plate 26

Shiva and Parvati Seated in a Pavilion

Himachal Pradesh, Chamba, c. 1790–1800
Brush and black and orange-red inks and opaque
watercolor over white opaque watercolor, ink, and
charcoal on beige laid paper
11¾ x 9⅜ inches (29.8 x 23.8 cm)
Philadelphia Museum of Art. The Conley Harris and
Howard Truelove Collection of Indian Drawings,
2013-77-12a

Plate 27

A Celebration of Shiva

Rajasthan, Bundi, c. 1800–1825
Brush and brown ink, watercolor, and opaque
watercolor on beige laid paper
7⅜ x 13⅞ inches (18.7 x 35.2 cm)
Philadelphia Museum of Art. The Conley Harris and
Howard Truelove Collection of Indian Drawings,
2013-77-11a

functions as backdrop for the notations, rather than as an accurate preparatory drawing. It is likely this work was stored in the workshop as a model or reference guide in the creation of other works.

Welch's definition of drawings as "two-dimensional works of art in any medium in which color is absent or subordinate" returns to mind when looking at works from the small subcourt of Sawar, near Ajmer, where artists produced partially colored portraits of and for their ruler, Maharaja Raj Singh (r. 1705–30), that are so polished they leave no question that they were intended as finished compositions. In *Raj Singh with a Standing Courtier* (plate 28), the ruler is seated on a terrace watched over by an attendant and surrounded by the accoutrements of courtly life. Both figures are depicted in a stiff contour line, with minimal shading and definition. Color accentuates sumptuous details, from their jeweled turbans to their delicately colored court sashes, a precious blue-and-white ceramic, and a rose. *A Portrait of a Prince Seated against a Bolster* (plate 29) follows the same compositional layout, where color (in this case, even more sparsely applied) has a similar effect of accentuating the drawn form. A third Sawar drawing, *Two Archers* (plate 30), further demonstrates that such partial color application is characteristic of the workshop. Here, the artist used a dark gray line and then overlaid it with a sharper black brushstroke. Raj Singh and his attendant are depicted as warriors, with quivers, bows, swords, and daggers; both wear pearl and jewel necklaces and earrings as indicators of nobility. The bold outlines accentuate the figures substantiality, while the added color, used sparingly, highlights their attributes. Among many of the works in the Harris-Truelove Collection, *Two Archers* reveals how the thoughtful addition of color, though still subordinate, can be the culmination of the drawing process, used to create a powerful representation.

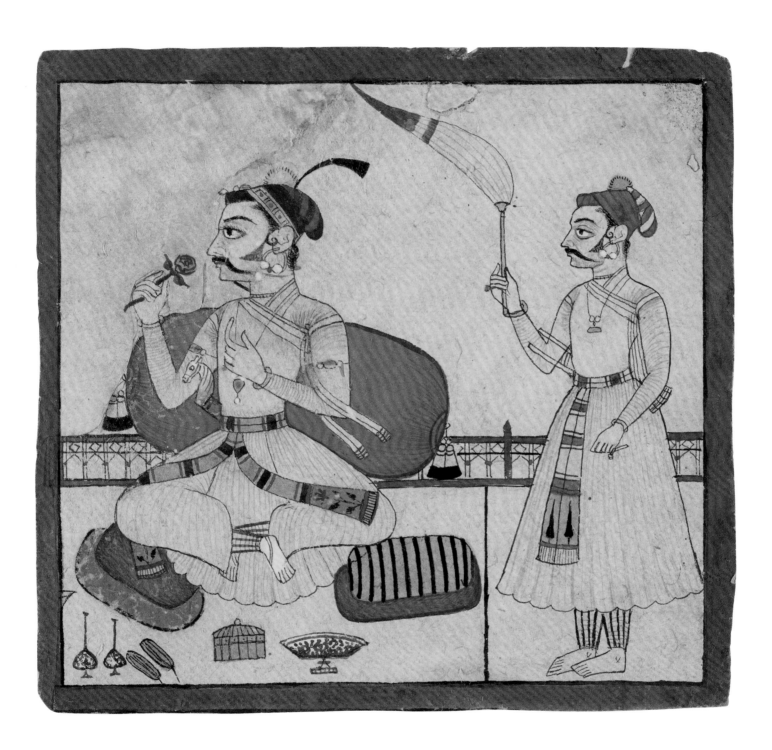

Plate 28

Raj Singh of Sawar with a Standing Courtier

Rajasthan, Sawar, c. 1710–20
Brush and black ink and white opaque watercolor on
beige paper
Image: 7⅛ x 7⅝ inches (18.1 x 18.5 cm), sheet: 7¹¹⁄₁₆ x
7⅞ inches (19.6 x 20 cm)
Philadelphia Museum of Art. The Conley Harris and
Howard Truelove Collection of Indian Drawings, 2013-77-18

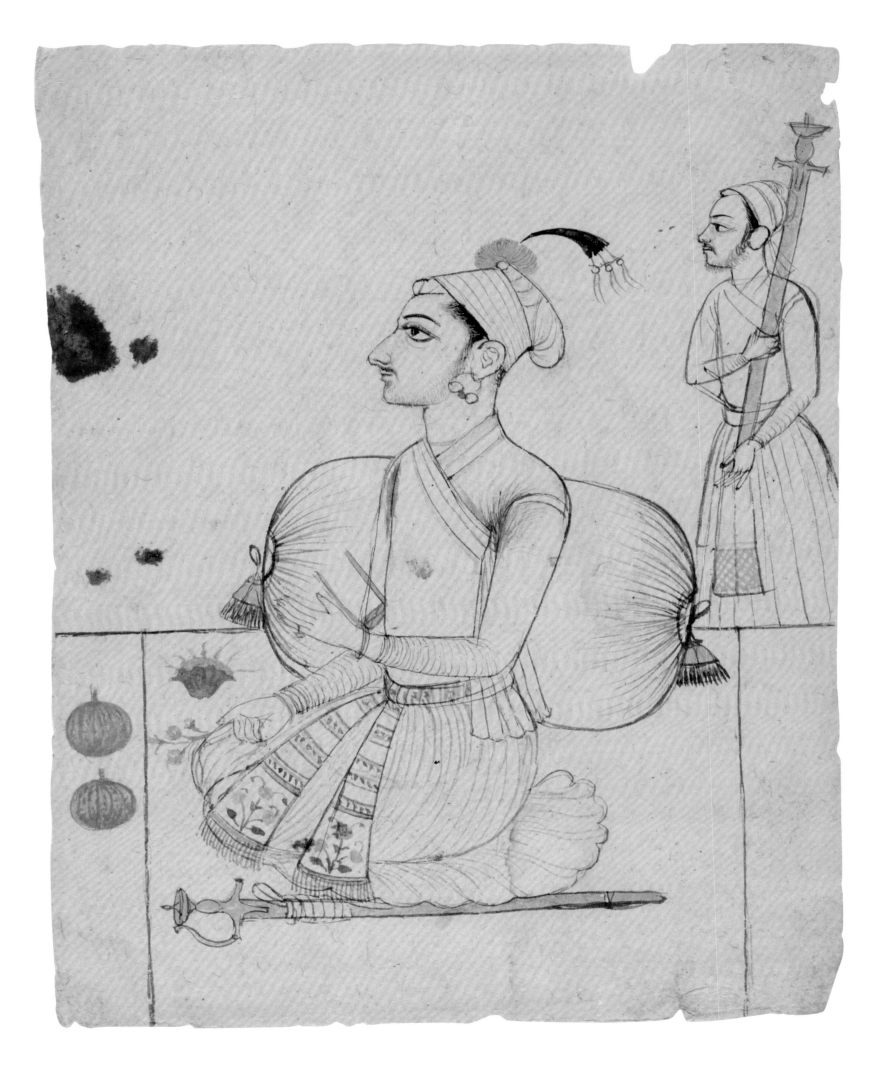

Plate 29

A Portrait of a Prince Seated against a Bolster

Rajasthan, Sawar, c. 1710–20
Brush and black ink and watercolor on beige paper
15½ x 11¼ inches (39.4 x 28.6 cm)
Philadelphia Museum of Art. The Conley Harris and
Howard Truelove Collection of Indian Drawings,
2013-77-4

Plate 30

Two Archers

Rajasthan, Sawar, c. 1710–20
Brush and black ink, watercolor, and opaque watercolor on
beige paper, mounted on paper
6¼ x 9 inches (15.9 x 22.9 cm)
Philadelphia Museum of Art. The Conley Harris and
Howard Truelove Collection of Indian Drawings, purchased
with the Stella Kramrisch Fund for Indian and Himalayan
Art, 2013-68-13

श्रीस्वामिनिजीकेचरणावाममचरणभसा
तचिन:॥ छत्र: चत्र: कमल: चुत्रा: जव: ंकु
स: वर्दुरेख: ॥॥ दख़णचरणकेचन्: सात
ग्धा: कमल: रथा बर्दी: मद्: वेदी: कुडल:

शुप्ररुद्यो गीव्व छरेही सुहृदसीफ

Reuse, Repetition, and Reinvention

DRAWING WAS A SKILL TAUGHT THROUGH REPETITION IN COURTLY INDIA.
An artist's understanding of line and form came as a result of familiarity with a workshop's previous production. A novice artist had to learn to re-create form before he could originate it, but there were numerous ways to achieve this, ranging from thoughtful visual analysis combined with the manual repetition of form to the use of stencils or pounces. Whatever means were employed, the artist's aim was not to produce homogenized replicas, but rather to internalize and respond to the tradition in which he was trained.[71] A drawing is thus studied not simply to identify the source of a reiterated image but to understand its modification over time.

Artists frequently created versions of the same subject to refine their technique, as well as to rehearse the image so that it could be drawn quickly and skillfully. For example, so-called puzzle pictures—animated studies of entwined and individual animals that are swiftly but confidently drawn (plate 31)—help us understand the nature, practice, and variations of artistic response.[72] These animals appear often in workshop sketches, demonstrating both the repetition that honed the artist's ability to reproduce an image effortlessly, and the reinvention of form that occurred within this refining of technique. This repetitive practice allowed a mature practitioner to create measured and unambiguous contour lines that are instantly recognizable as part of a particular workshop's corpus of material.

The Battle between the Demon and the Monkey Armies (plate 32), a folio from a *Ramayana* series attributable to Chamba, is an excellent example of such repetition of form. The series is recognizable by its crowded compositions and tiny, distinctive figures drawn in a light contour line. As in the lively battle scene here, the line throughout the series tends to be practiced and with no obvious corrections, the composition filling the page with a sense of movement from edge to edge.[73] In this case the sheet is covered predominantly with repeated iterations of one particular form: a monkey holding a tree aloft as a weapon, facing a demon carrying a shield and weapon in defense (see detail on p. 85).

Plate 31

A Study of Entwined Animals

Rajasthan, Kota, c. 1780–90
Brush and black, red, and blue inks and watercolor on beige paper
10 x 6¼ inches (25.4 x 15.9 cm)
Philadelphia Museum of Art. The Conley Harris and Howard Truelove Collection of Indian Drawings, 2013-77-34a

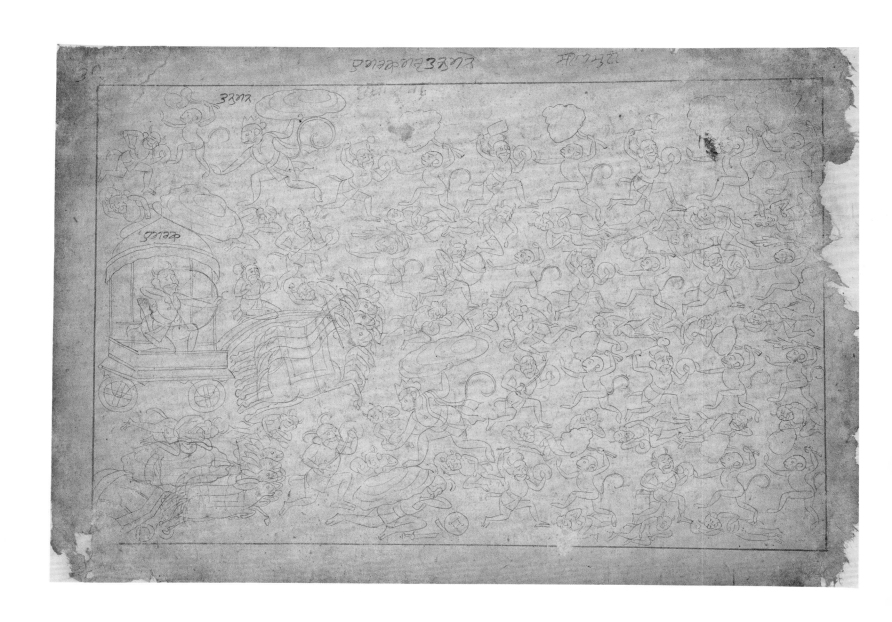

Plate 32

The Battle between the Demon and the Monkey Armies

From the *Ramayana*
Himachal Pradesh, Chamba, c. 1730–35
Brush and black ink over charcoal on beige laid paper
7½ x 11¼ inches (19.1 x 28.6 cm)
Philadelphia Museum of Art. The Conley Harris and
Howard Truelove Collection of Indian Drawings, purchased
with the Stella Kramrisch Fund for Indian and Himalayan
Art, 2013-68-15

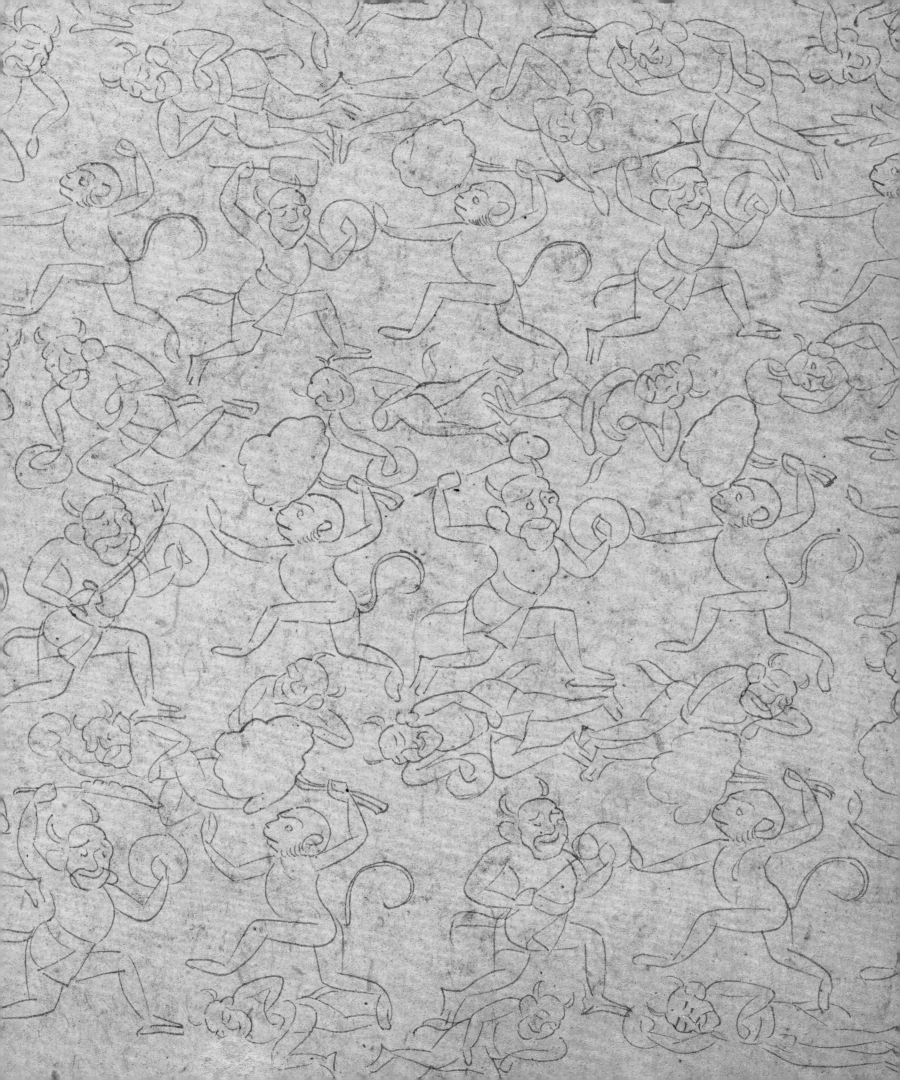

The resultant scene, of monkey paired with demon, is more like a choreographed dance than a battle. The near-identical monkey soldiers stem from a practiced hand adept at consistent rendition and at deploying accumulation as a mode of composition.

Industrious workshops often reused images, either by reproducing entire compositions or by borrowing one element of a painting, such as a single figure, and inserting it into a new context.[74] *Portrait of Samsam ud-Daula Khan Dauran* (plate 33) shows a courtier at the late Mughal court of Emperor Muhammad Shah but was made in the Rajasthani court of Kishangarh.[75] Recognizable by his sleek jawline and sharply defined facial hair, Daula Khan has been memorialized in individual portraits, and he is one of three ministers often portrayed with Muhammad Shah in *darbar* scenes.[76] It was not unusual for Mughal artists to produce individual portraits of key ministers and courtiers during the reign of Muhammad Shah, but this portrait in the Kishangarh regional style demonstrates the pervasiveness of reuse, as Mughal images were copied in the setting of a very different court.[77] Repetition is a powerful tool, whereby the dissemination of a particular form may be considered an assertion of power and identity.

If portrait elements could be repeated, modified, and redeployed to assert power and identity, so too could iconic religious images gain power through reiteration and repeated ritual use.[78] Images of Srinathji, the form of Krishna worshiped at Nathdwara, usually follow a set composition, with the deity portrayed standing with left arm held aloft (plate 34), an iconographic stance that references the moment the deity was discovered buried in the ground in Vrindavan. In Nathdwara images, a priest at times accompanies the deity to the right, and a devotee (the patron responsible for commissioning the work) is shown at worship to the left. Other variations include the adornment of the deity, whose ornaments differ according to which festival or celebration is represented. Yet the posture of Srinathji is unchanging, making for a consistent and powerful statement in all representations of the deity. Indeed, the repetition of the divinity's iconic form is intrinsic to the devotional practice of Srinathji worship. Even today, devotees visit Nathdwara and acquire images for home shrines as pilgrimage souvenirs. For artists, the act of creating such images is also an act of devotion; even this quick sketch would have accrued merit for the artist through the repeated action of drawing the deity's form.

Writing about Persian workshop practice, David Roxburgh argues that repetition demonstrates a conscious engagement with a visual past.[79] Whether in exact repetitions of an icon or in the internalization and adaptation of motifs, this engagement can be traced throughout the court practices of India. Yet it is not the existence of repeated forms that is significant, but how these images are considered in the art-historical record. Merely identifying an original source yields only a partial understanding of process. In fact, we need to question the very idea of an original source. In this complex system of adaptation—use and reuse—where is the original? There is no master and copy, but rather works that fluctuate and vary within a spectrum of reimagined forms.

Plate 33

Portrait of Samsam ud-Daula Khan Dauran

Rajasthan, Kishangarh, c. 1700–1735
Brush and black and red inks, watercolor, and opaque
watercolor over traces of charcoal on beige laid paper on
decorative mount with gold flecks
Image: 4¾ x 3½ inches (12.1 x 8.9 cm), sheet 12⅞ x
8⅚ inches (32.5 x 21.2 cm)
Philadelphia Museum of Art. The Conley Harris and
Howard Truelove Collection of Indian Drawings, 2013-77-8

Alongside the repetition and dissemination of familiar forms throughout the regional centers of courtly India, a sustained interaction with Europe from the sixteenth-century onward—in politics as well as in art—introduced a new range of possible inspirations. The first Jesuit missionaries who arrived at the Mughal court (1580–83 and 1591) brought from Europe many engraved images, including works by German and Flemish artists in the circle of Albrecht Dürer, and a copy of the heavily engraved Royal Polyglot Bible.[80] As many scholars have noted, artists in the region adopted aspects of the visual language of these European works, such as the illusion of depth through recession of the picture plane, as well as the shading and modeling of figures. Mughal-trained artists expanded their visual repertoire through these new techniques, even inserting European prints into albums of their own drawings, and at times painting over the print itself to internalize new and varied contour lines and to add color to the monochromatic works. In some cases entire prints, or individual figures excerpted from larger compositions, were directly copied, imitating even the engraving technique through delicate cross-hatching. The Deccan region in south-central India was another melting pot of artistic visions in the sixteenth and seventeenth centuries. Deccani painting fused Mughal, Persian, Turkmen, Ottoman, European, and indigenous sources to create a dreamlike visual style that was used for both portraits and mythological subjects.[81] European subjects and types appear frequently in Deccani painting, and Deccani artists unattached to a particular court occasionally received patronage from Europeans.

Artists in the Deccan, as in the Mughal court, began to include reimagined Christian imagery in their work.[82] An extraordinary Crucifixion scene in the Harris-Truelove Collection (plate 35) combines European subject matter and naturalism with both Mughal and Deccani characteristics. The superbly rendered, heavily modeled figures at first appear to be from the hand of a Mughal-trained draftsman working during the reign of Akbar, when the practice of copying Christian iconography was at the height of its popularity. However, on closer inspection the figures are more angular than one would associate with a Mughal hand, with sharp contour lines replacing the standard soft, rounded Mughal forms. The sharply defined drapery of the bystanders' robes, where each fold produces a deeply shaded crevasse, creates a feeling of heaviness that is out of step with Mughal workshop practice (see detail on p. 91).[83] Is this the work of a Mughal draftsman influenced by the experience of the Deccan, or of a Deccani artist exposed to Mughal drawings? Whatever its origins, the drawing displays the hand of a resourceful artist who reimagined an array of sources to produce an innovative vision.

This comparatively large drawing is beautifully detailed. The figure of Christ, with his emaciated form and long, curling hair, tendrils of which fall down his back, has a powerful presence. His slightly distended belly contrasts with his muscular legs, leading the eye toward the rigid form of the cross and downward to the cluster of people gathered at its base. Five women and a child are positioned to the left of the cross, five more to the right. The elongated forms and cascading robes of the figures whose bodies are visible mirror the length and shape of the cross. Few of the other figures seem engaged with Christ: two of them hold opened books; one has her hands pressed together in prayer as she turns

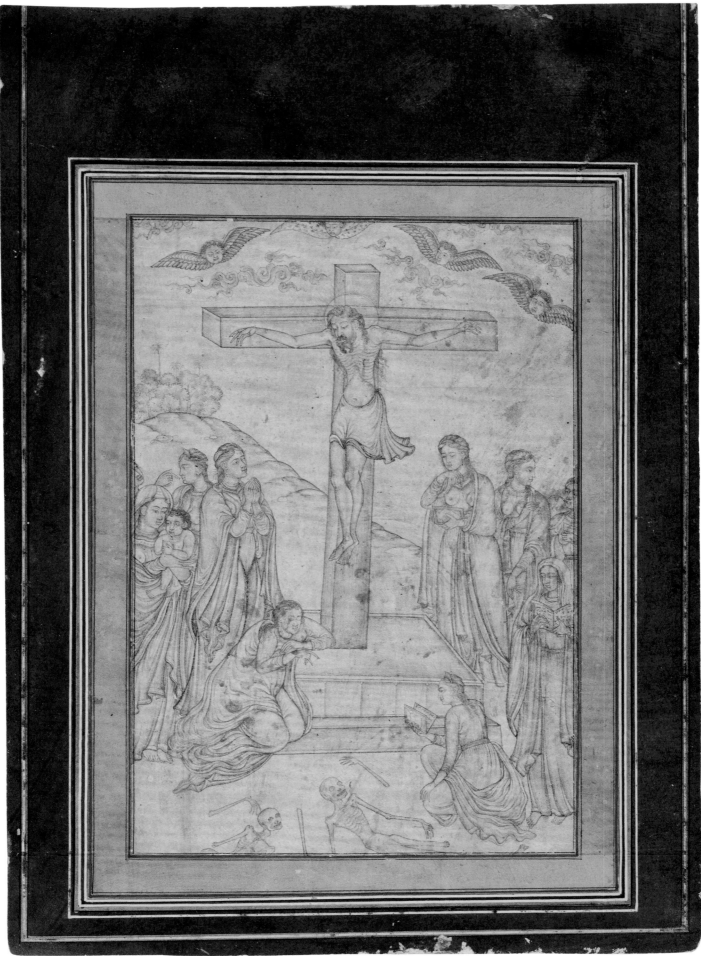

Plate 35

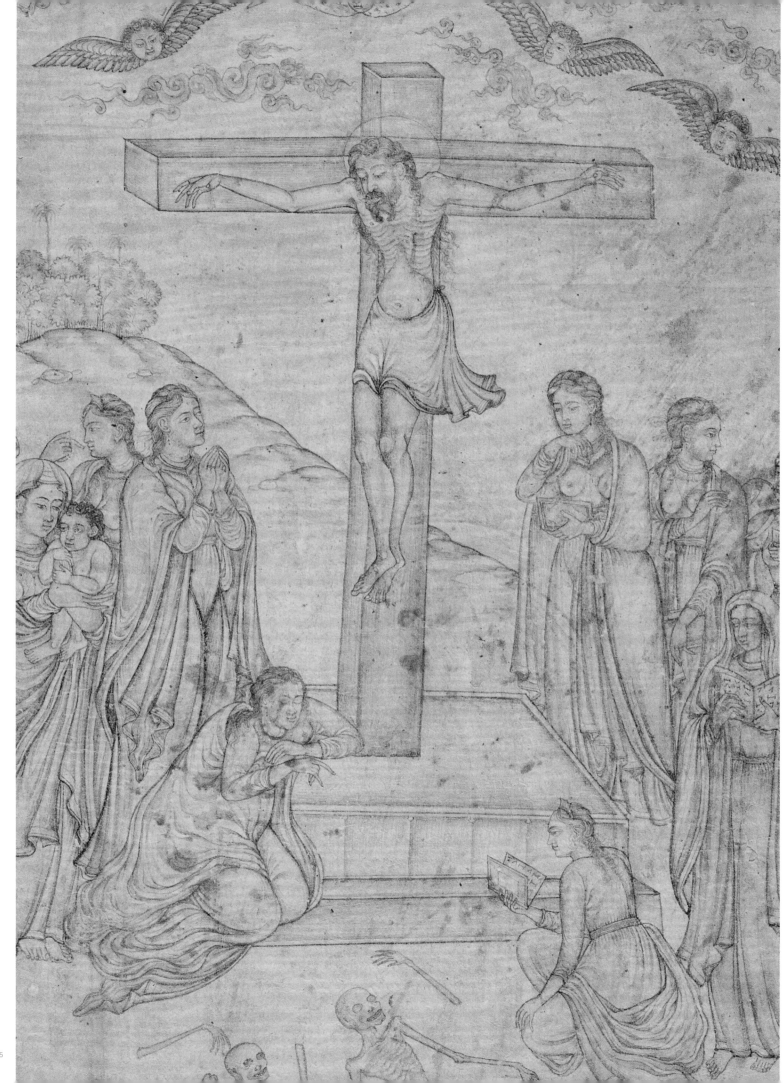

toward the Savior; two others look away in conversation; one is collapsed at Christ's feet; one looks at the child; and one looks down pensively. Indeed, the scene's uncharacteristic level of animation encourages the viewer to regard it as a pastiche of Christian imagery. The reading women are a visual trope associated with Mary Magdalene and representations of the Ascension, whereas the talking women are unusual for this somber scene. The woman holding a small boy suggests the Madonna and Child motif—iconography revered by both the Mughal emperor Akbar and his son, Prince Salim[84]—and the woman praying is also associated with representations of the Madonna. While most of the figures are identifiable, the presence of ten women and a child in a Crucifixion scene is unusual.[85] The tomb or plinth in the foreground and the skeletons below are often associated with depictions of Christ Risen from the Tomb,[86] while the clouds and winged angels above are a conflation of Chinese, Persian, and European imagery commonly seen in Mughal painting. By isolating these figures from a variety of engraved sources, the artist has crafted an original composition in which the intended religious message of the imagery is subordinate to a fascination with the formal elements of drawing.[87] Understanding the appropriation of compositional elements involves not simply identifying their sources, but also observing the modifications those sources underwent when used as material for new compositions.

The combination of compositional elements in *Men Falling from Their Rearing Horses* (plate 36), made in Guler around 1790 and recognizably in the Seu family style (see also plates 1, 49), demonstrates another artist's thoughtful response to existing imagery.[88] Executed in a light gray wash, the drawing portrays two horsemen falling from their swiftly moving mounts. The horses are expressive and obviously out of control. The turban of the rider to the left has fallen off; while reaching for it, he shields his head from a rampaging hoof. The rider to the right pulls the horse's reins taut as he falls, turning the animal's head to face him. The human figures are drawn in a thinner, more precise line than the rest of the composition, and their expressions are surprisingly serene given the tumult surrounding them.

In a work now in the British Museum, *A Man Thrown from His Horse* (fig. 12), the renderings of horse and rider are extremely similar to those in the Harris-Truelove

Plate 36 (opposite)

Men Falling from Their Rearing Horses

Himachal Pradesh, Guler, c. 1790
Brush and black ink over charcoal on beige laid paper
7½ x 9½ inches (19.1 x 24.1 cm)
Philadelphia Museum of Art. The Conley Harris and Howard Truelove Collection of Indian Drawings, purchased with the Stella Kramrisch Fund for Indian and Himalayan Art, 2013-68-6

Fig. 12. *A Man Thrown from His Horse*. Himachal Pradesh, Guler, eighteenth century. Ink wash on paper, 7¹⁵⁄₁₆ x 8¹⁵⁄₁₆ inches (20.2 x 22.7 cm). The British Museum, London. Purchased from J C French ICS (retd). 1926,0616,0.5

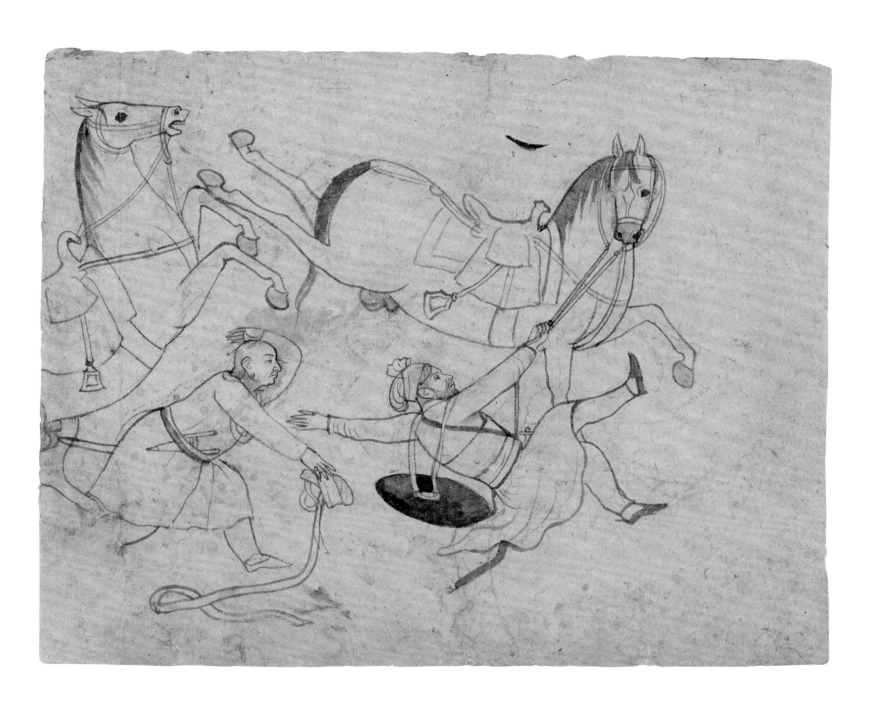

drawing—so similar, in fact, as to suggest shared authorship or the close study of one artist's work by another. Subtle differences appear in the position of the rearing horses, and there are significant disparities between the thrown riders in the two drawings. For example, in the Philadelphia drawing the bald male figure is portrayed as clean-shaven, while in the London sheet he sports a beard. These subtle variations in an otherwise recognizable figure reveal the pervasiveness of reuse in the Guler workshop. The rider represents not an eighteenth-century gentleman recorded by the artist, but rather a figure known to him only from other workshop drawings and paintings. This male form—replicated in the Philadelphia and London drawings—may have been inspired by the priest in the painting *Purifying Rituals* (fig. 13), dated to around 1735–40 and attributed to the master artist of the Seu family, Nainsukh. These weathered and timeworn figures are older than one would expect for a horseman, but not for a priest. All three works likely originated in the same workshop and were either inspiration for, or modified from, other materials.

TECHNIQUES OF TRANSFER

Another way in which workshop artists reused and circulated images was through mechanical transfer, but even here it was not always a case of exact replication. Mughal artists were expert at reusing imagery inventively to create new forms. Through the use of *charbas*, or tracings, individual dynastic portraits could be combined to create group portraits that document genealogy and the transfer of the Mughal crown from one generation to the next. *Jahangir Rises to Embrace Prince Khurram on His Return from the Deccan Campaign in 1617* (fig. 14), now in the British Library, depicts a crowded *darbar* scene from the *Padshahnama* (History of the Emperor Shah Jahan). Mughal draftsmen used tracings pricked with holes to add the portraits of the many noblemen in attendance. These portraits could be repositioned and altered according to the whims of the workshop supervisor or court historian. In this particular example, many of the noblemen are positioned differently than they are on the subsequent painting. In an act of

Fig. 14. *Jahangir Rises to Embrace Prince Khurram on His Return from the Deccan Campaign in 1617.* Mughal Empire, 1635–40. Brush drawing heightened with white and some color on paper; image: 11⅝ x 8⅜ inches (29.6 x 20.8 cm), sheet: 16⅛ x 10⅞ inches (41.1 x 26.6 cm). The British Library, London. Johnson Album, 4,2

historical revisionism, Khan Jahan Lodi, who would have been present at the 1617 event depicted, is excluded from both works—his rebellion and death in 1631 deemed him an inappropriate figure to include in this image produced later in the decade.[89]

While there are numerous methods of transferring images, the pounce was most often used in courtly India.[90] A technique that most likely came from Persia, pouncing is typically begun by placing a translucent piece of paper or vellum over the drawing designated for transfer. Using a sharp stylus, the artist pierces a series of small holes following the outline of a particular detail or a full composition. He then places this pierced work on a clean sheet and, using a small mesh bag containing powdered charcoal, carefully pats the pierced sheet to transfer the image. The wisp of a line that appears on the pounced sheet is used as a guide, which the artist darkens and solidifies to create the outline of a new drawing. In India, the interim step was often omitted and the original drawing, instead of an overlaid translucent sheet, was perforated.[91]

The many dirty and darkened drawings found in collections today testify to the use of pouncing in courtly India. In fact, several drawings in the Harris-Truelove Collection reveal evidence of transmission by direct transfer. Some works, such as *Rustam Battling a Demon* (plate 37), include a dark residue that can obscure detail. Even with the dark smudges of charcoal, clear lines join to create this composition of Rustam, a great hero of the Persian epic the *Shahnama* (Book of Kings), proving his strength by overpowering a demon. Both figures are pierced intermittently with a pin. By using the pounce technique, these isolated figures could either be inserted into a larger narrative painting or remain the focus of the composition; contemporary viewers would have easily recognized Rustam's tiger-head helmet and the grotesque demon antagonist.

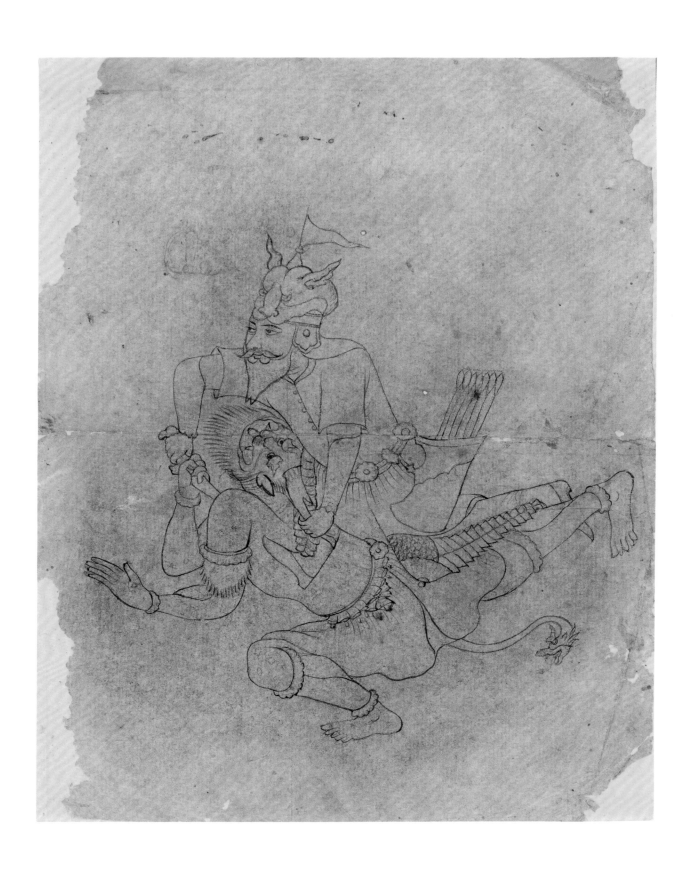

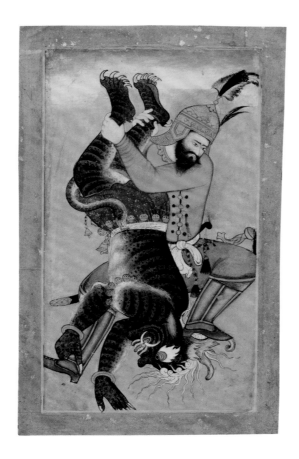

A Mughal painting of the same scene (fig. 15) awards a similarly dramatic presence to the isolated figures.

A Swooning Woman with Three Attendants (plate 38), another perforated drawing from the Harris-Truelove Collection, is boldly and at times crudely executed. A series of rough ovals suggest flowers in the background, and similar shapes near the bed indicate a rose-water sprinkler and other courtly accoutrements. The common theme—of a lovesick woman surrounded by doting attendants—is here reduced to its fundamentals. The four figures and the canopy are perforated along the contour lines, but auxiliary details such as the bolsters and the features of the women's faces remain untouched, as revealed by transmitted-light photography of the sheet (fig. 16). The artist would have taken the basic composition from the pounce and created his own version by elaborating the details.

The popularity of this theme is evidenced by two further examples in the Harris-Truelove Collection: *A Woman Resting against a Bolster* (plate 39), another perforated drawing, and *A Princess Swooning on a Bed* (plate 40), which is unperforated. The pin-pricked drawing, done in a clear red line with thick black overdrawing, offers a magnified view of this popular theme, with little space to contextualize the central figure. A dark residue covers most of the page, but it appears to be an overpainted layer of dark wash, rather than leftover charcoal. The female figure leaning casually and confidently on the oversized bolster offers an interesting comparison to the woman in *A Princess Swooning on a Bed*, who, as in *A Swooning Woman with Three Attendants*, is prostrate with grief. *Princess Swooning* could potentially be identified as illustrating a verse from one of the love-classification texts, most likely the *Rasamanjari*,[92] where a female consort is burning up with love for an absent male. The surrounding attendants massage her feet and fan her

to cool her down.[93] The older female attendant carrying a cane—often included in such paintings of pining women—serves as the messenger between the lovers.

One of the most finely detailed drawings in the Harris-Truelove Collection, attributable to the late Mughal court at Farrukhabad, is *Ladies on a Terrace with Fireworks* (plate 41). This meticulously rendered image portrays a noblewoman seated on a Western-style chair. She is much larger in scale than her cluster of female attendants—a common practice in which greater size indicates higher social standing. The architecture, complete with inlaid niches and rolled textiles used to delineate space, is delicately drawn and also shows a great interest in the recession of pictorial space. Each detail of the drawing—from the women's diaphanous robes, to the ruled lines of the architecture, to the quickly sketched fireworks in the background—has been pin-pricked for transfer. Considering the charcoal residue that remains on the reverse of this drawing (fig. 17), it appears to have been used to transfer the composition to another sheet. Unfortunately, it is rare to find a stencil and the resultant image, and this is no exception. Such pin-pricked drawings would remain in the artist's workshop, while a completed painting created from a pounce might enter the patron's royal collection. Though we can seldom reunite the two elements needed for mechanical transfer—tool and result—existing works in both of these stages can tell us much about the dissemination of imagery, including the movement of materials, styles, and motifs.[94]

We are fortunate to have such a comparison with *Krishna Recites the Bhagavata Gita to Arjuna* (plate 42), a late eighteenth-century drawing from Kangra. In this work, most of the pictorial space is occupied by the precisely depicted chariot that carries Arjuna, with Krishna facing him. The composition is covered in small color notations, in Devanagari script, which are visible on the horses and on Arjuna's bolster, sword, *patka* (sash), and armor. A fully colored version of this precise work can be found in the National Museum of India in New Delhi. An exact replica, in reverse, of the Harris-Truelove drawing, the painting provides invaluable insight into the translation of imagery through pounces, which made it possible to flip compositions. Another drawing to add to this comparison is *Krishna Instructing Arjuna on the Field of Battle* (fig. 18), now in the Museum of Fine Arts, Boston. The horses on the Boston drawing face to the left, as do those in the National Museum painting. The Harris-Truelove drawing is flipped on the horizontal axis. The directional differences among these works bring into question whether a norm existed for such images, or if it was left to the whim of the artist. A further example (fig. 19)—though not an exact replication of the drawing (as evidenced in Krishna's altered posture)—demonstrates the pervasiveness of this image. Probably created a generation later, this painting's format, including the oval framing device, remains consistent with the previous examples.

What is missing from this comparison, however, is an interleaving perforated layer. A thin sheet of paper would presumably have been placed on top of the Harris-Truelove drawing, the drawing would have been lightly traced, and this new drawing would have been pricked for transfer. The Philadelphia drawing, with no evidence of pin-pricked holes or indentations, may instead have been used as a color guide.[95] The addition of precise written color notations on the drawing's surface would continue to inform the workshop

Plate 38

A Swooning Woman with Three Attendants

Rajasthan, Kota, c. 1830
Brush and black ink with corrections by the artist in white opaque watercolor on beige laid paper, pricked for transfer and pounced with charcoal
10 x 7 inches (25.4 x 17.8 cm)
Philadelphia Museum of Art. The Conley Harris and Howard Truelove Collection of Indian Drawings, 2013-77-37a
(For opposite side, see plate 9)

Fig. 16. Transmitted-light photograph of detail of plate 38, revealing the perforation along the contour lines of two figures

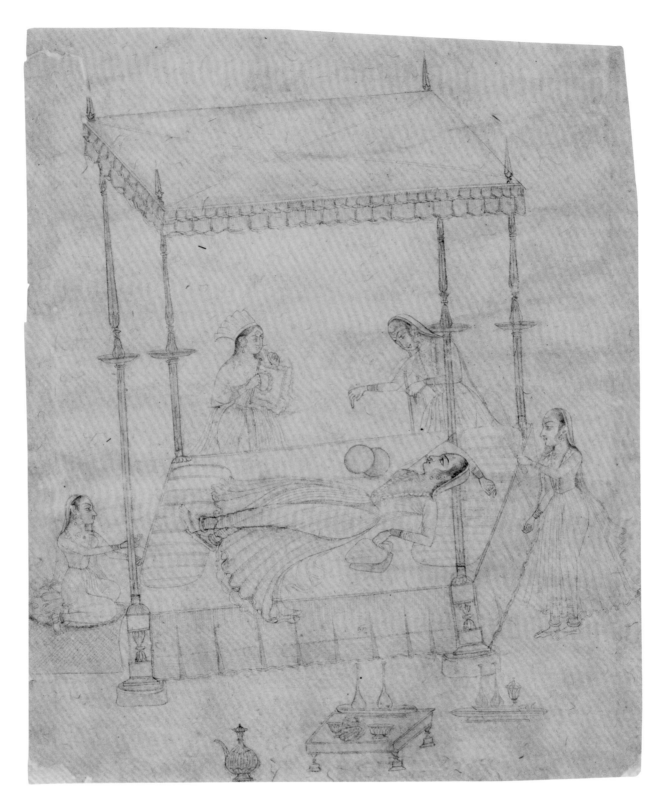

Plate 39

Woman Resting against a Bolster

Rajasthan, Kota, c. 1800
Brush and black and red ink over opaque watercolor
and inks on beige paper, pricked for transfer and
pounced with charcoal
10½ x 9 inches (26.7 x 22.9 cm)
Philadelphia Museum of Art. The Conley Harris and
Howard Truelove Collection of Indian Drawings,
purchased with the Stella Kramrisch Fund for Indian and
Himalayan Art, 2013-68-4

Plate 40

A Princess Swooning on a Bed

Rajasthan, Bikaner, c. 1675–1700
Brush and black, red, and blue inks on beige paper
8½ x 6 inches (21.6 x 15.2 cm)
Philadelphia Museum of Art. The Conley Harris and
Howard Truelove Collection of Indian Drawings, 2013-77-1

Plate 41

Plate 41

Ladies on a Terrace with Fireworks

Uttar Pradesh, Farrukhabad, c. 1760–80
Brush and black ink with corrections by the artist
in white opaque watercolor on beige laid paper,
pricked for transfer and pounced with charcoal
9¼ x 12 inches (23.5 x 30.5 cm)
Philadelphia Museum of Art. The Conley Harris and
Howard Truelove Collection of Indian Drawings,
2013-77-16

Fig. 17. Reverse of plate 41 showing charcoal residue,
probably from transferring the image to another
sheet

Detail of pl.

Fig. 18. **Attributed to the Family of Nainsukh.** *Krishna Instructing Arjuna on the Field of Battle.* Himachal Pradesh, Kangra, late eighteenth century or first quarter of the nineteenth century. Ink on paper, 4⅜ x 5⅜ inches (11.1 x 13.5 cm). Museum of Fine Arts, Boston. Ross-Coomaraswamy Collection, 17.2548

Fig. 19. *Krishna Reciting the Bhagavata Purana to Arjuna.* Himachal Pradesh, Kangra, c. 1800–1820. Opaque watercolor with gold on paper, 6¹¹⁄₁₆ x 9¹¹⁄₁₆ inches (17 x 24.5 cm). Collection of Jai and Sugandha Hiremath, Mumbai

Plate 42

Krishna Recites the Bhagavata Gita to Arjuna

Himachal Pradesh, Kangra, late eighteenth century
Brush and black and orange-red inks and watercolor
on beige paper
6⅛ x 10⅛ inches (15.7 x 25.7 cm)
Philadelphia Museum of Art. The Conley Harris and
Howard Truelove Collection of Indian Drawings,
2013-77-19

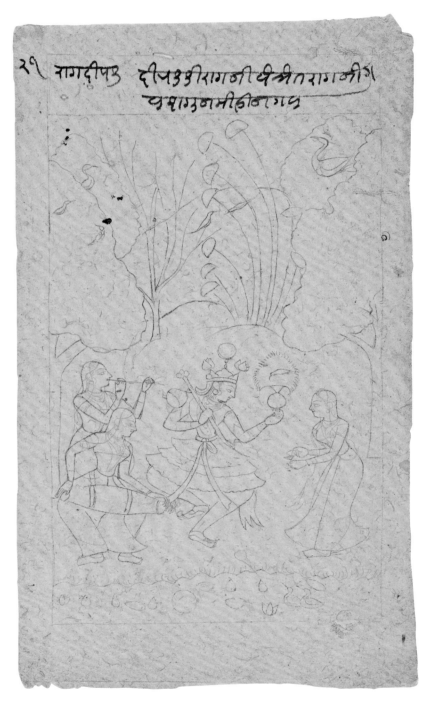

Plate 43

Vasanta Ragini

From a *ragamala* series
Rajasthan, Bundi, c. 1650–1750
Brush and black and orange-red inks on beige laid paper
9¾ x 5¼ inches (24.8 x 13.3 cm)
Philadelphia Museum of Art. The Conley Harris and
Howard Truelove Collection of Indian Drawings, 2013-77-39

Plate 44

Vasanta Ragini

From a *ragamala* series
Rajasthan, Bundi, c. 1650–1750
Brush and black and orange-red inks on beige laid paper
9½ x 5½ inches (24.1 x 14 cm)
Philadelphia Museum of Art. The Conley Harris and
Howard Truelove Collection of Indian Drawings, 2013-77-38

process in the creation of other paintings, such as the two just cited. Locating a drawing and subsequent compositions based upon it demonstrates again that numerous studies were needed to perfect a composition—and also identifies the Philadelphia drawing's role in that process.

A pounce may be used numerous times to create multiple compositions derived from the same drawing. This encourages us to consider why particular images were popular or deemed important to reproduce.[96] Drawings and paintings that use a variety of love relationships and worship scenes to illustrate the modes of Indian music (ragas), produced in sets known as *ragamalas*, or "garlands of ragas," were popular throughout courtly India from the sixteenth to nineteenth centuries. The relatively consistent iconography of these sets allowed for frequent mechanical transfer. Two drawings in the Harris-Truelove Collection that portray the same mode, Vasanta Ragini—a celebration of the arrival of spring often visualized as dancing Krishna surrounded by *gopis* playing music in a verdant landscape—may be attributed to the Bundi workshop and datable to about 1650–1750. In one, a stocky Krishna cavorts with two *gopis* below serpentine monsoon clouds (plate 43).[97] The second work is very similar, with Krishna sporting a skirt with three ruffles and an elaborate lotus crown (plate 44). He carries a *vina* in one hand, and a *lota* (water pot) in the other. The dancing Krishna is surrounded by three female figures, one of whom plays a drum, the other a flute. Rather than a view of the monsoonal sky, here the focus is on an overgrown landscape full of pairs of birds, a symbol of love in Rajasthani painting. Yet another example, from the Stella Kramrisch Collection (fig. 20), demonstrates the pervasiveness of Vasanta Ragini iconography and alludes to the importance of consistency in *ragamala* representation at the Bundi workshop. Molly Aitken has suggested that artists in the Bundi workshop during the seventeenth and eighteenth centuries were using late sixteenth-century pounces inherited from their artist-ancestors to remake *ragamala* compositions.[98] The consistency in *ragamala* iconography witnessed here lends weight to her argument.

Even with the standardized forms seen in the pages of a Bundi *ragamala*, subtle differences among the drawings individualize them. From Krishna's dress to the variety of details included in the landscape, each picture has aspects of an original composition. Even the transmission of form through mechanical means can involve a restatement rather than a replication of imagery. Our appreciation for the innovation of courtly workshop artists can be heightened by an understanding of how compositions were reworked, altered, and reinvented.

Fig. 20. *Vasanta Ragini*. Rajasthan, Bundi, c. 1675–1700. From a *ragamala* series. Ink wash and watercolor on paper; image: 7¼ x 4⅞ inches (18.4 x 11.3 cm), sheet: 8 x 4½ inches (20.3 x 11.4 cm). Philadelphia Museum of Art. Stella Kramrisch Collection, 1994-148-404

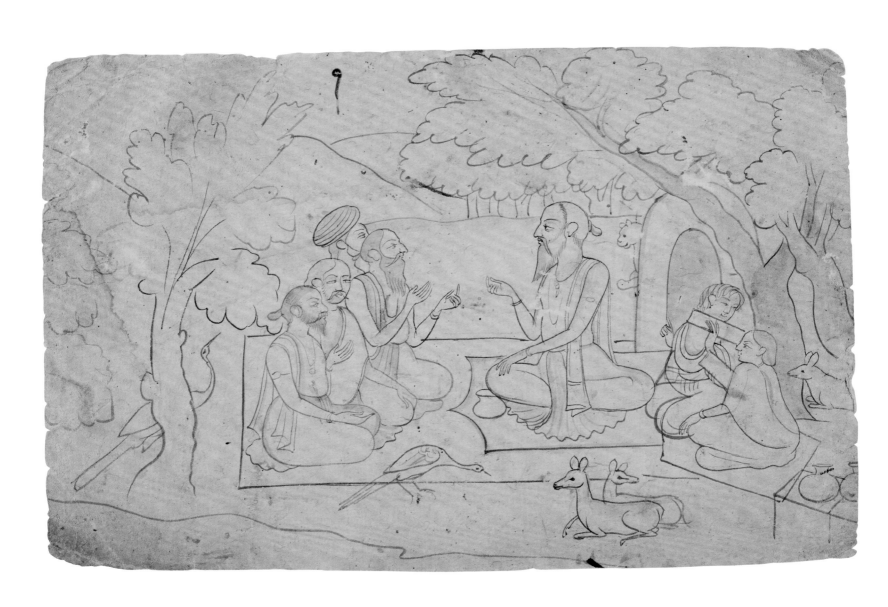

What Line Reveals

THE PREVIOUS SECTIONS HAVE EXPLORED DRAWINGS THROUGH THE SKILL REQUIRED to create them and delved into the artistic practice at the court workshops of North India. These two areas overlap and intertwine, as the process of building up an image through successive layers of ink and watercolor on paper is linked to the changes that same image underwent within the workshop. Whether through white wash corrections, multiple lines to accentuate form, or the addition of color, such modifications are as fundamental to workshop practice as the inherent skill of the artist. Drawings are the treasured outcomes of a workshop system that preserved these materials and handed them down from one generation to the next. To see and value this continuity is not to imply that the court workshops were static—far from it—but rather to recognize that drawings were created through the informed adoption of previous ideals.

Drawings are a tangible—and revealing—product of the artist's hand. This section looks closely at the delicate forms that result when the artist's brush first meets paper and what these lines can tell us about artistic authorship. Indian court artists employed thoughtful variations in brushstroke to develop a composition and vary its graphic effect. These subtle variations may reveal both the individual artist's hand and, for workshop-trained artists, the region in which they learned their craft. The dense darkness that results from stippling, for example, or the quick, sketchy line that articulates movement, can tell us much about the hand of a trained draftsman. Even when the individual artist is not known, however, it is still possible to identify characteristics that unify the output of a workshop.

IDENTIFYING ARTIST AND WORKSHOP

The artist and collector Howard Hodgkin noted that in Indian drawings, "volume is more often implied than described. Indian draftsmen must surely be among the absolute masters of enclosing a weighty form between two simple lines, leaving the spectator to fill in what lies between."[99] *A Hindu Ascetic and Devotees in a Forest Setting* (plate 45) is a wonderful visualization of Hodgkin's statement. In this animated composition, four male devotees visit an ascetic at his forest dwelling, with trees bending protectively overhead. Each visual element is drawn in a fluid contour line, with minimal definition to create volume or depth—yet each occupies a substantial space in the composition, with little need for extraneous detail.[100] In works from the Pahari region, the elegant

Plate 45

A Hindu Ascetic and Devotees in a Forest Setting

From the *Bhagavata Purana*
Himachal Pradesh, Kangra, c. 1800
Brush and black and orange-red inks on beige paper
6 x 9 inches (15.2 x 22.9 cm)
Philadelphia Museum of Art. The Conley Harris and
Howard Truelove Collection of Indian Drawings,
2013-77-36

Plate 46

Rampant Elephant Attacking a Crowd

Rajasthan, Kota, c. 1750–70
Brush and black ink and white opaque watercolor over
traces of charcoal on beige paper on decorative mount
Image: 5⅝ x 6½ inches (14.3 x 16.5 cm), sheet: 7⅞ x 9⁷⁄₁₆
inches (20 x 23.9 cm)
Philadelphia Museum of Art. The Conley Harris and
Howard Truelove Collection of Indian Drawings, purchased
with the Stella Kramrisch Fund for Indian and Himalayan
Art, 2013-68-12

line is paramount; the curving brushstrokes, which reveal as well as conceal, are recognizable for their economy.

By contrast, Rajasthani drawings can often be identified by a shorter, choppier line. Compositions are created when these lines connect into a broader brushstroke. The resultant picture has an accumulated depth, but closer inspection reveals the individual markings used to build up the image. This preference for a shorter line might relate to the popularity of modeling in several of the courtly styles of Rajasthan, where shading is added to a work through brief parallel strokes. However, unlike in the European tradition, where both stippling and shading are used to denote light and shade, Rajasthani draftsmen used this concentrated line to accentuate roundness. *Rampant Elephant Attacking a Crowd* (plate 46) portrays a finely drawn and shaded elephant full of life and movement. His large form is positioned to charge as the scrambling attendants, depicted as a mass of moving and writhing body parts, attempt to escape his path. While the attendants are lightly and quickly drawn, the elephant's form is thoughtfully composed. His large ears are beautifully enunciated through the accumulation of short parallel strokes that, when combined, create shaded detail denoting the skin's rough, patterned surface (see detail below).

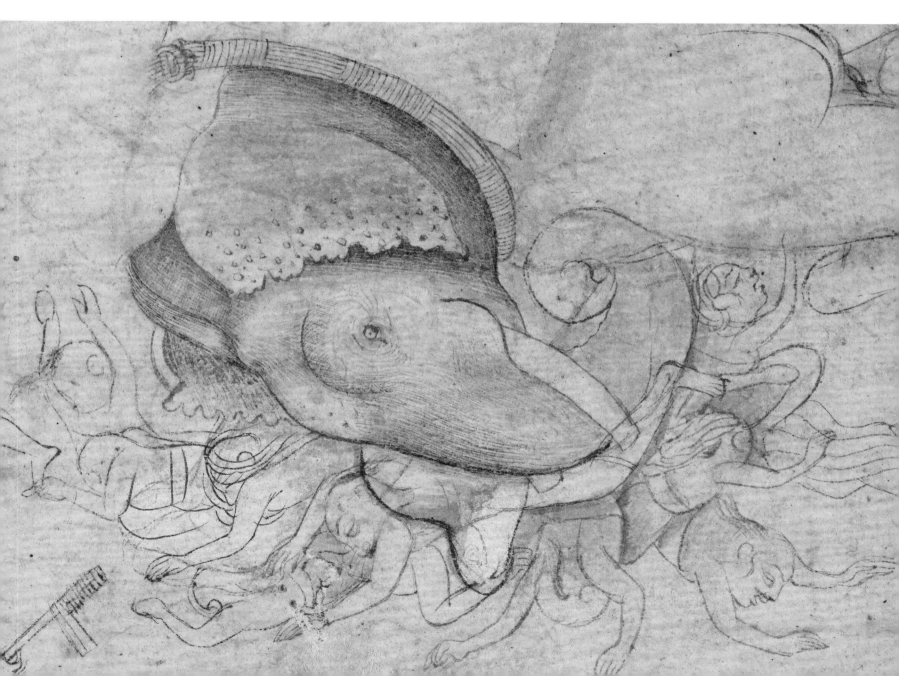

Drawings from Rajasthan span a wide spectrum, from the highly graphic works from Sawar already discussed (see plates 28–30) to the delicately shaded *Rampant Elephant Attacking a Crowd*. While vastly different in finish, all are nevertheless created by the accumulation of short lines. Drawings from Bikaner and Kishangarh, two Rajasthani courts that were heavily influenced by the Mughal artistic tradition, further transform these staccato marks into softer, smoother compositions. *Walking Vaishnava Disciples* (plate 47)—a detailed late eighteenth-century work probably from Bikaner—depicts three disciples walking through a minimally defined landscape, with turbulent clouds above subtly accentuated by yellow pigment and a modulated ground below. The sectarian markings on the foreheads of all three figures identify them as devotees of Vishnu.[101] Each figure is finely drawn, with the addition of modeling to highlight their serene expressions and emaciated forms. However, it is the third figure, wearing only a *dhoti*, that reveals a masterful line, as each thin brushstroke combines to amplify the slack skin of his cheeks, his emaciated torso with protruding ribs, and the defined musculature of his legs (see detail at left). This shading, which elucidates depth through accumulated brushstrokes, is a signature of the image-making process in the Bikaner workshop.

The shaded and modeled line used in Bikaner was adapted from *nim qalam*, a technique practiced in Mughal India to create subtly drawn works as a response to the monochrome engravings from Europe that flooded the Mughal court after 1580.[102] These works from the imperial court extol a rounded, softer-looking line, and with less reliance on a contour outline to define form; aspects are instead delineated through a build-up of soft, shaded brushstrokes. A double-sided album page in the Harris-Truelove Collection includes a sheet of birds, beautifully drawn in the Mughal imperial style, on one side, and a detail from a wonderful etching by the Dutch artist Salomon Savery commemorating Marie de' Medici's visit to Amsterdam in 1638, on the other (plates 48a,b).[103] Instead of a heavily shaded, *nim qalam*–inspired line, however, this artist has concentrated the delivery of detail into each slender brushstroke. Four delicately drawn avian specimens, with the lines of each feather visible to the naked eye, grace the page. The drawing style and treatment of the feathers resemble the natural history paintings of early seventeenth-century Mughal India, where flora and fauna were expertly recorded. Two of the birds are perched on branches with clearly articulated leaves, and a European cityscape and arched bridge (typical of Mughal painting's interpretation of European landscapes) is visible in the background. The birds were probably drawn from life and can be identified as distinct Eurasian species.[104] Each bird faces in a different direction, with two aligned to a horizontal reading of the page and two to a vertical reading. This page was never conceived as a cohesive composition, but rather as four distinct drawings—an artist's practice sheet useful to perfect form before the inclusion of these birds in other compositions.[105]

As discussed in the previous section, drawing in courtly India was taught through repetition, meaning that the process of developing an artist's skills could temper expressions of his individuality. Identifying the hand of a particular artist is problematic when one considers that artists were often following—and responding to—earlier models. Yet while the trained draftsman is adept at working within the parameters of an accepted regional approach, it is still sometimes possible to see the individual's hand in the work.

Plate 47

Walking Vaishnava Disciples

Rajasthan, Bikaner, late eighteenth century
Brush and black ink and watercolor over traces of charcoal
on beige laid paper
6½ x 3⅝ inches (16.5 x 9.2 cm)
Philadelphia Museum of Art. The Conley Harris and Howard
Truelove Collection of Indian Drawings, 2013-77-5

Plate 48a

Plates 48 a,b

Artist Sheet of Birds and Foliage (a)
Mughal Empire, 1636–37

Detail of *Marie de' Medici's Visit to Amsterdam* (b)
Salomon Savery (Dutch, 1594–1678)
Early seventeenth century

(a) Brush and black and blue inks on beige paper on decorative
mount; (b) etching
Image: (a) 6⁹⁄₁₆ x 10⁷⁄₁₆ inches (16.6 x 26.6 cm); (b) 5¼ x 8⁵⁄₈ inches
(13.3 x 21.8 cm); sheet: 12⁵⁄₁₆ x 17¼ inches (31.3 x 43.8 cm)
Philadelphia Museum of Art. The Conley Harris and Howard
Truelove Collection of Indian Drawings, purchased with the Stella
Kramrisch Fund for Indian and Himalayan Art, 2013-68-16a,b

برزبان تسبیح و در دل کار و خر　　در دهن خسرو بدل یا دِخدا

اچنین تسبیح کی دارد اثر　　اچنین خسری چراه بود درروا

Plate 49

Attributed to Manaku (Indian, active 1730–60)

An Illustration from the Bhagavata Purana

Himachal Pradesh, Guler, c. 1740
Brush and black ink and white opaque watercolor over
charcoal on beige laid paper
8¾ x 13 inches (22.2 x 33 cm)
Philadelphia Museum of Art. The Conley Harris and
Howard Truelove Collection of Indian Drawings, purchased
with the Stella Kramrisch Fund for Indian and Himalayan
Art, 2013-68-9

The artist Manaku, already noted as the maker of *Battle Scene with Demons* (see plate 1), is also responsible for *An Illustration from the Bhagavata Purana* (plate 49), drawn around the same time, in his identifiable hand, and from the same series.[106] As discussed, this series from the *Bhagavata Purana* was an extensive undertaking, several hundred folios in length, with opaque watercolor paintings portraying the narrative in great detail up to the tenth chapter, and a series of drawings continuing to narrate the tale from there.[107] Each painting and drawing is numbered and identified through a brief inscription.

In this composition, a crowned figure is seated to the left, facing five seated male figures, all of whom are both framed and partially hidden by three cusped arches in the foreground. The thinly drawn, confident line warrants an attribution to Manaku, known for creating expressive and individualistic figures with an awareness of naturalism, while still firmly rooted in the Seu family style. Of this family of painters, Manaku is considered the most restrained. Instead of viewing this as a fault, however, we can marvel at what he accomplished with an understated line. The sixth figure in this composition is shown departing the scene; especially characteristic of Manaku's hand is the jaunty forward tilt of the front boss on his pointed crown.[108] The delineation of figures and the compositional format in *An Illustration from the Bhagavata Purana* are identifiers of the broader style of court painting from Guler in the late eighteenth century, while Manaku's unique hand is revealed through the delicate additions and changes to this ascribed form.

Artists in the courtly workshops of India did not labor in isolation, and their products were most often collaborative endeavors. And while artists were often affiliated with a specific workshop for most of their careers, they did have the freedom to move to another setting, bringing their training and expertise with them. This resulted in a dissemination of style throughout a region, blurring boundaries between workshops. A nimble hand is responsible for the delicate, precisely drawn line in *Maharaja Raj Singh of Kishangarh with Two Courtiers* (plate 50), a drawing from the Rajasthani court of Kishangarh attributed to Dalchand (active 1710–60), a Mughal-trained artist who worked for the imperial atelier at Delhi as well as the Jodhpur workshop before his final move east to Kishangarh around 1728. The reasons behind the itinerant nature of his career are unknown, but it is assumed his final move to Kishangarh was to reunite with his aging father, the acclaimed painter Bhavanidas.[109]

Dalchand was a gifted portrait painter who reached his artistic maturity in the 1730s in Kishangarh. His oeuvre includes numerous double portraits in which the sitters are positioned on an outdoor palace terrace. Though they are rather stiff overall, the figures in *Maharaja Raj Singh of Kishangarh with Two Courtiers* benefit from the addition of shading and modeling to accentuate their profiles. For such a lightly drawn work there is a remarkable amount of added detail; the carpet below is heavy with a busy floral pattern, and the court sash (*patka*) worn by the two courtiers is visually described in opulent detail. A sparse application of color—seen on the standing courtiers' lips and Raj Singh's turban ornaments—completes the work. A fully realized painting of a remarkably similar composition (fig. 21) shares the same carpet pattern, as well as the posture of Raj Singh, with sword crossing his lap, and his distinctive turban ornament (*sarpech*) with black feather crest. These formal portraits of the ruler both emphasize kingship and power, and

Plate 50

Attributed to Dalchand (Indian, born c. 1690–95, active c. 1710–60)

Maharaja Raj Singh of Kishangarh with Two Courtiers

Rajasthan, Kishangarh, c. 1730–40
Brush and black ink and watercolor on beige laid paper
7 x 9 inches (17.8 x 22.9 cm)
Philadelphia Museum of Art. The Conley Harris and Howard
Truelove Collection of Indian Drawings, purchased with the Stella
Kramrisch Fund for Indian and Himalayan Art, 2013-68-11

Fig. 21. **Attributed to Nihal Chand (Indian, 1710-1782).**
Maharaja Raj Singh Receiving Fateh Singh. Rajasthan,
Kishangarh, c. 1750. Opaque watercolor and gold on
paper; image: 11¼ x 9 inches (28.6 x 22.9 cm), sheet: 13 x
10½ inches (33 x 26.7 cm). Collection of Eberhard Rist.
Courtesy Bonhams, New York

all the accoutrements of court—dagger, sword, jewels, and bolster—are present, with Raj
Singh slightly elevated relative to his courtiers. Drawings and paintings often reveal more
than workshop practice—subtle clues in their execution can be read to understand the
rules and complexities of the court and the position of the ruler himself.

IDENTIFYING THE POWER OF DRAWING

If drawings can be so broadly defined as to include a quick sketch on reused paper, an
artist's practice sheet, or a work transformed by white wash corrections, how do we posi-
tion precisely drawn, exquisite representations of form? For that, it is useful to return to
the question posed at the beginning of this essay: What is a finished drawing? And, how
and when can a drawing be thus identified? Present-day scholars often see subtle shading
and modeling and the strategic addition of color as hallmarks or indicators of a "finished"
state. Beyond that, distinguishing features such as whether the work is a portrait or genre
scene, a stand-alone work of art or part of a larger series, can vary. What is consistent,
however, is that "finished" drawings rarely contain evidence of workshop process such as
white wash corrections or color notations. Thus, finished drawings are often seen as the
product of a senior artist whose expertly defined line needed no alteration.

With that in mind, a drawing is considered "finished" when the subject is fully real-
ized and the artist's idea of coloration appears complete. The final consideration, however,
relates not to the artistic endeavor, but to its function. A work could meet all the qualifi-
cations of a finished drawing, yet remain in the workshop as a teaching tool, as is assumed
for *The Birth of Krishna* discussed earlier (see plate 5). Or, a drawing could enter a court
library or a patron's holdings, as evidenced by the inscriptions added to works as they

entered the Udaipur royal collection,[110] and seen on the Mughal *Artist Sheet of Birds and Foliage* (see plate 48a). Thus, a new definition of "finished drawing" is needed—one that looks beyond the physical evidence of the artistic process and encompasses a drawing's use within the court hierarchy. Beyond any retrospective judgment of technical completion, *nazar*—the presentation of the work of art to a patron—is integral to distinguishing "finished" from "unfinished."

The practice of gathering works on paper into albums gave many drawings a continued life, often through creating arrangements and juxtapositions the artists could never have anticipated.[111] *Portrait of a Seated Ruler Dressed for Ritual Practice*[112] (plate 51), for example, is framed by a blue floral illuminated border highlighted with gold. This detailed drawing, whose shaded and modeled figure has a strong and dark contour outline, was likely once part of a densely illustrated album. Thoughtfully assembled albums of drawings, paintings, and calligraphy are known to have been created during the Mughal Empire, a practice that was later adopted at the Rajasthani courts. The Persian inscription along the top border of this work identifies the artist,[113] another nod toward the album format, which came originally from Persia. The figure is seated in an archer's pose, raising his right knee and wearing an archer's thumb ring. These attributes, along with his pearl and jeweled necklace, imply a noble birth or high standing, complicating his ascetic attire of simple robes, stretched earlobes, and dreadlocked hair.[114] A drawing that may have been intended to honor the sitter's ascetic practices is distorted by its inclusion in a court album.

The subtle brushstrokes of a workshop-trained artist reveal the style to which a drawing belongs, the practices of the workshop and the court from which it originates, as well as the mood the artist wished to evoke or enhance through its subject matter and composition. A light but steady hand is needed to achieve a lyrical feeling, where expressive outlines and an economy of means combine to great effect. An album page from the Harris-Truelove Collection that exemplifies these qualities is *Krishna Dancing atop Kaliya* (plate 52), where the delicately drawn composition surrounded by a gold speckled border has a presence that cannot be explained through academic means alone. Kaliya, a poisonous, hundred-headed serpent-demon that dwelled in the Yamuna River, is seen here as a dense mass of muscle. The shading on the demon creates roundness and the impression of depth, his form dominating the pictorial space and in turn foregrounding the presence of the two main figures. Krishna's body is in motion, with arms raised and legs braced for the impact of the writhing demon's movements. Six *naginis*—Kaliya's part-human, part-snake wives—beseech Krishna to spare their demon husband. The three *naginis* to the left hold lotus flowers; on the right, one holds a lotus, one tugs on Krishna's shawl, and the third holds out her hands in a combination of reverence and pleading. Little definition is given to their facial features, but their voluptuous forms and delicately shaded breasts give them a captivating depth and presence. This episode in the life of Krishna, taken from the Tenth Book of the *Bhagavata Purana*, is one of the most commonly depicted scenes from this narrative and would have been instantly recognizable to contemporary viewers. The action is suspended at the pivotal moment of the battle—and though Krishna will undoubtedly emerge victorious, the power of the demon has yet to be quelled.[115]

عل فيبر امر انكام

Plate 51

Portrait of a Seated Ruler Dressed for Ritual Practice

Rajasthan, Kishangarh, c. 1740
Brush and black ink and watercolor over charcoal with
corrections by the artist in white opaque watercolor on
beige laid paper on decorative mount
Image: 6 x 4 inches (15.2 x 10.2 cm), sheet: 8 x 6 inches
(20.3 x 15.2 cm)
Philadelphia Museum of Art. The Conley Harris and
Howard Truelove Collection of Indian Drawings, 2013-77-25

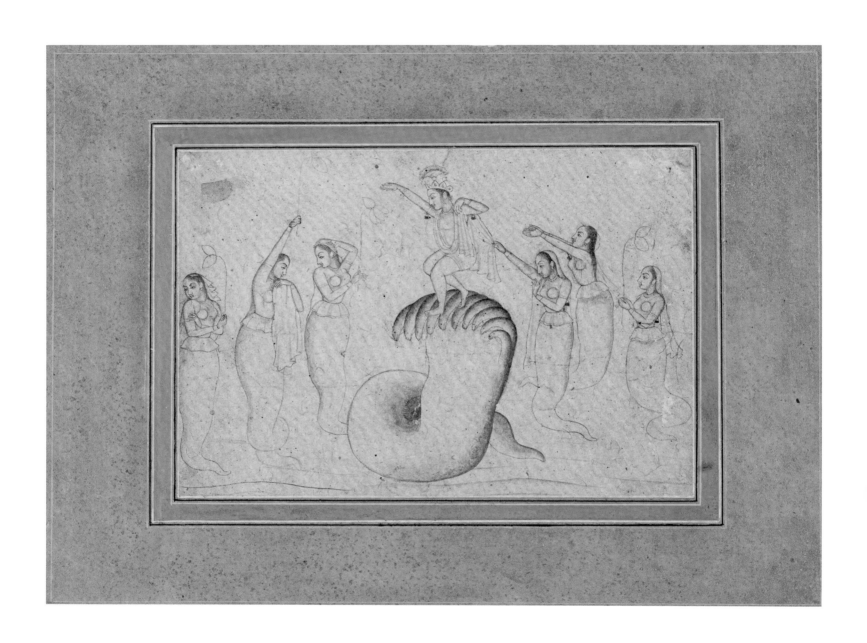

Plate 52

Krishna Dancing atop Kaliya

From the *Bhagavata Purana*
Rajasthan, Bikaner, c. 1770–1800
Brush and black ink with touches of red ink over traces of
charcoal on beige paper on decorative mount with gold flecks
Image: 4⅛ x 5¾ inches (10.5 x 14.6 cm), sheet: 6¹¹⁄₁₆ x 8¹⁵⁄₁₆ inches
(16.9 x 22.6 cm)
Philadelphia Museum of Art. The Conley Harris and Howard
Truelove Collection of Indian Drawings, 2013-77-23

By referencing the larger narrative but suspending the action in this crucial moment, the drawing offers us more than the sum of its parts.

The process of art making in courtly India was a complex endeavor, encompassing many phases. Working within the intricate, hierarchical workshop structure with custom-made materials, individual artists set brush to paper to conceive and create powerful, expressive images that served a variety of functions. Drawings were preparatory materials and educational tools—of course—but also, and more importantly, they were and are works of art. A brushstroke can convey a wide range of expression, as the trained artist's thoughtful application of line allows charcoal, ink, or watercolor to be wielded with restraint, with vigor, or with willful abandon. At their core, drawings reduce form to its very essence, allowing the slightest manipulation of line to carry significance and meaning. Drawings are subtle, but not simple.

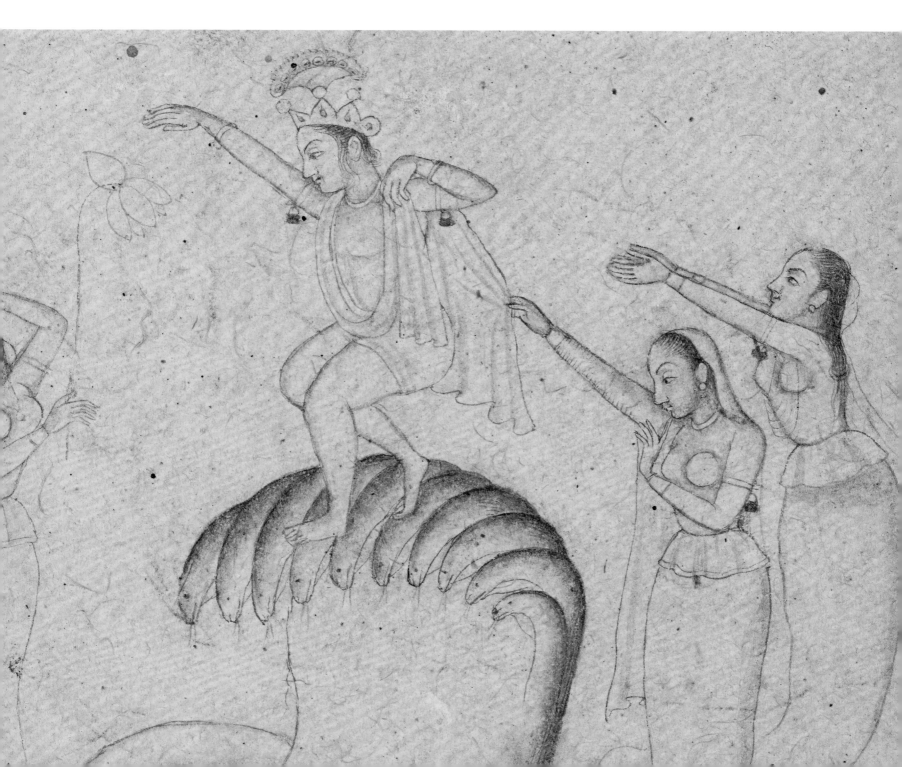

NOTES

The Artists' Workshop

1. The Conley Harris and Howard Truelove Collection of Indian Drawings is weighted toward works from the Pahari region and Rajasthan, a result of both the personal taste of the collectors and the availability of works on the art market. The collection includes eighteen works from the Pahari region (attributed as seven from Kangra; six from Guler; three from Chamba; and one each from Jammu, Mandi, and the Sikh courts of the Punjab region), forty-three from the various kingdoms of Rajasthan (eleven from Kota; eight from Bikaner; eight from Bundi; six from Kishangarh; three from Sawar; two from Udaipur; two from Jodhpur; and one each from Jaipur and Nathdwara), as well as one work attributed to the late Mughal court of Farrukhabad, one to the imperial Mughal court, and two to the Deccan region.

2. The most detailed investigation of this *Bhagavata Purana* series is B. N. Goswamy and Eberhard Fischer, *Pahari Masters: Court Painters of Northern India* (Zurich: Artibus Asiae; Museum Rietberg, 1992). The authors estimated that there were nearly a thousand paintings and drawings in the series and included a partial list of public collections with such works (p. 245); see pp. 258–63, especially cats. 109, 110. However, the estimated number of folios was reduced to several hundred in B. N. Goswamy and Caron Smith, *Domains of Wonder: Selected Masterworks of Indian Painting*, exh. cat. (San Diego: San Diego Museum of Art, 2005), p. 216. This series, particularly the drawings, is widely dispersed in public and private collections around the world, including four folios in the Jagdish and Kamla Mittal Museum of Indian Art, Hyderabad. Two of the masterful drawings in the Mittal Museum depict the progression of the same battle between gods and demons as seen in plate 1; see John William Seyller and Jagdish Mittal, *Pahari Drawings in the Jagdish and Kamla Mittal Museum of Indian Art* (Hyderabad: Jagdish and Kamla Mittal Museum of Indian Art, 2013), cats. 13, 14.

3. See Goswamy and Fischer, *Pahari Masters*, pp. 211–365; B. N. Goswamy, *Nainsukh of Guler: A Great Indian Painter from a Small Hill-State* (Zurich: Artibus Asiae; Museum Rietberg, 1997); Joan Cummins, *Indian Painting: From Cave Temples to the Colonial Period* (Boston: MFA Publications, 2006), pp. 182–93; B. N. Goswamy and Eberhard Fischer, "Manaku," "Nainsukh of Guler," and "The First Generation after Manaku and Nainsukh of Guler," in *Masters of Indian Painting*, ed. Milo C. Beach, Eberhard Fischer, and B. N. Goswamy, 2 vols. (Zurich: Artibus Asiae, 2011), vol. 1, pp. 641–718; Mary Brockington and John Brockington, "Manaku's Siege of Lanka Series: Words and Pictures," *Artibus Asiae* 73, no. 1 (2013), pp. 231–40; Seyller and Mittal, *Pahari Drawings*, pp. 35–99.

4. Goswamy and Fischer, "Manaku," p. 653, assume that Manaku worked ahead of the rest of the workshop in creating these, while the other artists created finished paintings.

5. Coomaraswamy uses this poetic analogy for the painting process during his discussion of several ancient texts on art production, namely the seventh-century *Vishnudharmottara*, the twelfth-century *Abhilasitarthacintamani*, and the sixteenth-century *Shilparatna*. He goes on to compare the reflective process of painting to that of worshiping the lingam, the phallic form of Shiva. The lingam is the aniconic form of the god—recognizable but not representational of his human form, and therefore considered "shown-unshown." Worship of the god in this intervening state can therefore be seen as a blossoming of form. See Ananda K. Coomaraswamy, "The Technique and Theory of Indian Painting," *Technical Studies in the Field of Fine Arts* 3, no. 2 (1934), pp. 74–75n16. Joan Cummins also mentions the *Vishnudharmottara*, in which the subtlety of line used to evoke form is highly valued as a painting technique, as well as other texts that contain instructions on how to represent the Hindu pantheon—including lists of attributes, but also guidelines for body proportions and demeanor. Such instructions were likely followed more closely by sculptors of temple icons than by later artists working on paper. See Cummins, "Appendix," in Amy G. Poster, *Realms of Heroism: Indian Paintings at the Brooklyn Museum* (New York: Hudson Hills, 1994), p. 309; Cummins, *Indian Painting*, p. 213.

6. Further examples of Pahari drawings suspended in this blossoming stage can be found in the Museum of Fine Arts, Boston (15.65 and Ross-Coomaraswamy Collection 17.2434, 17.2438, 17.2442, 17.2444, 17.2611, 17.2613, 17.2618, and 17.2619). One of these examples, *Krishna Fluting*, drawn in Kangra about 1825 (17.2619), is particularly striking for its use of gold to signify the brightly lit sky of the setting sun, and the dense green pigments coloring the cluster of trees behind the unpainted figures.

7. For a translation of Akbar's chronicles, see Abu al-Fadl `Allami, *The A'in-i Akbari*, vol. 1, trans. Henry Blochmann (New Delhi: Oriental Books Reprints Corp., 1977); for those of his son, see *The Jahangirnama: Memoirs of Jahangir, Emperor of India*, trans. Wheeler M. Thackston (New York: Oxford University Press, 1999). The French jeweler François Bernier visited the Mughal court and recorded the workshop system; see Bernier, *Travels in the Mogul Empire, A.D. 1656–1668*, trans. Archibald Constable (Westminster, England: A. Constable, 1891). For thoughtful discussion on the imperial atelier, see John Seyller, *Workshop and Patron in Mughal India: The Freer Ramayana and Other Illustrated Manuscripts of `Abd al-Rahim* (Zurich: Artibus Asiae, 1999); Susan Stronge, *Painting for the Mughal Emperor: The Art of the Book, 1560–1660* (London: V&A Publications, 2002).

8. *Kitab-khana* is generally translated as "library," yet implicit in that definition is the notion of the patron's personal collection. From the fifteenth century on the term has been used to signify a place where books are made as well as stored; according to Marianna Shreve Simpson, it can also be used to describe an atelier; see Simpson, "The Making of Manuscripts and the Workings of the Kitab-khana in Safavid Iran," in *The Artist's Workshop*, ed. Peter M. Lukehart (Hanover, NH: University Press of New England, 1993), p. 105.

9. Those responsible for creating the materials were also present, including pigment-makers and goldsmiths. Yet even with this pronounced bureaucratic system, artists retained the freedom to accept commissions from various patrons within the Safavid royal family, from other workshops, and from other nobles at the court. While the artist retained a certain amount of freedom and the workshop functioned as an independent entity, it remained part of the patron's personal property. The establishment of a workshop was born of an individual patron's initiative, and it did not pass automatically from "father to son or ruler to heir." See Simpson, "Making of Manuscripts," p. 111, for an in-depth look at the Safavid workshop system.

10. Milo Cleveland Beach. "Mansur," in Beach, Fischer, and Goswamy, *Masters of Indian Painting*, vol. 1, pp. 243–58.

11. Almost all of the Rajasthani courts kept meticulous records of purchases, commissions, and gifts, which were bound in registers called *bahis*. This format of record-keeping most likely came to Rajasthan by way of the Mughals; paintings were the most closely documented art form, and the only instance where the names of the artisans were often recorded. See Rosemary Crill, "Patronage at Court," in *Maharaja: The Splendour of India's Royal Courts*, ed. Anna Jackson and Amin Jaffer, exh. cat. (London: V&A Publishing, 2009), pp. 142–43.

12. David J. Roxburgh, "Persian Drawings, ca. 1400–1450: Materials and Creative Procedures," *Muqarnas: An Annual on the Visual Culture of the Islamic World* 19 (2002), p. 44.

13. Four other figures to the right of the central couple have been colored over with a pink pigment, presumably to be redrawn.

14. This typical Bikaner green hue is likely made from the mineral malachite, a basic copper carbonate ground, and levigated to produce the pigment. The cracks and breaks in the paper support seen in the green painted area of this drawing are consistent with the degradation of malachite in paper supports when works are stored at elevated temperatures and humidity. Thanks are due to Rebecca Pollak, Mellon Fellow in Paper Conservation at the Philadelphia Museum of Art, for her time and expertise in pigment analysis—here and throughout this book.

15. It is noteworthy that the birth of Krishna is here being treated as a celebration, as opposed to a secret that requires the infant to be whisked away for his safety. The scene could be interpreted as Nanda giving presents to the rejoicing villagers of Gokul after the baby Krishna has been exchanged for Yashoda's child and is being nursed by his foster mother on the right; however, it is equally likely that the artists of this Pahari workshop elevated the villagers to royal status to mark the occasion. The National Museum of India, New Delhi, has an opaque watercolor version of this scene that is similar in composition; see W. G. Archer, *Indian Paintings from the Punjab Hills: A Survey and History of Pahari Painting* (London: Sotheby Parke Bernet, 1973), vol. 2, p. 210; Karl J. Khandalavala, *Pahari Miniature Painting* (Bombay: New Book Co., 1958), no. 235. For a discussion of this series, see Archer, *Indian Paintings*, vol. 1, pp. 293–95; for illustrations, see ibid., vol. 2, pp. 210–12. Another representation of Krishna's early years from this same series is seen in *Nanda and His Kinsmen Camping on a River Bank* (Guler, c. 1780–85), a drawing in the Government Museum and Art Gallery, Chandigarh, India. See Goswamy and Fischer, *Pahari Masters*, cat. 139, for a reproduction. Here, however, the figures have traded the shelter of palace terraces for tents.

16. This notion was suggested by Joan Cummins in a thoughtful discussion of drawing. See Cummins, "Appendix," p. 307.

17. Many scholars of Rajasthani and Pahari painting have looked to the region's contemporary workshops to illuminate past practice. This is problematic as it implies a strict continuation of tradition, with little innovation in the last hundred years. Tryna Lyons addressed this issue in her study of twentieth-century Nathdwara workshops, recording the artists' reflections without assuming that past workshops strictly adhered to contemporary practice. See Lyons, *The Artists of Nathadwara: The Practice of Painting in Rajasthan* (Bloomington: Indiana University Press; Ahmedabad, India: Mapin, 2004), esp. p. 101.

18. Ibid., pp. 128–33. The sketchbooks Lyons saw also contained pasted-in images of inspiration to the artist, including excerpts of other designs, prints, and found objects. Anything that appealed, without reference to the original context, was reserved for future artistic ideas.

19. Ibid., p. 97. Lyons also writes of games played among artists in which blindfolds and timed exercises were deployed as fun and creative ways to produce drawings.

Paper, Ink, and Brush

20. Wood pulp was not used extensively in creating paper until after 1870.

21. For a fascinating and comprehensive study on the history of paper, from its origins in China a century or two before the Christian Era to its adoption in Central Asia as early as the eighth century and its spread to India as well as to Europe through Spain in the eleventh century, see Jonathan M. Bloom, *Paper before Print: The History and Impact of Paper in the Islamic World* (New Haven: Yale University Press, 2001). Earlier publications dedicated to the history and development of paper that are useful to consult include Albertine Gaur, *Writing Materials of the East* (London: The British Library, 1979); Nigel Macfarlane, *Handmade Papers of India* (Winchester, England: Alembic Press, 1987); and Neeta Premchand, *Off the Deckle Edge: A Paper-Making Journey through India* (Bombay: Ankur Project, 1995).

22. Extant writing in India on leaves, wooden boards, and other materials dates to the second half of the third millennium BC. While the earliest recorded use of paper in India dates to the eleventh century, evidence of papermaking doesn't surface until the fifteenth century, when a Kashmiri ruler, returning from Samarkand, brought with him artisans to establish a papermaking industry. Bloom suggests that the long delay in instituting local manufacture may have been due to the hot and humid climate, which was and is unsuitable for preserving paper, and would have been a disincentive to adopting this new material for use in an established craft. See Bloom, *Paper before Print*, pp. 41–42. Later papermaking centers in India included Multan, Rawalpindi, Lahore, and Delhi in the north, as well as Ahmedabad, Surat, Dharwar, and Aurangabad in the west.

23. Evidence suggests that paper created in the artistic workshops of the Pahari region, in the foothills of the Himalayas, developed tangentially to the rest of India. The *Daphne cannabina*, a plant found high in the hills

and exported only as far as Tibet, was the primary material used in a mixture of several plants, possibly inspired by its use in China around the fourteenth century. See George Watt, Edgar Thurston, and T. N. Mukharji, *A Dictionary of the Economic Products of India*, vol. 3, *Dacrydium to Gordonia* (Calcutta: Superintendent of Government Printing; London: W. H. Allen, 1889), p. 22; Moti Chandra, *Technique of Mughal Painting* (Lucknow: U. P. Historical Society, 1949), p. 7; Macfarlane, *Handmade Papers of India*, pp. 1–11.

24. The script has been tentatively identified as Lahnda, or Western Punjabi. Shana Dumont and Supriya Gandhi, *Stages of Depiction: Indian Drawings, 17th–19th Centuries*, exh. cat. (Cambridge, MA: Hurst Gallery, 2006), p. 32.

25. Craigen W. Bowen with Amy Snodgrass, "Line and Color: Painting Materials and Techniques in Kotah," in *Gods, Kings, and Tigers: The Art of Kotah*, ed. Stuart Cary Welch (Munich: Prestel, 1997), p. 85.

26. An attempt has been made throughout this work not to rely on the terms *recto* and *verso* as these workshop-based drawings often include a variety of sketches and it is difficult to determine which was prioritized.

27. On the Kota workshop, see W. G. Archer, *Indian Painting in Bundi and Kotah* (London: Her Majesty's Stationery Office, 1959); Welch, *Gods, Kings, and Tigers*; Milo Cleveland Beach, *Rajput Painting at Bundi and Kota* (Zurich: Artibus Asiae, 1974); Milo Cleveland Beach, "Masters of Early Kota Painting," in Beach, Fischer, and Goswamy, *Masters of Indian Painting*, vol. 2, pp. 459–78.

28. Images of Kota rulers at worship with Srinathji are common and follow the compositional format lightly sketched here. The ruler would be in attendance to the left, with a priest to the right of the central deity. For details, see Welch, *Gods, Kings, and Tigers*, pp. 184–201, as well as the discussion of Srinathji on p. 86 of this volume.

29. This is likely to be a depiction of "Dhola Maru," a love story most typically associated with the neighboring court of Marwar, where the hero and heroine escape from harm's way riding atop a camel.

30. I thank J. P. Losty for helping to date this figure through analysis of his uniform.

31. Andrew Topsfield, "Ketelaar's Embassy and the Farangi Theme in the Art of Udaipur," *Oriental Art*, n.s., 30, no. 4 (Winter 1984–85), pp. 350–67.

32. Several drawings similar in subject matter and format to *A European Concoction* are found in other collections (e.g., The British Museum, London, 1955,1008,.21) or have recently appeared on the art market, including the near-identical painting *Fools: Europeans Seated on a Carpet*; see Christie's New York, *The Doris Wiener Collection* (New York: Christie's, 2012), lot 221. Three further comparable drawings were included in the same sale (lots 222–24). John Seyller offers an interesting reading of this work in Darielle Mason et al., *Intimate Worlds: Indian Paintings from the Alvin O. Bellak Collection*, exh. cat. (Philadelphia: Philadelphia Museum of Art, 2001), pp. 154–55. As Seyller notes, sources may have included the satirical engravings of the English artist William Hogarth, which have been distorted in their reinterpretation by the Udaipur workshop. See

Mason et al., *Intimate Worlds*, p. 154. See also Christie's New York, *The Doris Wiener Collection*, which builds on Seyller's European attribution and includes a reproduction of a sixteenth-century Flemish painting (location unknown) attributed to Pieter Balten (c. 1526/28–before 1584), *Rebus: The World Feeds Many Fools*, c. 1600, that may have contributed to this iconography. The two figures in the drawing who are clustered closely together with hands held near their noses are reminiscent of this Flemish work.

33. Topsfield, "Ketelaar's Embassy," p. 363. The foreigner (*farangi*) theme, while short-lived, was strong enough to warrant its own designation in the Udaipur paintings inventory. See also Ainsley M. Cameron, "Evidence of an Artist" (unpublished paper, 2013), for another example at the Mewar court where the *farangi* theme is useful for dating Udaipur works.

34. Sectarian markings in ash or red powder on the forehead of a devotee often denote allegiance to a particular god. Those devoted to Shiva often have half-oval markings like those seen here, while followers of Vishnu often have perpendicular lines.

35. The black-gray particulate material is similar to charcoal, but shares attributes with black chalk. It is best described by Craigen W. Bowen, "Close Looking: Notes on Media and Technique," in *From Mind, Heart, and Hand: Persian, Turkish, and Indian Drawings from the Stuart Cary Welch Collection*, ed. Stuart Cary Welch and Kim Masteller, exh. cat. (New Haven: Yale University Press; Cambridge, MA: Harvard University Art Museums, 2004), pp. 32–34.

36. Another drawing that embodies this gestural quality is *The Gopis Beseech Krishna to Return Their Clothes* (Museum of Fine Arts, Boston, Ross-Coomaraswamy Collection, 17.2451), where the *gopis* surge forward toward Krishna.

37. The *Shilparatna* explores production in both the visual and the performing arts. See Coomaraswamy, "Technique and Theory of Indian Painting," pp. 62–70. In the Persian tradition, both a brush and a reed pen were used, often in the same drawing. Particular line qualities were easier to make with one tool or the other. An extended line, for example, would be easier to maintain (both in width and ink density) with a reed pen. With shorter lines, a brush offers fluctuations between thinning and thickening lines, as well as variations in tonal range. See Roxburgh, "Persian Drawings," p. 50.

38. Bowen with Snodgrass, "Line and Color," p. 84.

39. For other examples from the series, see Georgette Boner, Eberhard Fischer, and B. N. Goswamy, *Sammlung Alice Boner: Geschenk an das Museum Rietberg Zurich: illustriertes Gesamtverzeichnis indischer Bilder* (Zurich: Museum Rietberg, 1994), nos. 390–96; Sotheby's London, *The Stuart Cary Welch Collection*, part 2: *Arts of India* (London: Sotheby's, 2011), cat. 64. A drawing that may be from the same series, formerly in the Pan-Asian Collection, was sold at Sotheby's London (June 20, 1983, lot 125). A later drawing (c. 1825) in the Museum of Fine Arts, Boston (Ross-Coomaraswamy Collection, 17.2592) shares subject matter and compositional format with *The Gods Plead with the Goddess Durga for Help* (see plate 12).

40. Further comparisons can be made with a work dated to about 1760 from Guler, now in the Victoria and Albert Museum, London (IS. 170-1953), which shows Durga and Shumbha battling, with the demon riding a horse-drawn chariot.

41. Various red ochres and iron oxide reds were used in the court workshops, including venetian (or "brick") red and a darker purple-red that most likely derives from hematite. These materials were often mixed with white lead and vermilion to make an opaque, cooler red. The red pigment preferred by the artists of the Kota workshop is likely a mix of organic red, lead white, hematite, and other pigments. Thanks again to Rebecca Pollak for illuminating discussions on pigments.

42. For an interesting comparison in subject matter, see a similar composition, most likely from the nearby court of Kangra, and now in the British Museum, London (1914,0217,0.11).

43. For an interesting discussion of this work, see Mason et al., *Intimate Worlds*, p. 198. Another painting, clearly from the same series, is in the collection of Paul Walter and is discussed in Pratapaditya Pal, *Dancing to the Flute: Music and Dance in Indian Art*, exh. cat. (Sydney: Art Gallery of New South Wales, 1997), frontispiece; p. 58, no. 14 (detail).

44. Another comparable practice sheet in the Museum of Fine Arts, Boston (15.90), has fifteen figures, mainly bearded and mustachioed, sporting a variety of turbans. Three colored turbans are also included, strangely suspended on the page without being attached to a particular portrait.

45. In Nathdwara, the form of Krishna depicted was Srinathji; in Kota, it was often Brijnath. For an interesting discussion of worship at the court, see Norbert Peabody, "The King Is Dead, Long Live the King! Karmic Kin(g)ship in Kotah," in Welch, *Gods, Kings, and Tigers*, pp. 73–82.

46. For more information on the depiction of women in Rajasthani painting, see Ainsley M. Cameron, "Painting at Devgarh: Three Generations of an Artist Family, an Exploration of Style (1756–1850)" (PhD diss., Oxford University, 2010), chap. 5; Molly Emma Aitken, "Spectatorship and Femininity in Kangra Style Painting," in *Representing the Body: Gender Issues in Indian Art*, ed. Vidya Dehejia (New Delhi: Kali for women in association with the Book Review Literary Trust, 1997), pp. 82–101; Molly Emma Aitken, "Pardah and Portrayal: Rajput Women as Subjects, Patrons and Collectors," *Artibus Asiae* 62, no. 2 (2002), pp. 247–80.

47. A comparable bust portrait of a late Mughal courtier, possibly Mitra Sen, at the Museum of Fine Arts, Boston (15.100), was also likely drawn from life. His delicately shaded features and lightly colored turban create a highly expressive composition.

Realms of Color

48. Stuart Cary Welch, *Indian Drawings and Painted Sketches: 16th through 19th Centuries*, exh. cat. (New York: Asia Society, 1976), p. 13. See also Stuart Cary Welch and Mark Zebrowski, *A Flower from Every Meadow*, exh. cat. (New York: Asia Society, 1973); Welch and Masteller, *From Mind, Heart, and Hand*.

49. Interesting comparisons include *Radha and Krishna Shelter from the Rain* in the Museum of Fine Arts, Boston (17.2445), which combines a very delicate depiction of Radha and Krishna in a thin red line with the oval compositional format popular in Kangra around 1820; and a drawing of Krishna in the collection of Subhash Kapoor, which has one long profile line from forehead to tip of nose, a thick bicep culminating in a thin bent wrist, and a crown with a tied textile worn like a turban beneath it (see Aaron M. Freedman, *Mala ke Manke: 108 Indian Drawings from the Private Collection of Subhash Kapoor* [New York: Art of the Past, 2003], cat. 99). The *gopi* facing Krishna in the Philadelphia drawing also resonates with Radha in Kapoor's drawing; they have a similar thick nose, short chin, and softer, less angular profile than the typical Kangra female type. *Krishna's Favorite Reaches for Him But He Has Vanished*, a late eighteenth-century drawing from Kangra in the Museum of Fine Arts, Boston (Ross-Coomaraswamy Collection, 17.2448), also includes boughs heavy with expectation, as in the Harris-Truelove drawing.

50. This female figure may or may not be intended as Radha.

51. For detailed analyses of pigments and their properties, see Chandra, *Technique of Mughal Painting*, pp. 18–34; Cummins, *Indian Painting*, p. 215; Desmond Peter Lazaro, *Materials, Methods, and Symbolism in the Pichhvai Painting Tradition of Rajasthan* (London: Art Books International, 2005); Shanane Davis, *The Bikaner School: Usta Artisans and Their Heritage* (New Delhi: RMG Exports, 2008), chap. 2.

52. For comparable works on paper from Jodhpur, see Rosemary Crill, *Marwar Painting: A History of the Jodhpur Style* (Mumbai: India Book House in association with Mehrangarh Publishers, 2000); Debra Diamond, Catherine Glynn, and Karni Singh Jasol, *Garden and Cosmos: The Royal Paintings of Jodhpur*, exh. cat. (Washington, DC: Arthur M. Sackler Gallery, Smithsonian Institution, 2008). For images of the Nagaur Fort, see Y. K. Shukla, *Wall Paintings of Rajasthan* (Ahmedabad: L.D. Institute of Indology, 1980), pp. 14–20; Mira Seth, *Indian Painting: The Great Mural Tradition* (New York: Abrams, 2006); Mira Seth, *Wall Paintings of Rajasthan* (New Delhi: National Museum, 2003).

53. For a discussion of the itinerant artists traveling to Marwar in the eighteenth century, see Crill, *Marwar Painting*, pp. 56–115.

54. Malini Roy, "Some Unexpected Sources for Paintings by the Artist Mihr Chand (fl. c. 1759–86), Son of Ganga Ram," *South Asian Studies* 26, no. 1 (March 2010), p. 21.

55. For a succinct biography of Richard Johnson, see Toby Falk and Mildred Archer, *Indian Miniatures in the India Office Library* (London: Sotheby Parke Bernet, 1981), pp. 14–29.

56. See J. P. Losty, "Towards a New Naturalism: Portraiture in Murshidabad and Avadh, 1750–80," in *After the Great Mughal*, ed. Barbara Schmitz (Mumbai: Marg Publications, 2002), pp. 34–35; J. P. Losty and Malini Roy, *Mughal India: Art, Culture and Empire* (London: The British Library, 2012), p. 163n43; J. P. Losty, "Indian Painting from 1730–1825," in Beach, Goswamy, and Fischer, *Masters of Indian Painting*, vol. 2, pp. 580n17, 582. For Polier's papers, see Muzaffar Alam and Seema Alazi, eds., *A European Experience of the Mughal Orient: The I'jaz-I*

Arsalani (Persian Letters, 1773–1779) of Antoine-Louis Henri Polier (New Delhi: Oxford University Press, 2001).

57. I thank Dr. Malini Roy of the British Library for bringing this work to my attention. Further research on this dispersed album is ongoing.

58. Thanks again to Rebecca Pollak for her expertise in identifying pigments.

59. See Chandra, *Technique of Mughal Painting*, pp. 18–34. Even though the highest quality cinnabar was available from China and Iran was rich in sulfide ores—both of which could have satisfied the demand for vermilion—the pigments necessary to make this peach-colored hue were imported from Europe. Another work in the Harris-Truelove Collection that displays this later addition of color is *Female Attendants Preparing the Lover's Room* (see Checklist no. 25 in this volume), a scene from the *Rasamanjari*. Copious amounts of color, in unusual hues derived from inventive combinations of materials, were added much later to this darkly shaded work from Bundi, dated to around 1770–1800. While this could be an example of extended workshop practice, it is more likely that someone added color to an earlier drawing in an effort to increase its value when it emerged on the art market.

60. Welch and Masteller, *From Mind, Heart, and Hand*, cat. 65, p. 186. Kishangarh is also known for its satirical sketches and portrait studies; however, this does not seem to be drawn in jest. See Navina Haidar, "Satire and Humour in Kishangarh Painting," in *Court Painting in Rajasthan*, ed. Andrew Topsfield (Mumbai: Marg Publications, 2000), pp. 78–91. See also Ellen Smart's entry on *Swami Hanuhaak* in Mason et al., *Intimate Worlds*, cat. 46, p. 122. A parallel tradition of depicting holy figures existed at the Mughal court, where the seventeenth-century drawing *Portrait of Maulvi Rumi*, now in the Museum of Fine Arts, Boston (14.664), includes compositional elements similar to those in *A Shaivite Ascetic*. The figures in both drawings are shown with a supporting stick, indicating their proclivity for meditation, while the ascetic's begging bowl in the Harris-Truelove drawing is replaced in the Boston drawing by a book, likely an indicator of Maulvi Rumi's status as a mystic poet. Further comparisons abound, including *Portrait of a Seated Man* from Rajasthan or the Pahari region, also at the Museum of Fine Arts, Boston (15.103).

61. Dumont and Gandhi, *Stages of Depiction*, p. 18.

62. This purple paint is likely a mixture of several minerals; it appears to include organic red, but could also contain mineral pigments such as vermilion, lead white, red lead toned down with ultramarine/indigo, and a little charcoal.

63. Numerous illustrated copies of the *Devi Mahatmya*, mostly derived from the *Markandeya Purana*, are associated with the Guler workshop. Six folios from a comparable series are in the Jagdish and Kamla Mittal Museum of Indian Art, Hyderabad, India, including *The Devi, Kali, and the Matrikas Slay the Demon Nishumbha and Rout His Army* (76.745 DR. 180), a similar composition to the Harris-Truelove drawing. This series, while smaller than any other known painted version, is an accomplished set of drawings and is assumed to be the model for any series dated 1781 and later. See Seyller and Mittal, *Pahari Drawings*, cats. 23–28. Further com-

parable drawings from a variety of sets are found in the collection of Subhash Kapoor (see Freedman, *Mala ke Manke*, cats. 14, 15) and in the collections of the Los Angeles County Museum of Art (m.72.83.3), the Museum of Fine Arts, Boston (Ross-Coomaraswamy Collection, 17.2588 and 17.2589), and the Government Museum and Art Gallery, Chandigarh, India. The Harris-Truelove drawing is number forty-four of an as-yet-unidentified set; further research should reveal related works from this manuscript copy, whether as paintings or drawings.

64. The more common set is seven figures, but at times throughout history an eighth, usually Narasimhi, was added.

65. The oversized floral and avian patterning at the top of the page was likely a design for a textile or piece of metalwork and is unrelated to the figures.

66. Roxburgh, "Persian Drawings," p. 49. According to Roxburgh, the use of white pigment to correct lines is very rare in Persian drawings, with the earliest known example dating to the seventeenth century.

67. While not expanding on the comment, Seyller and Mittal (*Pahari Drawings*, cat. 89, p. 229) touch on "a concern with verisimilitude" in relation to a portrait from Chamba of *Raja Umed Singh of Chamba Smoking a Hookah* (c. 1750–55; Jagdish and Kamla Mittal Museum of Indian Art, Hyderabad, India, 86.813 DR. 248). The artists of the *Padshahnama* (History of the Emperor Shah Jahan) were equally concerned with authentic representation, as well as with historical accuracy in large *darbar* scenes (see, e.g., fig. 14 in this volume). See Losty and Roy, *Mughal India*, p. 139, for a short discussion on preparatory drawings related to this manuscript.

68. This added coat of white primer was most commonly used at the Mughal court and the North Indian workshops that were heavily influenced by Mughal practice. A group of drawings from a *Nala Damayanti* series from Kangra, dated to about 1790–1800, include this white primer stage (Museum of Fine Arts, Boston, 17.2394–17.2433); within the series, several drawings with white primer also have the border clearly articulated (see 17.2394–17.2396 and 17.2399 for examples), as in the Harris-Truelove drawing from Chamba.

69. A stylistic comparison between the cloud-like trees visible here and those in *The Battle between the Demon and the Monkey Armies* (see plate 32) strengthens this attribution to the small court of Chamba.

70. Written color notations are included on two drawings in the Harris-Truelove Collection discussed elsewhere in this book; see plates 7 and 42. The luxuriously drawn *Damayanti Dispatches the Stork to Nala* in the Museum of Fine Arts, Boston (Ross-Coomaraswamy Collection, 17.2449), also includes such notations. Another drawing in the Museum of Fine Arts, Boston, *Equestrian Portrait of a Sikh Ruler* (17.2699), includes both color and written notations, a rare occurrence. When such notes are lacking, the colorist was likely following oral instructions. See John Seyller, *Pearls of the Parrot of India: The Walters Art Museum Khamsa of Amir Khusraw of Delhi*, exh. cat. (Baltimore: Walters Art Museum, 2001), pp. 112–13.

Reuse, Repetition, and Reinvention

71. Jean C. Wilson, "Workshop Patterns and the Production of Paintings in Sixteenth-Century Bruges," *Burlington Magazine* 132, no. 1049 (August 1990), p. 527. Molly Aitken develops a similar argument in her discussion of the many visual manifestations of Layla and Majnun through Mughal and Rajasthani painting: "To dismiss such paintings is to presume that they constituted a shortcut, an efficient manner of accomplishing a narrative brief that involved as little thought as possible on the part of the artist. The objection to repetition falters, however, if repetition is itself found to be meaningful." See Molly Emma Aitken, *The Intelligence of Tradition in Rajput Court Painting* (New Haven: Yale University Press, 2010), p. 155.

72. "Puzzle pictures" refer to images in which several animal forms are joined, allowing multiple forms to appear: a horse with a few added lines quadruples its form, and an elephant and bull share the same brushstroke.

73. This series was densely illustrated, with surviving pages in many public and private collections, most of which include a similar numbering system and identifying inscriptions along the upper border of a standard-size page. Six folios are in the collection of the Jagdish and Kamla Mittal Museum of Indian Art (see Seyller and Mittal, *Pahari Drawings*, cats. 74–79), and two reside in the Brooklyn Museum (81.188.8 and 80.261.24; the latter Brooklyn drawing is likely to be the next folio in the series after the Philadelphia drawing). Two further drawings were sold as a lot at Sotheby's London; see *The Stuart Cary Welch Collection*, part 2, *Arts of India* (London: Sotheby's, 2011), lot 63. Other drawings from this series are reportedly in the Bharat Kala Bhavan Museum, Varanasi; the Salar Jung Museum, Hyderabad; the Andhra Pradesh State Museum, Hyderabad; the Bhuri Singh Museum, Chamba; the Los Angeles County Museum of Art; the Minneapolis Institute of Art; the Berkeley Art Museum; the Rhode Island School of Design Museum, Providence; the Fralin Art Museum, University of Virginia, Charlotte; the Museum Rietberg, Zurich; and the Israel Museum, Jerusalem. According to Seyller, this series, unlike many others that include a combination of drawings and completed paintings, was never meant to be painted; rather, the "drawings in this series recorded the master artist's composition and inventive passages." See Seyller and Mittal, *Pahari Drawings*, pp. 195–207.

74. The concept of a "busy workshop" is effectively examined by Susie Nash in her discussion of the mass production of illuminated manuscripts in commercial workshops in fifteenth-century France. The use of repeated patterns was deemed essential for production to meet demand; however, there were "artistic consequences" to this practice, which resulted in a stagnation of the repeated form. See Susie Nash, "Imitation, Invention or Good Business Sense? The Use of Drawings in a Group of Fifteenth-Century French Books of Hours," in *Drawing 1400–1600: Invention and Innovation*, ed. Stuart Currie (Aldershot, England: Ashgate, 1998), pp. 13–18.

75. I thank Dr. Malini Roy for the identification of Samsam ud-Daula Khan and for discussing the courtier's various pictorial incarnations with me.

76. Malini Roy, "The Revival of the Mughal Painting Tradition during the Reign of Muhammad Shah," in *Princes and Painters in Mughal Delhi, 1707–1857*, ed. William Dalrymple and Yuthika Sharma (New Haven: Yale University Press, 2012), p. 21.

77. Samsam ud-Daula, while recognizable, displays the profile and rigid stance of a Kishangarh portrait. Aitken discusses the distinction between artists of a single court responding to one another's work, and the continual changes that occur across larger geographic areas, as artists engaged in less of an "intimate conversation" move away from the original composition. See Aitken, *Intelligence of Tradition*, p. 199.

78. Wilson, "Workshop Patterns," p. 527.

79. David Roxburgh, *The Persian Album, 1400–1600: From Dispersal to Collection* (New Haven: Yale University Press, 2013), pp. 290–94. Aitken makes the connection that if the Mughal workshop system was adopted from Persian counterparts, then it is likely that Mughal attitudes toward painting processes were correspondingly adopted from Persia. See Aitken, *Intelligence of Tradition*, p. 169. To continue this thread, Rajasthani and Pahari workshops, themselves adopted from the Mughal system on a smaller scale, should also reflect Persian models.

80. The Jesuits also brought works with Christian subject matter that were made in India: oil paintings and images of the Virgin and Child from the Portuguese settlement in Goa. The Portuguese had been in Goa since 1510, and Emperor Akbar established an embassy there in 1575, so European works of art are assumed to have reached the Mughals at that time. For Jesuit influence on the Mughals, see Edward Maclagan, *The Jesuits and the Great Mogul* (New York: Octagon Books, 1972); Gauvin Alexander Bailey, *Art on the Jesuit Missions in Asia and Latin America, 1542–1773* (Toronto: University of Toronto Press, 1999).

81. For a synopsis of regional influences on the Deccani style, see Sheila R. Canby, *Princes, Poets and Paladins: Islamic and Indian Paintings from the Collection of Prince and Princess Sadruddin Aga Khan*, exh. cat. (London: British Museum Press, 1998), p. 155.

82. Falk and Archer, *Indian Miniatures*, p. 220. The Dutch had established their first factory in India in 1605, at Masulipatam, a principal seaport of Golconda. Their activities extended to other ports of the Coromandel Coast, as well as inland to the courts of Golconda and Bijapur. The English and French also had trading interests in the region, bringing a rich variety of Christian imagery with them.

83. Compare the drapery seen here with *A Christian Subject: The Madonna and Child*, made around 1605–10 in Bijapur in the Deccan, and now in the Freer Gallery of Art, Smithsonian Institution, Washington, DC (F1907.155). The Madonna in the Freer Gallery drawing, as well as the majority of the figures in the Harris-Truelove *Crucifixion*, are depicted with bare chests. It is my contention that at some point a female figure from a European print was misinterpreted by a Deccani-trained artist as being bare-chested. This misrepresentation was subsequently repeated in later Deccani drawings, and is now an iconographic clue to the Deccani origin of several Christian-themed drawings. For another example,

see *European Lady with a Dog*, a tinted drawing with additions of gold, dated to about 1640, in the British Library (Johnson Album 14,7).

84. John Seyller, *Mughal and Deccani Paintings: Eva and Konrad Seitz Collection of Indian Miniatures* (Zurich: Museum Rietberg, 2010), p. 20. Akbar is recorded as praying in front of an image of Mary.

85. A Mughal painting where the Crucifixion is also paired with a heaving crowd of onlookers can be found in the British Museum, London (1983,1015,0.1); see J. M. Rogers, *Mughal Miniatures* (London: Thames and Hudson, 1993), p. 68; Gian Carlo Calza, ed., *Akbar: The Great Emperor of India*, exh. cat. (Rome: Fondazione Roma Museo, Skira, 2012), cat. v.8.

86. Typically only one symbolic skull is included in Crucifixion scenes. I would like to thank Jerry Losty and Shelley Langdale for their assistance in identifying the Christian iconography incorporated in this drawing.

87. For research exploring Christian imagery at the Mughal court, see Losty and Roy, *Mughal India*, p. 78; Milo Cleveland Beach, "The Gulshan Album and Its European Sources," *Bulletin of the Museum of Fine Arts* 63, no. 332 (1965), p. 77. Keshav Das, Basawan, and his son Manohar were three leading Mughal-trained artists responsible for much of the European-influenced work associated with the Mughal court.

88. Molly Aitken's discussion of repetition has led her to coin the term "response paintings," defined as works that are not copies, but "neither are they wholly original"; see Aitken, *Intelligence of Tradition*, pp. 174–85. For more on the Seu family of painters, see the sources cited in notes 2–4 above.

89. For a discussion of this drawing, see Losty and Roy, *Mughal India*, pp. 137–39.

90. Whether another method of transferring images was practiced in courtly India—be it at a one-to-one ratio or through scaling—is at this stage unknown. Pouncing is only successful as a transfer technique when there is a one-to-one ratio of images. For scaling of images, artists in Renaissance Italy and sixteenth-century England used squaring grids, a technique not introduced to India until the nineteenth century. Two examples of the use of grids in India include a drawing in the collection of the Brooklyn Museum, New York (80-261-1), where a grid-like structure is visible on a portrait of a Sikh gentleman. The surrounding grid is numbered with Arabic numerals, and was likely employed to transfer imagery to a larger canvas, possibly even an oil painting. Another work with this grid-like structure is a partially painted composition of Parvati offering bhang to Shiva, now in the Victoria and Albert Museum, London (IS.193.1952), dated to the mid-nineteenth century and likely from Jaipur.

91. For more on this second method of transfer, see Roxburgh, "Persian Drawings," p. 61; Molly Emma Aitken, "The Laud Ragamala Album, Bikaner, and the Sociability of Subimperial Painting," *Archives of Asian Art* 63, no. 1 (2013), pp. 29–30. This process transfers the composition to the paper beneath by creating one drawing full of holes and a second sheet bearing a combination of holes and indentations where the stylus did not completely penetrate the paper. The artist then uses ink or charcoal to connect the dots on the underlying piece

of paper, revealing the transferred image. To determine if this method was employed, hold a drawing up to a light—if the perforations do not entirely penetrate the support, then this method may have been used.

92. The *Rasamanjari* (or "blossom-cluster of delight") is a love treatise by the poet Bhanudatta that describes and classifies the many varied moods of lovers.

93. For another example in the Harris-Truelove Collection, see Checklist no. 25 in this volume. See also *A Languishing Lady*, an eighteenth-century drawing likely to be from Bikaner and now in the Paul F. Walter Collection; Pratapaditya Pal and Catherine Glynn, *The Sensuous Line: Indian Drawings from the Paul F. Walter Collection*, exh. cat. (Los Angeles: Los Angeles County Museum of Art, 1976), cat. 7, p. 16.

94. Aitken, "The Laud Ragamala Album," p. 44.

95. The drawing was examined under low magnification in raking and specular light; there is no indication of image transfer.

96. Wilson, "Workshop Patterns," p. 523.

97. A very similar painted composition, with the same serpentine clouds above, is in the Jagdish and Kamla Mittal Museum of Indian Art, Hyderabad, and soon to be published in the forthcoming volume titled *Rajasthani Paintings in the Jagdish and Kamla Mittal Museum*.

98. Aitken, "The Laud Ragamala," p. 42.

What Line Reveals

99. Howard Hodgkin, "Introduction to the Exhibition," in Terence McInerney, *Indian Drawing: An Exhibition Chosen by Howard Hodgkin*, exh. cat. (London: Arts Council of Great Britain, 1983), p. vi.

100. A discussion of a sparsely formed line in drawing often leads to a comparison with the written word. However, as there is little calligraphic tradition in India outside of the Persian-influenced Mughal and Deccani courts, the comparison of the calligraphic tradition to line drawing is beyond the realm of this discussion. For the calligraphic arts in the Persian tradition, see Roxburgh, *Persian Drawings*, pp. 48–60; Wheeler M. Thackston, "Treatise on Calligraphic Arts: A Disquisition on Paper, Colors, Inks, and Pens by Simi of Nishapur," in *Intellectual Studies on Islam: Essays Written in Honor of Martin B. Dickson*, ed. Michael Mazzaoui and Vera Moreen (Salt Lake City: University of Utah Press, 1990), pp. 219–28. Somewhat tangentially, see Ann Bermingham, *Learning to Draw: Studies in the Cultural History of a Polite and Useful Art* (New Haven: Yale University Press, 2000), p. 42, for an evocative discussion of Italian drawing manuals of the thirteenth to seventeenth centuries. Bermingham quotes from Leone Battista Alberti's *On Painting*, a fifteenth-century treatise on technique: "I should like youths who first come to painting to do so as those who are taught to write. We teach the latter by first separating all the forms of the letters which the ancients called elements. Then we teach the syllables, next we teach how to put together all the words. Our pupils ought to follow this rule in painting. First of all they should learn to draw the outlines of the planes well. Here they should learn how to join the planes together. They should learn each distinct form of each member and commit to memory whatever differences

there may be in each member." And finally, see Filiz Çakir Phillip, *Enchanted Lines: Drawings from the Aga Khan Collection* (Toronto: Aga Khan Museum, 2014), p. 18, who compares two Persian texts—the preface by the Persian calligrapher and artist Dust Muhammad (1550–1592) to the Bahram Mirza Album, and the *Golestan-e Honar* (Rose garden of art; 1596–1606) by the Safavid historian Qazi Ahmad Monshi Qommi—to Giorgio Vasari's *Lives of the Most Excellent Painters, Sculptors, and Architects*, an exhaustive compendium of Italian artists from the thirteenth to the sixteenth centuries, bringing our foray into calligraphic instruction full circle.

101. The exact sect to which these devotees belong is unclear. The unusual conical hat worn by the tallest of the three should be a clear identifying factor, but it presents several possibilities. They may be devotees of the mystic poet and Hindu saint Kabir (c. 1440–c. 1518), whose followers often wore hats similar to the one seen here. It is equally possible, however, that these figures are Ramanandi *mahants* (chief priests) of Pindori Dham, from the Gurdaspur district of the Punjab, whose distinctive conical hats are described in B. N. Goswamy and J. S. Grewal, *The Mughal and Sikh Rulers and the Vaishnavas of Pindori: A Historical Interpretation of 52 Persian Documents* (Simla: Indian Institute of Advanced Study, 1969), p. 6. I thank James Mallinson for bringing the latter possibility to my attention. For works that portray two saints of the Pindori sect, see *The Vaishnava Saints Bhagwanji and Narainji of the Pindori Gaddi* (Philadelphia Museum of Art, Stella Kramrisch Collection, 1994-148-511); Sotheby's, *The Stuart Cary Welch Collection*, part 2, *Arts of India* (London: Sotheby's, 2011), lot 58, which has a partially colored drawing of the same two saints titled *The Saints Bhagwan and Narayan Holding Prayer Beads* and dating to the early eighteenth century.

102. For examples, see Losty and Roy, *Mughal India*, pp. 72–75.

103. See Caspar Barlaeus, *Medicea Hospes* (Amsterdam: Willem Jansz. Blaeu, 1638). The series is described in F. W. H. Hollstein, *Dutch and Flemish Etchings, Engravings, and Woodcuts* (Amsterdam: M. Hertzberger, 1949–2010), vol. 24, p. 74, no. 144g; and in Frederik Muller, *Nederlandse Historieplaten* (Amsterdam: Israel, 1970), no. 1793/15. To return to the Harris-Truelove drawing, three further leaves from this peculiar album have been identified and are with Francesca Galloway in London, each in the format of a drawing centered within plain borders with a *nasta'liq* inscription in large gold letters: *An Unusual Portrait of a Nobleman from the Dodiya Clan with a Conjoined Twin Growing from His Stomach*, with bird studies on the verso (ML1096); *Farrukh Fal and an Attendant*, with calligraphy on the verso (ML978); and *Portrait of the Sufi Mystic Shah Daula*, with calligraphy on the verso (ML979). Along with the *nasta'liq* inscription, all three works also include a Devanagari inscription in gold ink. The inscriptions were likely added later, when the album was in Mewar, as evidenced by the fact that each inscription avoids covering the seal impression in the lower right corner. I thank Jerry Losty for bringing these three additional works to my attention, as well as discussing the placement of the inscriptions and the seal.

104. The bird on the lower left is a Eurasian jay, identified by its distinctive patterning. The bird in the middle of the page, near the upper border, is either a common (Eurasian) magpie or a green magpie, identified by its bill and tail. The bird to the far right of the page, oriented vertically, is identified as a great spotted woodpecker by the distinctive central tail feathers and facial patterning. The fourth bird is a common buzzard, long-legged buzzard, or rough-legged hawk. Thanks to Morgan Tingley and his colleagues at the University of Connecticut, as well as Wendy Palen of Simon Fraser University, for helpfully orchestrating this art historian's foray into ornithology.

105. Mughal drawings of birds are not unusual; see, for example, the quirky drawing of a cassowary in the Museum of Fine Arts, Boston (14.678). A particularly captivating example is *Owl Attacked by Birds* of about 1615, attributed to Manohar (Museum of Fine Arts, Boston, 14.662), whose specimens are placed in a naturalistic landscape with the subtle addition of gold pigment to indicate the clouds above.

106. See Christie's New York, *The Scholar's Vision: The Pal Family Collection* (New York: Christie's, 2008), lots 204 and 205, for four folios from a later *Bhagavata Purana* manuscript (Kangra or Guler, c. 1770). The depiction of architecture, figural display, and limited shading are similar to the series from about 1740, albeit drawn in a less confident hand and with less individuality bestowed upon the figures.

107. See Goswamy and Fischer, *Pahari Masters*, pp. 244–45.

108. See ibid., pp. 245–48, for an in-depth description of Manaku's style.

109. For informative descriptions of both artists' oeuvres, see Terence McInerney, "Dalchand," and Navina Haidar, "Bhavanidas," in Beach, Fischer, and Goswamy, *Masters of Indian Painting*, vol. 2, pp. 531–46. See also Toby Falk, "The Kishangarh Artist Bhavani Das," *Artibus Asiae* 52, nos. 1/2 (1992), notice 1–2; Navina Haidar, "The Kishangarh School of Painting, c. 1680–1850" (PhD diss., Oxford University, 1995).

110. In the nineteenth century, during the reign of Maharana Fateh Singh (r. 1884–1930), the Udaipur royal collection of court painting was assembled and reorganized under a new cataloguing system. Clerks would add their own memoranda to the reverse of earlier paintings, including inventory numbers, location notes, stock-checking dates, or valuations. See Andrew Topsfield, "The Royal Paintings Inventory at Udaipur," in *Indian Art and Connoisseurship: Essays in Honour of Douglas Barrett*, ed. John Guy (New Delhi: Indira Gandhi National Centre for the Arts, 1995), pp. 189–96. On the role of scribes in the Mughal atelier, see John Seyller, "Scribal Notes on Mughal Manuscript Illustrations," *Artibus Asiae* 48, nos. 3/4 (1987), pp. 247–77.

111. Bermingham, *Learning to Draw*, p. xii.

112. An interesting comparison can be made with *A Group of Noblewomen Visiting a Hermitage*, attributed to Dalchand and dated to about 1720–40; see Sotheby's, *Arts of the Islamic World* (London: Sotheby's, 2011), lot 145. The ascetic seated in the lower right corner of the image wears a hair band similar to that of the figure in the Harris-Truelove drawing.

113. The inscription translates as "'amal-i (work of) Mirza Murad Kam." This attribution requires further research.

114. James Mallinson (email correspondence, January 27, 2015) pointed out that the absence of a beard suggests that the man is not a full ascetic, but most likely a ruler dressed for devotional practice. Another identification could be as a *mahant* of a Sannyasi order, possibly the householder lineage known as Gosains.

115. Another evocative drawing depicting this scene is in the Museum of Fine Arts, Boston (17.2450). Instead of isolating Krishna and Kaliya, the Boston drawing includes numerous onlookers who stand on the riverbed and point toward the struggling pair. This has a similar effect of directing attention toward the central conflict, yet without the narrative tension created in the Harris-Truelove drawing.

Selected Bibliography

Aitken, Molly Emma. *The Intelligence of Tradition in Rajput Court Painting*. New Haven: Yale University Press, 2010.

———. "The Laud Ragamala Album, Bikaner, and the Sociability of Subimperial Painting." *Archives of Asian Art* 63, no. 1 (2013), pp. 27–58.

———. "Pardah and Portrayal: Rajput Women as Subjects, Patrons and Collectors." *Artibus Asiae* 62, no. 2 (2002), pp. 247–80.

———. "Spectatorship and Femininity in Kangra Style Painting." In *Representing the Body: Gender Issues in Indian Art*, edited by Vidya Dehejia, pp. 82–101. New Delhi: Kali for women in association with the Book Review Literary Trust, 1997.

Alam, Muzaffar, and Seema Alazi, eds. *A European Experience of the Mughal Orient: The I'jaz-I Arsalani (Persian Letters, 1773–1779) of Antoine-Louis Henri Polier*. New Delhi: Oxford University Press, 2001.

`Allami, Abu al-Fadl. *The A'in–i Akbari*. 3 vols. Translated by Henry Blochmann. New Delhi: Oriental Books Reprints Corp., 1977.

Archer, W. G. *Indian Painting in Bundi and Kotah*. London: Her Majesty's Stationery Office, 1959.

———. *Indian Paintings from the Punjab Hills: A Survey and History of Pahari Painting*. 2 vols. London: Sotheby Parke Bernet, 1973.

Bailey, Gauvin Alexander. *Art on the Jesuit Missions in Asia and Latin America, 1542–1773*. Toronto: University of Toronto Press, 1999.

Beach, Milo Cleveland. "The Gulshan Album and Its European Sources." *Bulletin of the Museum of Fine Arts* 63, no. 332 (1965), pp. 63–91.

———. *Rajput Painting at Bundi and Kota*. Zurich: Artibus Asiae, 1974.

Beach, Milo C., Eberhard Fischer, and B. N. Goswamy, eds. *Masters of Indian Painting*. 2 vols. Zurich: Artibus Asiae, 2011.

Bermingham, Ann. *Learning to Draw: Studies in the Cultural History of a Polite and Useful Art*. New Haven: Yale University Press, 2000.

Bernier, François. *Travels in the Mogul Empire, A.D. 1656–1668*. Translated by Archibald Constable. Westminster, England: A. Constable, 1891.

Bloom, Jonathan M. *Paper before Print: The History and Impact of Paper in the Islamic World*. New Haven: Yale University Press, 2001.

Cameron, Ainsley M. "Painting at Devgarh: Three Generations of an Artist Family, an Exploration of Style (1756–1850)." PhD diss., Oxford University, 2010.

Canby, Sheila R. *Princes, Poets and Paladins: Islamic and Indian Paintings from the Collection of Prince and Princess Sadruddin Aga Khan*. Exh. cat. London: British Museum Press, 1998.

Chandra, Moti. *Technique of Mughal Painting*. Lucknow: U. P. Historical Society, 1949.

Coomaraswamy, Ananda K. *Catalogue of the Indian Collection in the Museum of Fine Arts, Boston*. 6 vols. Boston: Museum of Fine Arts, 1923–30.

———. *Indian Drawings*. London: India Society, 1910.

———. *Indian Drawings: Second Series, Chiefly Rajput*. London: India Society, 1912.

———. *Rajput Painting*. 2 vols. London: Oxford University Press, 1916.

———. "The Technique and Theory of Indian Painting." *Technical Studies in the Field of Fine Arts* 3, no. 2 (1934), pp. 59–89.

Crill, Rosemary. *Marwar Painting: A History of the Jodhpur Style*. Mumbai: India Book House in association with Mehrangarh Publishers, 2000.

Cummins, Joan. *Indian Painting: From Cave Temples to the Colonial Period*. Boston: MFA Publications, 2006.

Currie, Stuart, ed. *Drawing, 1400–1600: Invention and Innovation*. Aldershot, England: Ashgate, 1998.

Diamond, Debra, Catherine Glynn, and Karni Singh Jasol. *Garden and Cosmos: The Royal Paintings of Jodhpur*. Exh. cat. Washington, DC: Arthur M. Sackler Gallery, Smithsonian Institution, 2008.

Dumont, Shana, and Supriya Gandhi. *Stages of Depiction: Indian Drawings, 17th–19th Centuries*. Exh. cat. Cambridge, MA: Hurst Gallery, 2006.

Eastman, Alvan Clark. *The Nala-Damayanti Drawings*. Boston: Museum of Fine Arts, 1959.

Falk, Toby. "The Kishangarh Artist Bhavani Das." *Artibus Asiae* 52, nos. 1/2 (1992), notice 1–2.

Falk, Toby, and Mildred Archer. *Indian Miniatures in the India Office Library*. London: Sotheby Parke Bernet, 1981.

Freedman, Aaron M. *Mala ke Manke: 108 Indian Drawings from the Private Collection of Subhash Kapoor*. New York: Art of the Past, 2003.

Gaur, Albertine. *Writing Materials of the East*. London: The British Library, 1979.

Goswamy, B. N. *Nainsukh of Guler: A Great Indian Painter from a Small Hill-State*. Zurich: Artibus Asiae; Museum Rietberg, 1997.

Goswamy, B. N., and Eberhard Fischer. *Pahari Masters: Court Painters of Northern India*. Zurich: Artibus Asiae; Museum Rietberg, 1992.

Goswamy, B. N., and J. S. Grewal. *The Mughal and Sikh Rulers and the Vaishnavas of Pindori: A Historical Interpretation of 52 Persian Documents*. Simla: Indian Institute of Advanced Study, 1969.

Goswamy, B. N., and Caron Smith. *Domains of Wonder: Selected Masterworks of Indian Painting*. Exh. cat. San Diego: San Diego Museum of Art, 2005.

Haidar, Navina. "The Kishangarh School of Painting, c. 1680–1850." PhD diss., Oxford University, 1995.

———. "Satire and Humour in Kishangarh Painting." In *Court Painting in Rajasthan*, edited by Andrew Topsfield, pp. 78–91. Mumbai: Marg Publications, 2000.

The Jahangirnama: Memoirs of Jahangir, Emperor of India. Translated by Wheeler M. Thackston. New York: Oxford University Press, 1999.

Khandalavala, Karl J. *Pahari Miniature Painting*. Bombay: New Book Co., 1958.

Lazaro, Desmond Peter. *Materials, Methods, and Symbolism in the Pichhvai Painting Tradition of Rajasthan*. London: Art Books International, 2005.

Losty, J. P. "Towards a New Naturalism: Portraiture in Murshidabad and Avadh, 1750–80." In *After the Great Mughal*, edited by Barbara Schmitz, pp. 34–55. Mumbai: Marg Publications, 2002.

Losty, J. P., and Malini Roy. *Mughal India: Art, Culture and Empire*. London: The British Library, 2012.

Lyons, Tryna. *The Artists of Nathadwara: The Practice of Painting in Rajasthan*. Bloomington: Indiana University Press; Ahmedabad, India: Mapin, 2004.

Macfarlane, Nigel. *Handmade Papers of India*. Winchester, England: Alembic Press, 1987.

Mason, Darielle, et al. *Intimate Worlds: Indian Paintings from the Alvin O. Bellak Collection*. Exh. cat. Philadelphia: Philadelphia Museum of Art, 2001.

McInerney, Terence. *Indian Drawing: An Exhibition Chosen by Howard Hodgkin*. Exh. cat. London: Arts Council of Great Britain, 1983.

Owens, Susan. *The Art of Drawing: British Masters and Methods since 1600*. London: V&A Publishing, 2013.

Pal, Pratapaditya. *Dancing to the Flute: Music and Dance in Indian Art*. Exh. cat. Sydney: Art Gallery of New South Wales, 1997.

Pal, Pratapaditya, and Catherine Glynn. *The Sensuous Line: Indian Drawings from the Paul F. Walter Collection*. Exh. cat. Los Angeles: Los Angeles County Museum of Art, 1976.

Phillip, Filiz Çakir. *Enchanted Lines: Drawings from the Aga Khan Collection*. Toronto: Aga Khan Museum, 2014.

Poster, Amy G. *Realms of Heroism: Indian Paintings at the Brooklyn Museum*. New York: Hudson Hills, 1994.

Premchand, Neeta. *Off the Deckle Edge: A Paper-Making Journey through India*. Bombay: Ankur Project, 1995.

Roxburgh, David. *The Persian Album, 1400–1600: From Dispersal to Collection*. New Haven: Yale University Press, 2013.

———. "Persian Drawings, ca. 1400–1450: Materials and Creative Procedures." *Muqarnas: An Annual on the Visual Culture of the Islamic World* 19 (2002), pp. 44–77.

Roy, Malini. "The Revival of the Mughal Painting Tradition during the Reign of Muhammad Shah." In *Princes and Painters in Mughal Delhi, 1707–1857*, edited by William Dalrymple and Yuthika Sharma, pp. 17–23. New Haven: Yale University Press, 2012.

———. "Some Unexpected Sources for Paintings by the Artist Mihr Chand (fl. c. 1759–86), Son of Ganga Ram." *South Asian Studies* 26, no. 1 (March 2010), pp. 21–29.

Scheller, Robert W. *Exemplum: Model-Book Drawings and the Practice of Artistic Transmission (ca. 900–ca. 1450)*. Amsterdam: Amsterdam University Press, 1995.

Seth, Mira. *Indian Painting: The Great Mural Tradition*. New York: Abrams, 2006.

———. *Wall Paintings of Rajasthan*. New Delhi: National Museum, 2003.

Seyller, John. *Mughal and Deccani Paintings: Eva and Konrad Seitz Collection of Indian Miniatures*. Zurich: Museum Rietberg, 2010.

———. *Pearls of the Parrot of India: The Walters Art Museum Khamsa of Amir Khusraw of Delhi*. Exh. cat. Baltimore: Walters Art Museum, 2001.

———. "Scribal Notes on Mughal Manuscript Illustrations." *Artibus Asiae* 48, nos. 3/4 (1987), pp. 247–77.

———. *Workshop and Patron in Mughal India: The Freer Ramayana and Other Illustrated Manuscripts of `Abd al-Rahim*. Zurich: Artibus Asiae, 1999.

Seyller, John, and Jagdish Mittal. *Pahari Drawings in the Jagdish and Kamla Mittal Museum of Indian Art*. Hyderabad: Jagdish and Kamla Mittal Museum of Indian Art, 2013.

Simpson, Marianna Shreve. "The Making of Manuscripts and the Workings of the Kitab-khana in Safavid Iran." In *The Artist's Workshop*, edited by Peter M. Lukehart, pp. 104–21. Hanover, NH: University Press of New England, 1993.

Stronge, Susan. *Painting for the Mughal Emperor: The Art of the Book, 1560–1660*. London: V&A Publications, 2002.

Thackston, Wheeler M. "Treatise on Calligraphic Arts: A Disquisition on Paper, Colors, Inks, and Pens by Simi of Nishapur." In *Intellectual Studies on Islam: Essays Written in Honor of Martin B. Dickson*, edited by Michael Mazzaoui and Vera Moreen, pp. 219–28. Salt Lake City: University of Utah Press, 1990.

Topsfield, Andrew. "Ketelaar's Embassy and the Farangi Theme in the Art of Udaipur." *Oriental Art*, n.s., 30, no. 4 (Winter 1984–85), pp. 350–67.

———. "The Royal Paintings Inventory at Udaipur." In *Indian Art and Connoisseurship: Essays in Honour of Douglas Barrett*, edited by John Guy, pp. 189–96. New Delhi: Indira Gandhi National Centre for the Arts, 1995.

Topsfield, Andrew, and Milo Cleveland Beach. *Indian Paintings and Drawings from the Collection of Howard Hodgkin*. Exh. cat. New York: Thames and Hudson, 1991.

Watt, George, Edgar Thurston, and T. N. Mukharji. *A Dictionary of the Economic Products of India*. 7 vols. Calcutta: Superintendent of Government Printing; London: W. H. Allen, 1889.

Welch, Stuart Cary. *Indian Drawings and Painted Sketches: 16th through 19th Centuries*. Exh. cat. New York: Asia Society, 1976.

———. *Rajasthani Miniatures: The Welch Collection from the Arthur M. Sackler Museum, Harvard University*. Exh. cat. New York: The Drawing Center, 1997.

Welch, Stuart Cary, ed. *Gods, Kings, and Tigers: The Art of Kotah*. Munich: Prestel, 1997.

Welch, Stuart Cary, and Kim Masteller, eds. *From Mind, Heart, and Hand: Persian, Turkish, and Indian Drawings from the Stuart Cary Welch Collection*. Exh. cat. New Haven: Yale University Press; Cambridge, MA: Harvard University Art Museums, 2004.

Welch, Stuart Cary, and Mark Zebrowski. *A Flower from Every Meadow*. Exh. cat. New York: Asia Society, 1973.

Wilson, Jean C. "Workshop Patterns and the Production of Paintings in Sixteenth-Century Bruges." *Burlington Magazine*, vol. 132, no. 1049 (August 1990), pp. 523–27.

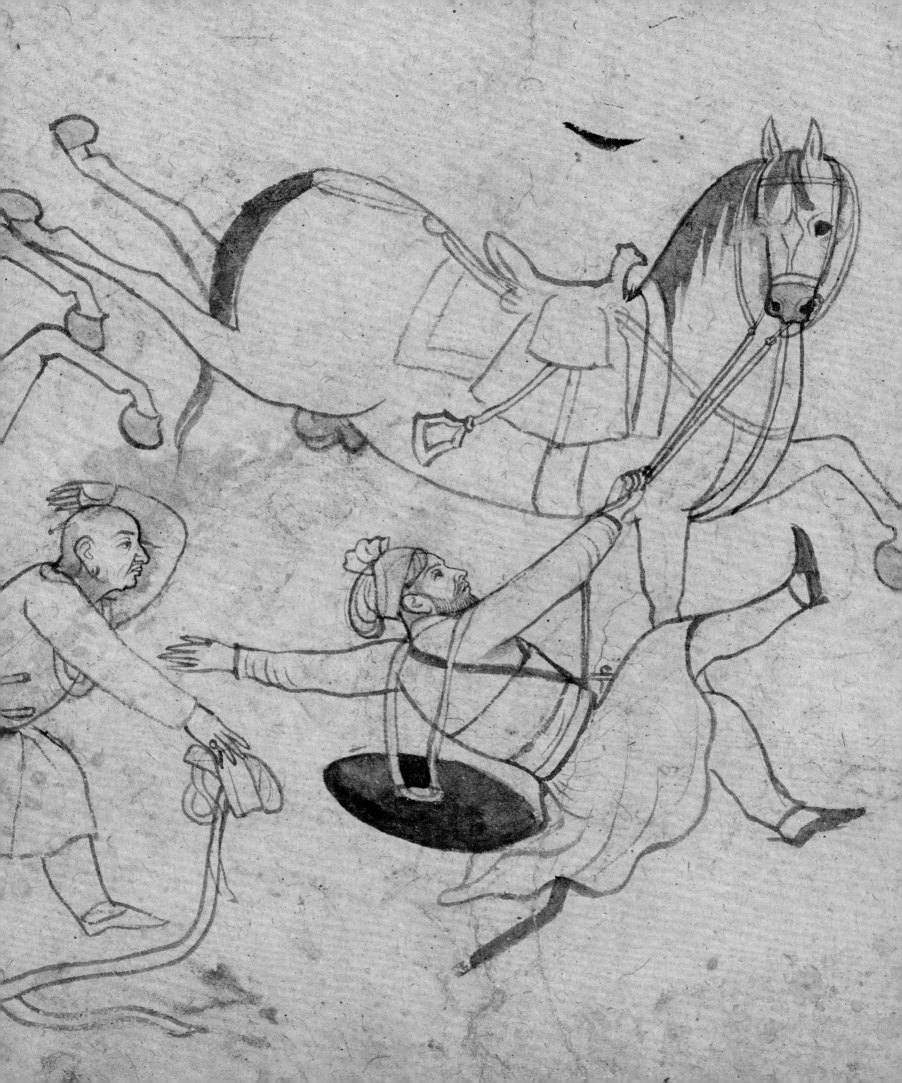

Checklist of the Conley Harris and Howard Truelove Collection of Indian Drawings

The checklist entries are organized by workshop within each regional designation. The Conley Harris and Howard Truelove Collection of Indian Drawings was acquired by the Philadelphia Museum of Art in 2013 as a combined gift/purchase. The credit lines reflect which works were designated as gifts from Harris and Truelove, and which were purchased through the Stella Kramrisch Fund for Indian and Himalayan Art.

DRAWN FROM THE MUGHAL COURTS

a

b

1 *Artist Sheet of Birds and Foliage* (a)
Mughal Empire, 1636–37

Detail of *Marie de' Medici's Visit to Amsterdam* (b)
Salomon Savery (Dutch, 1594–1678)
Early seventeenth century

(a) Brush and black and blue inks on beige paper on decorative mount; (b) etching
Image: (a) 6⁹⁄₁₆ x 10⁷⁄₁₆ inches (16.6 x 26.6 cm); (b) 5¼ x 8⁹⁄₁₆ inches (13.3 x 21.8 cm); sheet: 12⁵⁄₁₆ x 17¼ inches (31.3 x 43.8 cm)
Philadelphia Museum of Art. The Conley Harris and Howard Truelove Collection of Indian Drawings, purchased with the Stella Kramrisch Fund for Indian and Himalayan Art, 2013-68-16a,b
Plates 48a,b

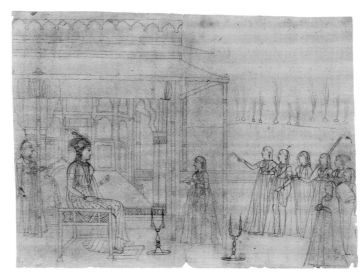

2 *Ladies on a Terrace with Fireworks*
Uttar Pradesh, Farrukhabad, c. 1760–80
Brush and black ink with corrections by the artist in white opaque watercolor on beige laid paper, pricked for transfer and pounced with charcoal
9¼ x 12 inches (23.5 x 30.5 cm)
Philadelphia Museum of Art. The Conley Harris and Howard Truelove Collection of Indian Drawings, 2013-77-16
Plate 41

3 *Crucifixion*
Deccan region, c. 1580–1620
Brush and black ink with touches of red ink on beige paper on decorative mount
Image: 7½ x 5 inches (19.1 x 12.7 cm), sheet: 11 x 7⅞ inches (27.9 x 20 cm)
Philadelphia Museum of Art. The Conley Harris and Howard Truelove Collection of Indian Drawings, purchased with the Stella Kramrisch Fund for Indian and Himalayan Art, 2013-68-1
Plate 35

5 *A Princess Swooning on a Bed*
Rajasthan, Bikaner, c. 1675–1700
Brush and black, red, and blue inks on beige paper
8½ x 6 inches (21.6 x 15.2 cm)
Philadelphia Museum of Art. The Conley Harris and Howard Truelove Collection of Indian Drawings, 2013-77-1
Plate 40

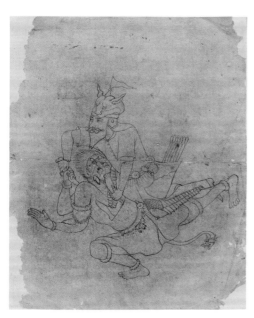

4 *Rustam Battling a Demon*
Deccan region, c. 1750–1800
Brush and black ink on beige laid paper, pricked for transfer and pounced with charcoal
8 x 7 inches (20.3 x 17.8 cm)
Philadelphia Museum of Art. The Conley Harris and Howard Truelove Collection of Indian Drawings, 2013-77-33
Plate 37

6 *Maharaja Gaj Singh with Court Ladies Playing Holi*
Rajasthan, Bikaner, c. 1750
Brush and black and red inks on opaque watercolor over traces of charcoal on beige laid paper
9 x 6½ inches (22.9 x 16.5 cm)
Philadelphia Museum of Art. The Conley Harris and Howard Truelove Collection of Indian Drawings, 2013-77-14
Plate 3

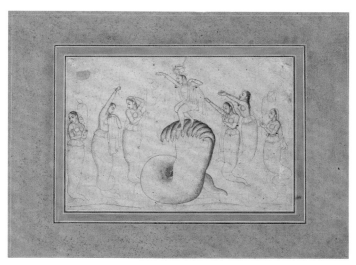

9 Krishna Dancing atop Kaliya
From the *Bhagavata Purana*
Rajasthan, Bikaner, c. 1770–1800
Brush and black ink with touches of red ink over traces of charcoal on beige paper on decorative mount with gold flecks
Image: 4⅛ x 5¾ inches (10.5 x 14.6 cm), sheet: 6¹¹⁄₁₆ x 8¹⁵⁄₁₆ inches (16.9 x 22.6 cm)
Philadelphia Museum of Art. The Conley Harris and Howard Truelove Collection of Indian Drawings, 2013-77-23
Plate 52

7 Maharaja Hari Singh of Kishangarh
Rajasthan, Bikaner, c. 1750
Brush and black ink and watercolor over traces of charcoal on beige laid paper
Image: 7½ x 4¾ inches (19.1 x 12.1 cm), sheet: 10¹¹⁄₁₆ x 6⅝ inches (27.1 x 16.8 cm)
Philadelphia Museum of Art. The Conley Harris and Howard Truelove Collection of Indian Drawings, 2013-77-6
Plate 4

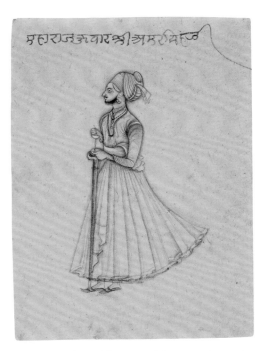

10 Walking Vaishnava Disciples
Rajasthan, Bikaner, late eighteenth century
Brush and black ink and watercolor over traces of charcoal on beige laid paper
6½ x 3⅝ inches (16.5 x 9.2 cm)
Philadelphia Museum of Art. The Conley Harris and Howard Truelove Collection of Indian Drawings, 2013-77-5
Plate 47

8 Portrait of a Nobleman Holding a Red Sword
Rajasthan, Bikaner, c. 1750–1800
Brush and black ink and watercolor on beige paper
6⅞ x 5 inches (17.5 x 12.7 cm)
Philadelphia Museum of Art. The Conley Harris and Howard Truelove Collection of Indian Drawings, 2013-77-7

11 Portrait of a Lady
Rajasthan, Bikaner, nineteenth century
Brush and black ink and charcoal on beige paper
5½ x 3¼ inches (14 x 8.3 cm)
Philadelphia Museum of Art. The Conley Harris and Howard Truelove
Collection of Indian Drawings, 2013-77-24

12 Ladies Relaxing on a Terrace
Rajasthan, possibly from Bikaner, nineteenth century
Brush and black ink over traces of charcoal with corrections by the artist in
white opaque watercolor on beige laid paper
7 x 5 inches (17.8 x 12.7 cm)
Philadelphia Museum of Art. The Conley Harris and Howard Truelove
Collection of Indian Drawings, 2013-77-44

13 Portrait of Samsam ud-Daula Khan Dauran
Rajasthan, Kishangarh, c. 1700–1735
Brush and black and red inks, watercolor, and opaque watercolor over
traces of charcoal on beige laid paper on decorative mount with gold flecks
Image: 4¾ x 3½ inches (12.1 x 8.9 cm), sheet 12⁷⁄₁₆ x 8⁵⁄₁₆ inches (32.5 x 21.2 cm)
Philadelphia Museum of Art. The Conley Harris and Howard Truelove
Collection of Indian Drawings, 2013-77-8
Plate 33

14 Attributed to Dalchand (Indian, born c. 1690–95, active c. 1710–60)
Maharaja Raj Singh of Kishangarh with Two Courtiers
Rajasthan, Kishangarh, c. 1730–40
Brush and black ink and watercolor on beige laid paper
7 x 9 inches (17.8 x 22.9 cm)
Philadelphia Museum of Art. The Conley Harris and Howard Truelove
Collection of Indian Drawings, purchased with the Stella Kramrisch Fund for
Indian and Himalayan Art, 2013-68-11
Plate 50

15 *Portrait of a Seated Ruler Dressed for Ritual Practice*
Rajasthan, Kishangarh, c. 1740
Brush and black ink and watercolor over charcoal with corrections by the
artist in white opaque watercolor on beige laid paper on decorative mount
Image: 6 x 4 inches (15.2 x 10.2 cm), sheet: 8 x 6 inches (20.3 x 15.2 cm)
Philadelphia Museum of Art. The Conley Harris and Howard Truelove
Collection of Indian Drawings, 2013-77-25
Plate 51

17 *Seated Courtier*
Rajasthan, Kishangarh, c. 1750
Brush and black and red inks, watercolor, and opaque watercolor on
thick beige paper
5¹⁵⁄₁₆ x 5⁷⁄₁₆ inches (15 x 13.9 cm)
Philadelphia Museum of Art. The Conley Harris and Howard Truelove
Collection of Indian Drawings, 2013-77-32

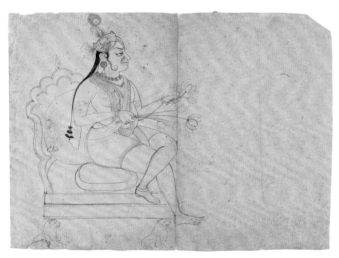

18 *Krishna Seated on a Throne*
Rajasthan, Kishangarh, c. 1800–1825
Brush and brown and black inks with corrections by the artist in white
opaque watercolor on beige laid paper
10³⁄₈ x 13½ inches (26.4 x 34.3 cm)
Philadelphia Museum of Art. The Conley Harris and Howard Truelove
Collection of Indian Drawings, purchased with the Stella Kramrisch Fund for
Indian and Himalayan Art, 2013-68-5

16 *A Shaivite Ascetic*
Rajasthan, Kishangarh, c. 1740
Brush and black and red inks and watercolor with corrections by the artist
in white opaque watercolor on beige paper
6 x 4½ inches (15.2 x 11.4 cm)
Philadelphia Museum of Art. The Conley Harris and Howard Truelove
Collection of Indian Drawings, 2013-77-20
Plate 22

19 *Hindola Ragini*
From a *ragamala* series
Rajasthan, Bundi, c. 1650–1750
Brush and brown and orange-red inks on beige paper
10¼ x 5¼ inches (26 x 13.3 cm)
Philadelphia Museum of Art. The Conley Harris and Howard Truelove
Collection of Indian Drawings, 2013-77-42

21 *Vasanta Ragini*
From a *ragamala* series
Rajasthan, Bundi, c. 1650–1750
Brush and black and orange-red inks on beige laid paper
9½ x 5½ inches (24.1 x 14 cm)
Philadelphia Museum of Art. The Conley Harris and Howard Truelove
Collection of Indian Drawings, 2013-77-38
Plate 44

20 *Asavari Ragini*
From a *ragamala* series
Rajasthan, Bundi, c. 1650–1750
Brush and black and orange-red inks on beige laid paper
9⅜ x 5½ inches (23.8 x 14 cm)
Philadelphia Museum of Art. The Conley Harris and Howard Truelove
Collection of Indian Drawings, 2013-77-43

22 *Vasanta Ragini*
From a *ragamala* series
Rajasthan, Bundi, c. 1650–1750
Brush and black and orange-red inks on beige laid paper
9¾ x 5¼ inches (24.8 x 13.3 cm)
Philadelphia Museum of Art. The Conley Harris and Howard Truelove
Collection of Indian Drawings, 2013-77-39
Plate 43

23 Gauri Ragini
From a *ragamala* series
Rajasthan, Bundi, c. 1650–1750
Brush and black and orange-red inks on beige laid paper
10⅝ x 5½ inches (27 x 14 cm)
Philadelphia Museum of Art. The Conley Harris and Howard Truelove
Collection of Indian Drawings, 2013-77-41

25 Female Attendants Preparing the Lover's Room
From the *Rasamanjari*
Rajasthan, Bundi, c. 1770–1800
Brush and black ink, watercolor, and opaque watercolor on beige paper,
mounted on paper with silk brocade border
6½ x 7½ inches (16.5 x 19.1 cm)
Philadelphia Museum of Art. The Conley Harris and Howard Truelove
Collection of Indian Drawings, purchased with the Stella Kramrisch Fund for
Indian and Himalayan Art, 2013-68-18

24 Dhanasri Ragini
From a *ragamala* series
Rajasthan, Bundi, c. 1650–1750
Brush and black and orange-red inks on beige paper
8½ x 5½ inches (21.6 x 14 cm)
Philadelphia Museum of Art. The Conley Harris and Howard Truelove
Collection of Indian Drawings, 2013-77-40

26 A Celebration of Shiva (a)
A Sheet of Sketches (b)
Rajasthan, Bundi, c. 1800–1825
(a) Brush and brown ink, watercolor, and opaque watercolor on beige laid paper; (b) brush and green ink and watercolor on beige laid paper
7⅜ x 13⅞ inches (18.7 x 35.2 cm)
Philadelphia Museum of Art. The Conley Harris and Howard Truelove Collection of Indian Drawings, 2013-77-11a,b
Plate 27 (a)

27 *Elephant Battle Scene* (a)
Sketches of Several Court Scenes and a British Officer (b)
Rajasthan, Kota, c. 1710–20 to c. 1880
(a) Brush and black and blue inks and watercolor on beige laid paper;
(b) brush and black and colored inks and watercolor on beige laid paper
9 x 21 inches (22.9 x 53.3 cm)
Philadelphia Museum of Art. The Conley Harris and Howard Truelove Collection of Indian Drawings, 2013-77-9a,b
Plates 7a,b

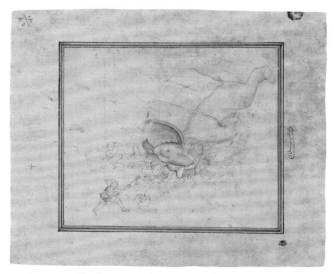

29 Rampant Elephant Attacking a Crowd
Rajasthan, Kota, c. 1750–70
Brush and black ink and white opaque watercolor over traces of charcoal on beige paper on decorative mount
Image: 5⅝ x 6½ inches (14.3 x 16.5 cm), sheet: 7⅞ x 9⁷⁄₁₆ inches (20 x 23.9 cm)
Philadelphia Museum of Art. The Conley Harris and Howard Truelove Collection of Indian Drawings, purchased with the Stella Kramrisch Fund for Indian and Himalayan Art, 2013-68-12
Plate 46

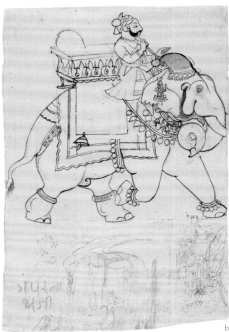

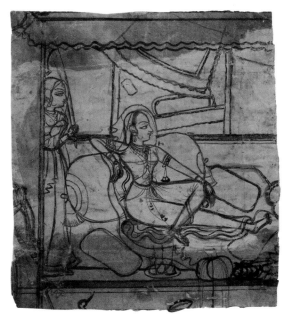

28 Portrait Studies of Courtiers and Visiting Noblemen (a)
Maharao Ram Singh II on an Elephant (b)
Rajasthan, Kota, c. 1750 (a) and c. 1840 (b)
(a) Brush and black, green, and red inks and watercolor with corrections by the artist in white opaque watercolor on beige paper; (b) brush and black, green, and red inks and watercolor with graphite notations on beige paper
10⅞ x 7½ inches (27.6 x 19.1 cm)
Philadelphia Museum of Art. The Conley Harris and Howard Truelove Collection of Indian Drawings, 2013-77-26a,b
Plate 16 (a)

30 Woman Resting against a Bolster
Rajasthan, Kota, c. 1800
Brush and black and red ink over opaque watercolor and inks on beige paper, pricked for transfer and pounced with charcoal
10½ x 9 inches (26.7 x 22.9 cm)
Philadelphia Museum of Art. The Conley Harris and Howard Truelove Collection of Indian Drawings, purchased with the Stella Kramrisch Fund for Indian and Himalayan Art, 2013-68-4
Plate 39

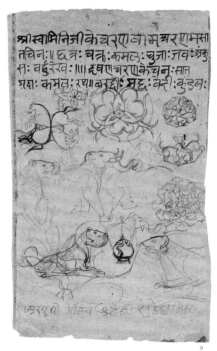

a

32 *Noblemen on Elephant during Holi Festival*
Rajasthan, Kota, late eighteenth century
Brush and red and black inks and watercolor, brushed and spattered,
on beige laid paper
5 x 6 inches (12.7 x 15.2 cm)
Philadelphia Museum of Art. The Conley Harris and Howard Truelove
Collection of Indian Drawings, 2013-77-22
Plate 14

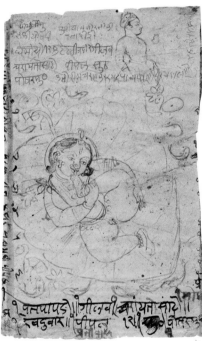

b

31 *A Study of Entwined Animals* (a)
Baby Krishna Resting on a Pipal Leaf (b)
Rajasthan, Kota, c. 1780–90
(a) Brush and black, red, and blue inks and watercolor on beige paper;
(b) brush and black and orange-red inks and opaque watercolor on
beige paper
10 x 6¼ inches (25.4 x 15.9 cm)
Philadelphia Museum of Art. The Conley Harris and Howard Truelove
Collection of Indian Drawings, 2013-77-34a,b
Plate 31 (a)

33 *Maharao Ram Singh II Hunting Tigers from a Royal Barge*
Rajasthan, Kota, c. 1820
Brush and black ink with touches of orange-red watercolor on beige paper
10 x 13 inches (25.4 x 33 cm)
Philadelphia Museum of Art. The Conley Harris and Howard Truelove
Collection of Indian Drawings, 2013-77-35
Plate 20

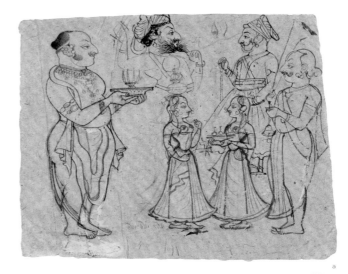

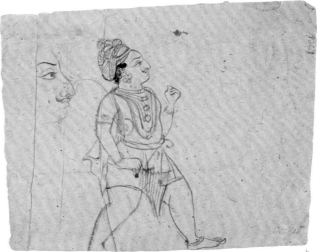

35 *Maharao Ram Singh II Making an Offering, alongside a Study of Court Attendants* (a)
Two Portrait Studies (b)
Rajasthan, Kota, c. 1830–40
(a) Brush and black and colored inks and opaque watercolor over traces of charcoal with corrections by the artist in white opaque watercolor on beige paper; (b) brush and black and blue inks and watercolor on beige paper
4½ × 5½ inches (11.4 × 14 cm)
Philadelphia Museum of Art. The Conley Harris and Howard Truelove Collection of Indian Drawings, 2013-77-15a,b
Plate 17 (a)

34 *A Swooning Woman with Three Attendants* (a)
Elephant Study (b)
Rajasthan, Kota, c. 1830
(a) Brush and black ink with corrections by the artist in white opaque watercolor on beige laid paper, pricked for transfer and pounced with charcoal; (b) charcoal on beige laid paper
10 × 7 inches (25.4 × 17.8 cm)
Philadelphia Museum of Art. The Conley Harris and Howard Truelove Collection of Indian Drawings, 2013-77-37a,b
Plates 38 (a), 9 (b)

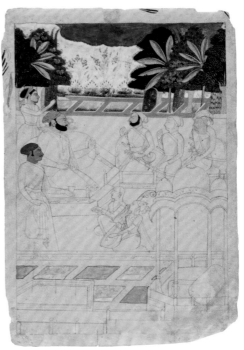

36 *Portrait of Madho Singh of Kota*
Rajasthan, Kota, c. 1840
Brush and black and green inks and opaque watercolor with corrections by
the artist in white opaque watercolor on beige paper, pricked for transfer
8¾ x 6⅜ inches (22.2 x 16.2 cm)
Philadelphia Museum of Art. The Conley Harris and Howard Truelove
Collection of Indian Drawings, purchased with the Stella Kramrisch Fund for
Indian and Himalayan Art, 2013-68-19
Plate 25

38 *A Prince and Courtiers in a Garden*
Rajasthan, Jodhpur, c. 1720–30 with later additions
Brush and brown ink, metallic gold and silver paints, and opaque watercolor
over traces of charcoal on beige laid paper
13 x 8½ inches (33 x 21.6 cm)
Philadelphia Museum of Art. The Conley Harris and Howard Truelove
Collection of Indian Drawings, 2013-77-31
Plate 21

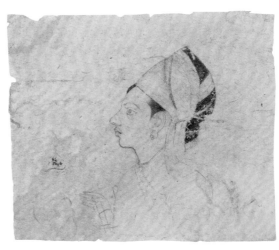

39 *A Portrait of a Young Prince*
Rajasthan, Jodhpur, c. 1750
Brush and black ink over charcoal on beige paper
2¾ x 3⅛ inches (7 x 7.9 cm)
Philadelphia Museum of Art. The Conley Harris and Howard Truelove
Collection of Indian Drawings, 2013-77-45
Plate 18

37 *Maharao Ram Singh II and Courtesan on a Hunting Expedition*
Rajasthan, Kota, c. 1840
Brush and brown and black inks on beige laid paper
14½ x 9½ inches (36.8 x 24.1 cm)
Philadelphia Museum of Art. The Conley Harris and Howard Truelove
Collection of Indian Drawings, 2013-77-13

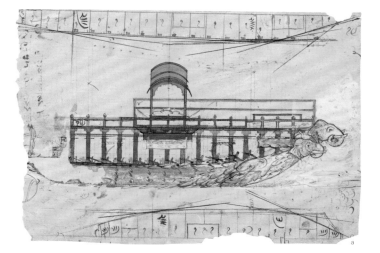

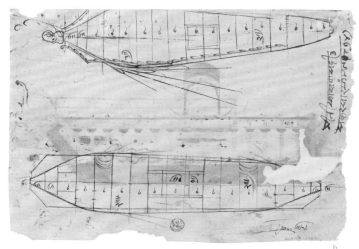

41 *Studies for a Pleasure Barge*
Rajasthan, Udaipur, 1817
Pen and brush and black ink and opaque watercolor over charcoal on beige laid paper
8½ x 12 inches (21.6 x 30.5 cm)
Philadelphia Museum of Art. The Conley Harris and Howard Truelove Collection of Indian Drawings, 2013-77-27a,b

40 *A Satirical Drawing of Two Ladies* (a)
A Standing Portrait of Two Noblemen (b)
Rajasthan, Udaipur and Bikaner, c. 1760–1800 and early eighteenth century
(a) Brush and black ink and watercolor over charcoal on beige laid paper;
(b) brush and black ink and watercolor on beige laid paper
7 x 6⅛ inches (17.8 x 15.6 cm)
Philadelphia Museum of Art. The Conley Harris and Howard Truelove Collection of Indian Drawings, 2013-77-28a,b
Plates 8a,b

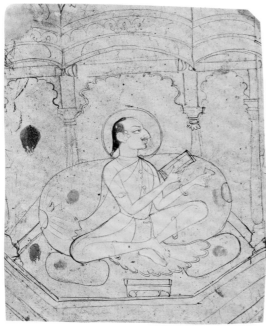

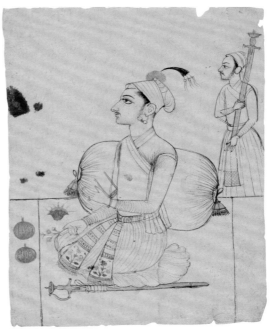

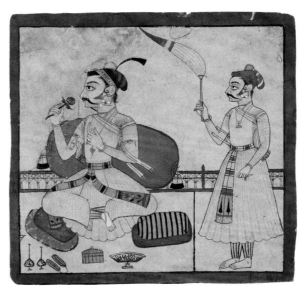

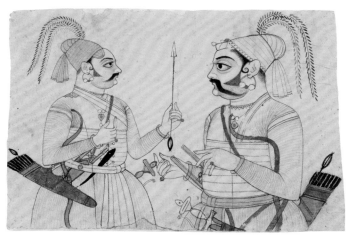

45 *Two Archers*
Rajasthan, Sawar, c. 1710–20
Brush and black ink, watercolor, and opaque watercolor on beige paper, mounted on paper
6¼ x 9 inches (15.9 x 22.9 cm)
Philadelphia Museum of Art. The Conley Harris and Howard Truelove Collection of Indian Drawings, purchased with the Stella Kramrisch Fund for Indian and Himalayan Art, 2013-68-13
Plate 30

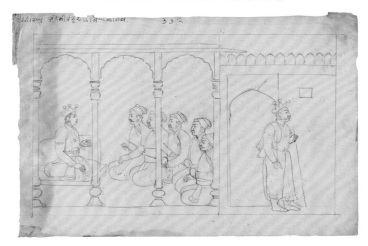

47 **Attributed to Manaku (Indian, active 1730–60)**
An Illustration from the Bhagavata Purana
Himachal Pradesh, Guler, c. 1740
Brush and black ink and white opaque watercolor over charcoal on beige laid paper
8¾ x 13 inches (22.2 x 33 cm)
Philadelphia Museum of Art. The Conley Harris and Howard Truelove Collection of Indian Drawings, purchased with the Stella Kramrisch Fund for Indian and Himalayan Art, 2013-68-9
Plate 49

46 *Portrait of a Woman with a Huqqa*
Rajasthan, Jaipur, c. 1780–1800
Brush and black and red inks with corrections by the artist in white opaque watercolor on beige paper
13½ x 9½ inches (34.3 x 24.1 cm)
Philadelphia Museum of Art. The Conley Harris and Howard Truelove Collection of Indian Drawings, 2013-77-17

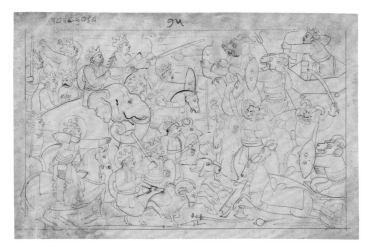

48 **Attributed to Manaku (Indian, active 1730–60)**
Battle Scene with Demons
From the *Bhagavata Purana*
Himachal Pradesh, Guler, c. 1740
Brush and black ink over charcoal with pen and red ink ruled line around perimeter on beige paper
7⅜ x 12 inches (18.7 x 30.5 cm)
Philadelphia Museum of Art. The Conley Harris and Howard Truelove Collection of Indian Drawings, purchased with the Stella Kramrisch Fund for Indian and Himalayan Art, 2013-68-2
Plate 1

**49 *Devi and the Shakti Forces Attack Nishumbha, Shumbha,
and Their Army***
From the *Markandeya Purana*
Himachal Pradesh, Guler, c. 1760
Brush and black, red, and orange-red inks and opaque watercolor over
black chalk on beige paper
8½ x 9½ inches (21.6 x 24.1 cm)
Philadelphia Museum of Art. The Conley Harris and Howard Truelove
Collection of Indian Drawings, purchased with the Stella Kramrisch Fund for
Indian and Himalayan Art, 2013-68-8
Plate 23

50 *Shiva and Parvati Preparing Bhang*
From an unidentified Shiva series
Himachal Pradesh, Guler, c. 1770–90
Brush and black and orange-red inks over traces of charcoal on beige
laid paper
12 x 15 inches (30.5 x 38.1 cm)
Philadelphia Museum of Art. The Conley Harris and Howard Truelove
Collection of Indian Drawings, 2013-77-10
Plate 15

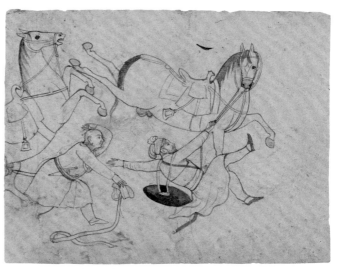

51 *Men Falling from Their Rearing Horses*
Himachal Pradesh, Guler, c. 1790
Brush and black ink over charcoal on beige laid paper
7½ x 9½ inches (19.1 x 24.1 cm)
Philadelphia Museum of Art. The Conley Harris and Howard Truelove
Collection of Indian Drawings, purchased with the Stella Kramrisch Fund for
Indian and Himalayan Art, 2013-68-6
Plate 36

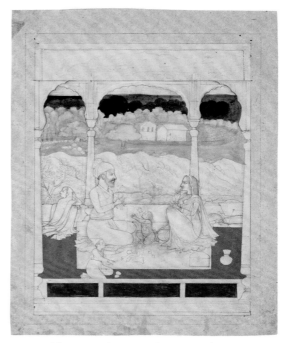

52 *A Nobleman and His Family in a Pavilion*
Himachal Pradesh, Guler, c. 1790
Brush and black and red inks, watercolor, and opaque watercolor with
corrections by the artist in white opaque watercolor on beige paper
10½ x 8¼ inches (26.7 x 21 cm)
Philadelphia Museum of Art. The Conley Harris and Howard Truelove
Collection of Indian Drawings, purchased with the Stella Kramrisch Fund for
Indian and Himalayan Art, 2013-68-14
Plate 2

53 *Chandi Defeats Shumbha*
From the *Markandeya Purana*
Himachal Pradesh, Kangra, c. 1780
Brush and red and orange-red inks and white opaque watercolor on beige paper
5⅝ x 7¾ inches (14.2 x 19.8 cm)
Philadelphia Museum of Art. The Conley Harris and Howard Truelove Collection of Indian Drawings, 2013-77-2
Plate 11

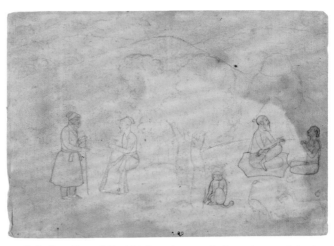

55 *Raja Surath and the Vaishya Approach the Ashram of the Sage Markandeya*
From the *Markandeya Purana*
Himachal Pradesh, Kangra, c. 1780
Brush and black and orange-red inks and opaque watercolor over charcoal on beige laid paper
5⅝ x 7¾ inches (14.2 x 19.7 cm)
Philadelphia Museum of Art. The Conley Harris and Howard Truelove Collection of Indian Drawings, 2013-77-46
Plate 13

54 *The Gods Plead with the Goddess Durga for Help*
From the *Markandeya Purana*
Himachal Pradesh, Kangra, c. 1780
Brush and red and orange-red inks and white opaque watercolor on beige paper
5⅝ x 7⅞ inches (14.2 x 19.9 cm)
Philadelphia Museum of Art. The Conley Harris and Howard Truelove Collection of Indian Drawings, 2013-77-3
Plate 12

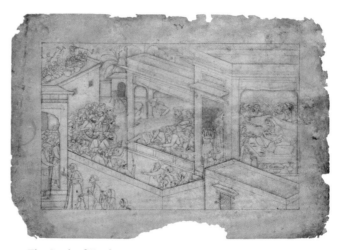

56 *The Birth of Krishna*
From the *Bhagavata Purana*
Himachal Pradesh, Kangra, c. 1780
Brush and black ink over charcoal with touches of blue watercolor on beige laid paper
8 x 12 inches (20.3 x 30.5 cm)
Philadelphia Museum of Art. The Conley Harris and Howard Truelove Collection of Indian Drawings, purchased with the Stella Kramrisch Fund for Indian and Himalayan Art, 2013-68-17
Plate 5

57 Krishna Recites the Bhagavata Gita to Arjuna
Himachal Pradesh, Kangra, late eighteenth century
Brush and black and orange-red inks and watercolor on beige paper
6⅛ x 10⅛ inches (15.7 x 25.7 cm)
Philadelphia Museum of Art. The Conley Harris and Howard Truelove
Collection of Indian Drawings, 2013-77-19
Plate 42

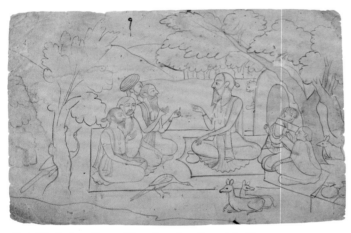

58 A Hindu Ascetic and Devotees in a Forest Setting
From the *Bhagavata Purana*
Himachal Pradesh, Kangra, c. 1800
Brush and black and orange-red inks on beige paper
6 x 9 inches (15.2 x 22.9 cm)
Philadelphia Museum of Art. The Conley Harris and Howard Truelove
Collection of Indian Drawings, 2013-77-36
Plate 45

59 The Sage Narada Awakening the Gopis
Himachal Pradesh, Kangra, c. 1800
Brush and black and orange-red inks over white opaque watercolor on
reused beige laid paper
10¼ x 5½ inches (26 x 14 cm)
Philadelphia Museum of Art. The Conley Harris and Howard Truelove
Collection of Indian Drawings, purchased with the Stella Kramrisch Fund for
Indian and Himalayan Art, 2013-68-7
Plate 6

60 The Battle between the Demon and the Monkey Armies
From the *Ramayana*
Himachal Pradesh, Chamba, c. 1730–35
Brush and black ink over charcoal on beige laid paper
7½ x 11¼ inches (19.1 x 28.6 cm)
Philadelphia Museum of Art. The Conley Harris and Howard Truelove
Collection of Indian Drawings, purchased with the Stella Kramrisch Fund for
Indian and Himalayan Art, 2013-68-15
Plate 32

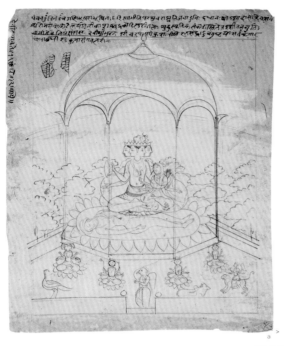

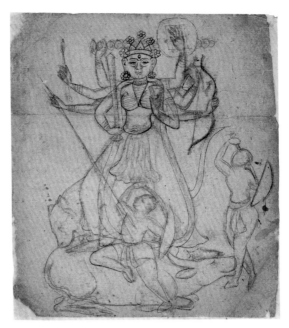

62 *Durga Mahishasuramardini*
Himachal Pradesh, Chamba, c. 1800
Brush and black ink over charcoal on beige laid paper
7⅛ x 6 inches (18.1 x 15.2 cm)
Philadelphia Museum of Art. The Conley Harris and Howard Truelove
Collection of Indian Drawings, purchased with the Stella Kramrisch Fund for
Indian and Himalayan Art, 2013-68-3
Plate 10

61 *Shiva and Parvati Seated in a Pavilion* (a)
***A Sheet of Sketches* (b)**
Himachal Pradesh, Chamba, c. 1790–1800
(a) Brush and black and orange-red inks and opaque watercolor over white
opaque watercolor, ink, and charcoal on beige laid paper; (b) brush and
black ink and watercolor on beige laid paper
11¾ x 9⅜ inches (29.8 x 23.8 cm)
Philadelphia Museum of Art. The Conley Harris and Howard Truelove
Collection of Indian Drawings, 2013-77-12a,b
Plate 26 (a)

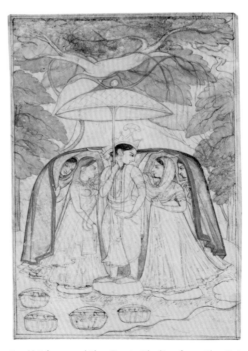

63 *Krishna and the Gopis Shelter from the Rain*
Himachal Pradesh, Mandi, c. 1840
Brush and black and red inks, watercolor, and opaque watercolor on
beige paper
8⅜ x 5⅝ inches (21.3 x 14.3 cm)
Philadelphia Museum of Art. The Conley Harris and Howard Truelove
Collection of Indian Drawings, 2013-77-29
Plate 19

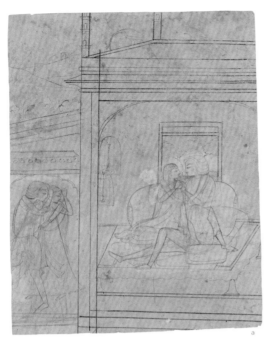

a

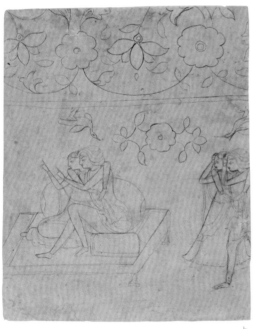

b

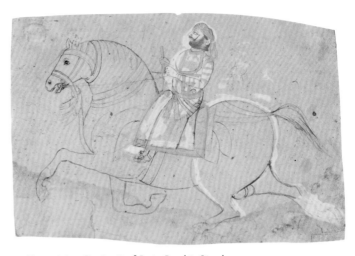

65 *Equestrian Portrait of Raja Ranbir Singh*
Jammu and Kashmir, Jammu, c. 1870–80
Brush and brown ink and yellow opaque watercolor over charcoal with corrections by the artist in white opaque watercolor on beige paper
8⅜ x 11⅜ inches (21.3 x 28.9 cm)
Philadelphia Museum of Art. The Conley Harris and Howard Truelove Collection of Indian Drawings, 2013-77-30

64 *Amorous Couples*
Punjab region, c. 1830–40
(a) Brush and black ink with corrections by the artist in white opaque watercolor on beige paper; (b) brush and black ink and traces of white opaque watercolor over charcoal on beige paper
10 x 7 inches (25.4 x 17.8 cm)
Philadelphia Museum of Art. The Conley Harris and Howard Truelove Collection of Indian Drawings, 2013-77-21a,b
Plates 24a,b